HOW TO TAKE GREAT PICTURES WITH YOUR SLR

Lou Jacobs, Jr.

Editor: Carl Shipman

Design: Josh Young

Photography: Lou Jacobs, Jr.

Typography and
Book Assembly: Ellen L. Duerr
Debbie McMillian
Nancy Fisher

Contents

	Frame zero	3
1	The anatomy of an SLR	4
2	How to select an SLR	14
3	How to choose lenses	25
4	How to select films and filters	54
5	How to get ideal exposures	70
6	How to compose	89
7	How to shoot portraits and people	105
8	How to capture action	122
9	How to shoot in available light	140
10	How to avoid the postcard cliche	148
11	An appreciation of color	160
12	How to shoot after dark	169
13	The close-up world	175
14	How to use flash	187
15	Case histories	209
	Frame 37	222

ISBN Number 0-912656-26-3

Library of Congress Catalog
Card Number 74-82515

© 1974 H.P. Books
1978 Lou Jacobs, Jr.

H.P. BOOKS, P. O. Box 5367
Tucson, AZ 85703

About This Book

This is one of a series of H. P. Books on photography. We asked author Lou Jacobs, Jr. to write for the happy owner of a new Single-Lens Reflex camera—who wants to learn how to use the impressive capabilities of the modern SLR to take outstanding pictures.

He did more than asked. At the beginning there are some tips on cameras and their selection. Throughout, he gives information in language the beginner can understand but of sufficient depth to benefit even an old hand.

By limiting scope to modern SLR cameras, accessories and systems, the book gets right to the point of using that camera you hold in your hand—without a lot of extraneous clutter related to other camera types or echoes from the past.

Experience is more valuable to you than advice, but you need some basic know-how so you can *have* meaningful experiences making photos. The know-how is here but it stops short of long lectures. Jacobs brings you just to the point where you are anxious to shoot pictures and then sends you out with blessings.

Images are of more value to image-makers than mere words. But beginners need some coaching in the language of imagery. That's here too. Lou Jacobs filled this book with pictures—more than 300—to start you thinking toward original expression and away from the standard cliche.

Some of the pictures are award-winners, some merely good, some plainly bad. The author doesn't try to force you into a mold. If you don't agree which is good and which bad, Jacobs says, *"Good for you!"* I say, "Good for Jacobs!" I think you'll like this book.

Carl Shipman
Editor

ABOUT THE AUTHOR

You've seen the work of photojournalist and author Lou Jacobs, Jr. in many national magazines such as *Look, TV Guide, Family Weekly, Pageant,* and others.

He started writing about photography in *U.S. Camera,* and his articles have appeared in many photo magazines including Petersen's *PhotoGraphic* and *Camera 35.*

His first book on photography was *How To Use Variable-Contrast Papers* in 1959, followed by others on lighting, flash, photojournalism, Petersen's *Basic Guide to Photography, The Konica Autoreflex Manual,* and others. He is also author or illustrator of 20 books for young readers on a variety of subjects.

He teaches photography at UCLA extension, and has taught at Brooks Institute. Lou is a member of the American Society of Magazine Photographers, and writes a regular column for *Home,* a Sunday magazine of the Los Angeles *Times.* He lives in Studio City, CA, with his wife—accomplished photographer Barbara Mills Jacobs—and an assortment of teen-age sons.

THE COVER PHOTOS

The golden view of Venice was taken by the author on Kodachrome II with a Hexanon zoom lens on a Konica Autoreflex T3. Karen Demuth took the interesting photo of the young baseball player. Bill Evans of Studio City, CA, photographed the girl behind the screen with a Honeywell Pentax ES on Agfachrome 64. His picture is used by courtesy of Honeywell Photographic Products Division.

Frame Zero

I'm delighted that you have chosen the current edition of this book, and hope it helps you find success and enjoyment in photography.

Since the late 1950's, I have been shooting with SLR cameras and have a large variety of picture-taking experiences to share. I've photographed Marilyn Monroe, the nomination of John F. Kennedy, the Watts riots, the unveiling of the Boeing SST, my children growing up, and the sights of three continents. I've written a lot of articles for photo magazines and this is my ninth book about photography. Some of the others covered lighting, photojournalism, variable-contrast papers and general surveys for teen-agers and adults.

I'm a photography columnist for *Home,* a Sunday magazine of the Los Angeles *Times,* and I've served as a judge in their annual photo contest for non-professionals since 1974. While looking over several thousand slides and prints I noticed most were shot with SLR cameras—a fine way to get outstanding images. But something bothered me. Too many of those pictures seemed to lack imagination and visual excitement. There were too many empty landscapes, too much reliance on sunset colors, and not enough feeling for complete compositions. A lot of b&w prints suffered from bad craftsmanship. Some of the photos were really good but most lacked the *essential ingredient.*

Young or old, experienced or beginner, we all want the same result—*picture impact.*

Good technique will take you only part of the way. You must also call on your creativity and imagination to tell a story effectively, tug on an emotion, record a memorable event or capture exciting action. Your slides and prints should be technically excellent when you use modern photographic equipment but that's not enough. Viewers must feel the reaction you did when you tripped the shutter. They will if you put the right image on film.

Non-professional photographers are their own clients. Payment is in self-satisfaction, an occasional kind word, the realization of growth and improved skills, and some great pictures. As a non-pro, you have to generate your own incentives to get out and take pictures. Maybe you must rationalize to justify buying some new equipment, or scrimp a little to protect your budget. We all go through some sort of struggle to make photography our means of expression. If we didn't shoot pictures, what creative effort could we turn to for equal stimulation and satisfaction?

I believe in the SLR and I really enjoy shooting pictures. I can get wound up in theory, equipment and technique. I hope this involvement is contagious.

Throughout this book you will find photo features entitled *What Makes a Good Picture?* With these outstanding images are short commentaries on technique and seeing, telling how the picture was made, and offering provocative ideas. These images are intended to illustrate highlights of chapters—the visual mode of communication—and help you take great pictures.

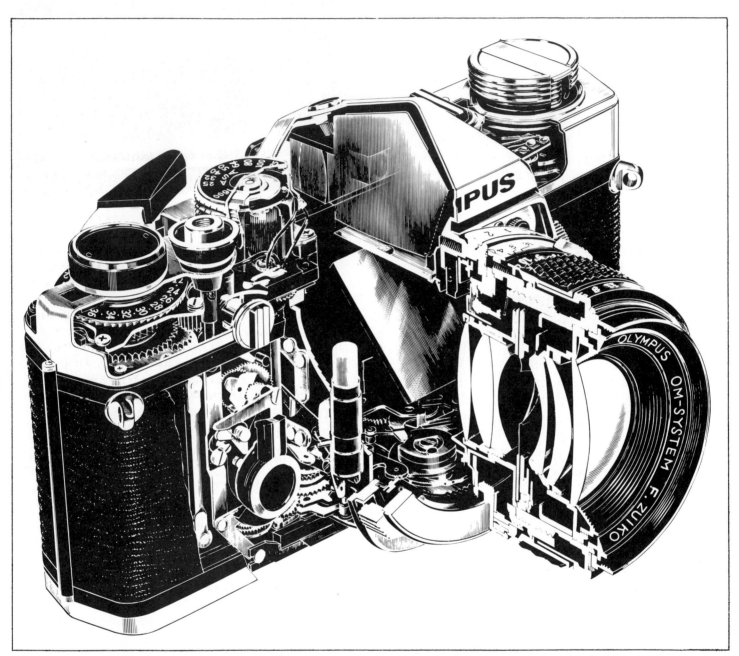

THE CAMERA BODY—In front you easily recognize the lens, and above is the housing for the prism, with dials and levers on top. Inside a modern SLR is far more complicated than seems apparent, and you would have a hard time identifying most of the components unless you're an electronics engineer.

Take apart a modern SLR—at your own crazy risk—and you might mistake it for a small radio. Wires, transistors, resistors, and batteries are all harnessed to the shutter and exposure-meter systems to make the camera semi-or even fully-automatic. This is a cross-section of an Olympus OM-1. Light enters the lens and is reflected by the mirror into the prism, and then through the viewing port to your eye. Two exposure-meter cells are built into the prism housing to measure the amount of light coming through the lens. Other camera brands and models may place the light sensor in another location but all modern SLRs have some way to measure the light.

Gears, levers, and springs are coordinated with electronics inside an SLR. At the instant you press the shutter-release button, the mirror swings up out of the way to allow the image to fall on the film at the back of the camera body.

This book is planned to be useful to photographers who have just bought their first single-lens reflex—SLR—and even to those who are just getting interested in the modern SLR. Therefore this chapter covers the buttons, functions and gadgetry of typical cameras. If you haven't bought yours yet, the next chapter gives you some advice on selecting an SLR to meet *your* requirements. These two chapters should get everybody up to speed and ready to start shooting pictures.

If you already own an SLR and it is not brand-new, you're welcome to compare notes with me by skimming through these two chapters, or you can just skip them and go directly to Chapter 3. That's where we pick up the main theme and start exploring ideas leading to great pictures.

There are good reasons why the single-lens reflex is the most popular type of camera among *aware* photographers, experienced or beginners. This popularity is based on its potential for fast, seemingly casual yet technically precise photography.

You view, compose and focus through the lens that is taking the picture no matter what focal length you have chosen to use, adjust exposure with a built-in meter or let the fully automatic SLR do it for you, take the picture, advance the film and cock the shutter in one or two seconds. And you do it all with less than 2 pounds of well-balanced equipment in your hands.

Lenses can be changed in 15 seconds, film unloaded and reloaded in a minute, and exposures can stop a horse jumping in mid-air—or show a coal miner at work by the light on his safety helmet. All this adds up to versatility and sophistication—the basic reasons we choose and use the SLR.

Because this is not a handbook for any specific brand, your camera may have some different features or locations from those you see here. Your brand may not have everything shown—or it may have additional features I didn't include. The basic parts of a typical SLR are included. For specific details about your own camera you should become familiar with its instruction book. You may also refer to full-length books written about specific brands . . . if yours happens to have been written about.

You probably know—at least in a general way—the purpose of the camera controls such as

FOCAL-PLANE SHUTTER—Open the back of an SLR and you nearly always find a focal-plane shutter. This curtain opens and then closes in front of the film to control the time duration of exposure. It may move horizontally or vertically, depending on the brand of camera and essentially it doesn't make much difference in normal photography. Focal-plane shutters are made of special cloth or metal. This one is cloth and travels horizontally. The metal type usually moves vertically and has the advantage of synchronizing for electronic flash at 1/125 second. Horizontal types sync at 1/60 second. When we talk about flash in Chapter 13 this distinction is explained further.

The average focal-plane shutter has a top speed of 1/1,000 second, though a few cameras have a 1/2,000 second setting. I wouldn't buy a camera *just* for the faster speed, but if you like the brand and model for other reasons, 1/2,000 second is good for stopping very fast action. More important are the slower shutter speeds used for the majority of picture situations you will encounter.

Sometime when you have the back of your camera open, set the shutter to a slow speed such as 1/8 and trip the shutter. You will see it do its trick. Don't get carried away with curiosity and poke at it though. You could hurt your shutter *and* your finger.

shutter-release button and film-speed selector. If you see some you don't know in the quick photographic tour that follows, please use the photos as a preliminary introduction. The controls and how you use them are described more fully in later chapters.

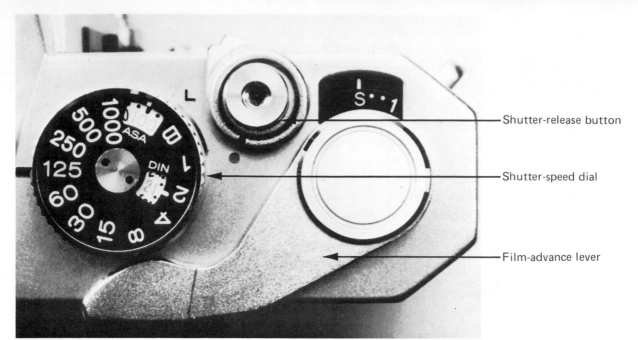

Shutter-release button

Shutter-speed dial

Film-advance lever

SHUTTER-SPEED DIAL—Each number on this dial represents an exposure time. Each step doubles exposure time or cuts it in half, depending on which way you turn the control. The 2 means 1/2 second, 4 means 1/4 second or half as much exposure as 1/2 second. 60 (1/60 second) is not precisely half of 125 (1/125 second), but it is close enough for correctly exposed negatives and slides.

B on the shutter-speed dial means *bulb*, a hangover term from ancient cameras where you squeezed a bulb in your hand to hold the shutter open for time exposures. Set on B, the focal-plane shutter stays open so long as you depress the release, and closes when you lift your finger. Some cameras have a locking mechanism to hold the shutter open on B for time exposures—on a tripod of course—making it easier to avoid camera movement. You can buy a locking cable release to screw into the shutter button. This allows you to trip the shutter and hold it open as long as you wish.

I've shown the shutter-speed dial and the top right side of two different SLR's to symbolize design variations on different brands. Note the X opposite 1/60 second; it is the top speed on this camera for electronic flash (EF). The 1/125 second mark on the other is printed in red to indicate the maximum EF speed for it.

The windows marked ASA and DIN show the film-speed rating you have selected. I'll show you how later.

FILM-ADVANCE LEVER—One flip of this lever—around 150 degrees rotation—cocks the shutter and advances the film. On most cameras the lever projects beyond the camera body for accessibility, and can be "parked" near the shutter-speed dial when not in use.

SHUTTER-RELEASE BUTTON—Depress to shoot a picture. This button may have a collar around it to turn the exposure meter on and off, locking the release against accidental exposures or both. On some automatic-exposure cameras, depressing the shutter button halfway will cause the camera to hold a meter reading while you move to a different spot to take the picture.

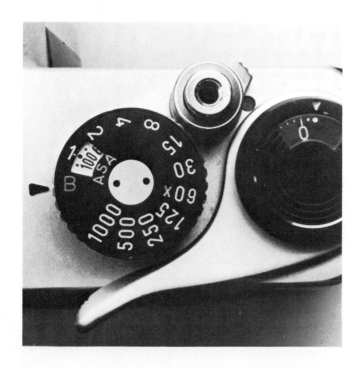

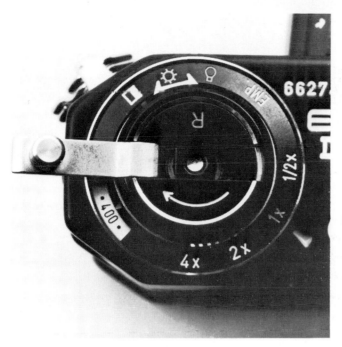

REWIND KNOB—To rewind the film back into the original cartridge, lift the crank-handle and turn clockwise. The ring around the knob in this photo has the film-speed selector window, plus switching to allow operator control of exposure automation. On some cameras, lifting the rewind knob opens the back door. Rewinding usually requires depressing a rewind clutch button on the bottom of the camera.

FILM-SPEED RING—Around the shutter-speed dial on many camera models is a lift-up collar to set the ASA or DIN speed number of the film you're using. Lift and rotate to set the number in the tiny window and you are adjusting the camera's built-in light meter for the sensitivity of the film you are using.

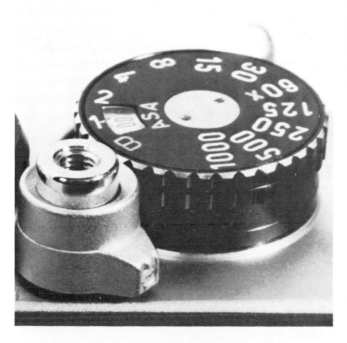

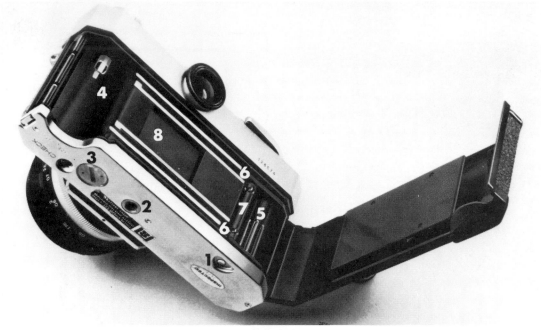

1. Rewind clutch button
2. Tripod socket
3. Battery compartment
4. Film cartridge chamber
5. Take-up spool
6. Film-support tracks
7. Sprocket
8. Metal-type focal-plane shutter

BOTTOM PLATE—Here you'll find the tripod socket and sometimes the battery compartment. Built-in meters and electronic shutters are powered by small mercury or silver-oxide cells in the camera body. Check the instruction booklet with your camera to be sure you use the correct battery. These little cells all look alike, but your camera's operation can be fouled up if you use the wrong one.

INSIDE THE BACK—Open the back and you see a film-cartridge chamber on the left and a take-up spool on the right.

With the camera back open you see the focal-plane shutter. This one is metal and runs vertically.

When your camera is put away for a while, be sure the shutter is not cocked, because springs left in tension may weaken and lead to eventual shutter-speed inaccuracy.

A pair of film-support tracks run above and below the rectangular image-window. The edges of the film ride on those chrome tracks and the emulsion side of the film—where the picture image is formed—is not supposed to touch *any* part of the camera body. Film normally touches only the felt lips of its cartridge and winds up against itself on the spools. When a camera ages, it may wear until there is a small amount of play in the mechanism. The film may then rub against the body and possibly be scratched. This doesn't happen often, but if you have a well-used SLR and find consistent scratches on the emulsion side of the film that cannot be blamed on film cartridges, check the take-up spool and sprocket for wear.

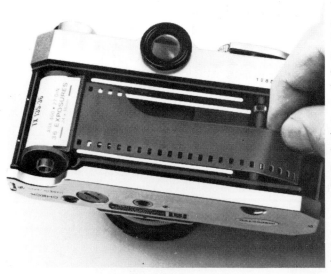

TAKE-UP SPOOL—Except on cameras with a special film-end *grabber*, the take-up spool has slots into which you insert the front end or leader of your film. Do it carefully, advance the film with the lever, close the back, and wind off a couple of frames. *Watch the rewind knob* as you do this. It should be turning by the time you have advanced three frames. The film counter operates whether film is actually being taken up or not, so it is possible to think film is being advanced when it is not. I don't care what tricky names are given to take-up spools, they are not fool-proof, and I have shot more than one roll of film in my lifetime, only to find it never went through the camera. Twenty years ago using a rangefinder camera with similar accident potential, I asked the Air Force to give me another jet ride for a story I was shooting because I "exposed" one roll that didn't. It's a very embarrassing feeling you can guard against with that simple precaution.

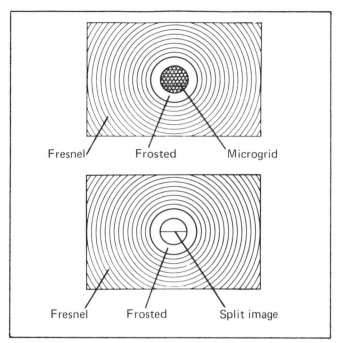

Fresnel Frosted Microgrid

Fresnel Frosted Split image

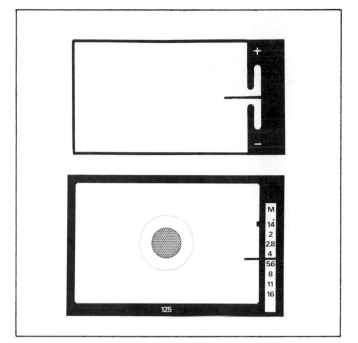

FINDER—Finder displays vary among SLR cameras. Some have a grid in the center for fine focusing, and others use a split-image which you line up for sharp focus. Camera systems may include interchangeable finders that are removable, and a choice of focusing screens. Instead of an eye-level finder, you may be able to install a waist-level finder you look down into, or a finder with special built-in meter or an angle-viewing attachment to let you see into the camera when it's too low/high to get your eye next to the finder window.

A few brands design an automatic exposure system into a removable finder, but most EE—electric eye—systems are built into camera bodies. In the finder display manufacturers use a variety of formats to indicate correct exposure. Two of these are shown here.

In one style, the meter needle is centered in a gap for correct exposure. At the top the symbol + means over-exposure and at the bottom - means underexposure.

The finder with the numerical display is one version of an automatic-exposure system. The needle indicates the ƒ-stop chosen by the system to work with the shutter speed—shown at the bottom—you have previously selected. The M at top is illuminated when the EE system is turned off and settings are made manually. In an alternate system a series of shutter speeds appears at the right side of the finder instead of ƒ-stops.

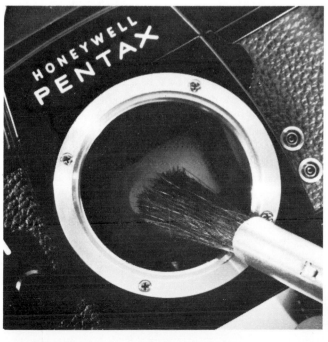

MIRROR—With the lens removed from your SLR you see the mirror which should *never* be touched with your fingers. Most manufacturers advise blowing dust from the mirror, but it can be brushed delicately with a soft brush made for photo equipment. The reason you don't touch it is because it is a front-surface mirror. The surface you see is the actual reflective coating and it is easily damaged. If the mirror should ever hang up or malfunction in your SLR, don't try to pry it or jar it back to position. You can damage other components and the mirror will probably stay stuck. Take it to a camera repairman.

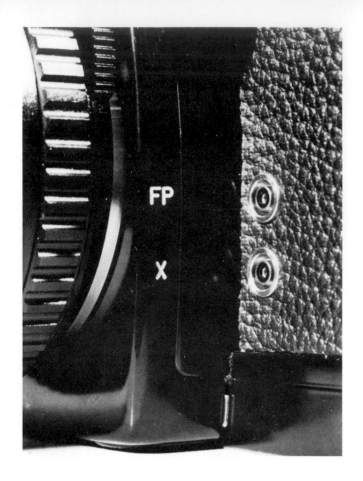

SYNC CONNECTORS—At the front, or sometimes on one side, are one or two flash terminals where you plug in the sync cord from flash to camera. Read your instruction booklet to see which terminal to use for flashbulbs or cubes; the X terminal is always used for electronic flash. Consult the instruction book for the type of flashbulbs required with the M or FP sync connection. You must also know which shutter speeds will work with flashbulbs or electronic flash. The speeds are different for different camera makes.

SELF-TIMER LEVER—On most cameras there is a self-timer lever you rotate to get delayed shutter release anywhere from 6 to 14 seconds after depressing the shutter release. This is handly if you want to run around and get into the picture yourself. It can also be used to take a picture without touching the camera if you don't have a cable release and must guard against even the slightest camera movement. This lever sometimes has more than one function. On some cameras it can also be used to lift and lock the mirror before releasing the shutter. This is done when it is critical to avoid any chance of camera vibration during exposure.

On most SLR cameras viewing and focusing is done at wide-open aperture but the picture is taken at some smaller lens opening. Because this affects which parts of a scene will appear to be in good focus it is usually desirable to close down the lens as a check while viewing to see what's going to get on the film. This function is often called *preview* and is sometimes accomplished by the self-timer lever, moved in the opposite direction.

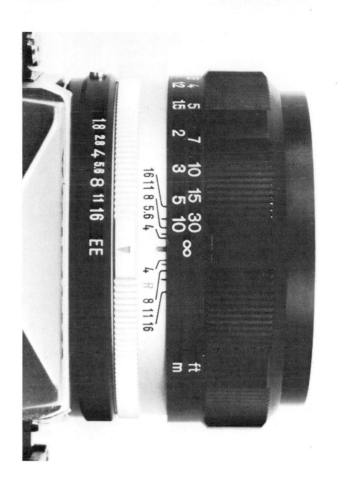

LENS BARREL SCALES—On the lens barrel are numbers for focusing distances in feet and meters, plus f-stops and the depth-of-field scale which is explained in Chapter 3. In the illustration the EE setting indicates the lens is set for automatic exposure; EE will not appear on your camera if it is not automatic.

HOT SHOE—Some SLR's include a hot shoe atop the camera to make direct electrical contact between a cordless flash unit and the shutter synchronizing mechanism. Into the same shoe you can slide accessory finders or any flash unit, plus swiveling flash holders when you want to point your flash at the ceiling—called bounce flash.

There may be a few other features on your particular SLR body, or within it, but these are the main ones.

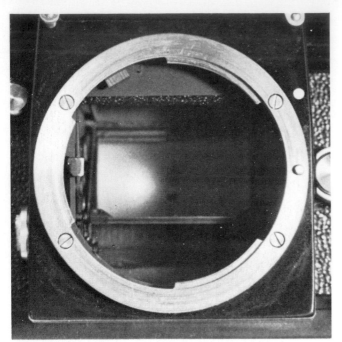

Bayonet-type lens mount on camera body has grooves around perimeter which accept mating fixture on lens.

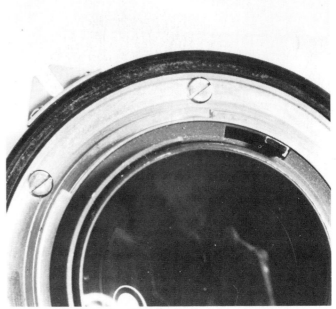

Lens has matching grooves. To install, place lens on camera and rotate bayonet fitting until it is tight, or clicks in place.

LENS MOUNTING METHODS

One reason you buy an SLR is the versatility of interchangeable lenses. The average 35mm SLR is sold with a *normal* lens, meaning its focal length is somewhere between 50mm and 57mm. This is the standard general-purpose lens. However, you can quickly remove that lens and substitute any of dozens to give you a different angle of view, or have specialized functions for close-ups, zoom, wide-angle or telephoto photography.

There are two basic lens mounts. One is the *screw mount.* The lens is threaded into the camera body and tightened until the aperture-operating pin in the lens touches a bar or small plate within the camera body to operate the aperture during exposure. There are more different brands and types for screw-mount lenses on the market than there are bayonet mounts.

The *bayonet* mount is faster to remove or replace but unfortunately each camera manufacturer has its own bayonet design. A Nikkor lens won't fit on a Konica T body without an adapter. With some—but not all—lens and adapter combinations you lose automatic features of the camera. Don't let all this deter you because more and more brands are made with a "T" mount adaptable to a wide variety of cameras. In fact, there are adapters for screw-mount lenses to bayonet-mount bodies. When we get into the next chapter, I'll discuss buying lenses made by the same manufacturer as your camera, or lenses made by other firms.

Whether you own a screw-mount or bayonet-mount camera, place and remove lenses carefully, making sure the precision mounts are not damaged, and the lenses click into place for smooth automatic-diaphragm operation and accurate focus.

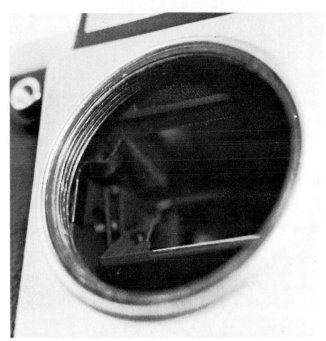

Camera bodies for screw-mount lenses have a threaded lens mount.

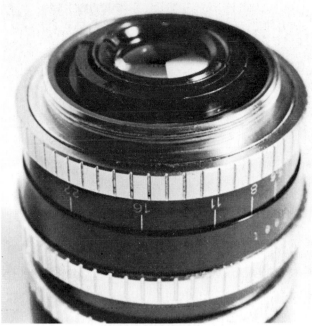

The lens naturally has a mating thread pattern and is screwed in place.

AUTOMATIC, MANUAL AND PRE-SET LENSES

Almost all SLR lenses available today include automatic-diaphragm operation. This means you view and focus with the lens wide open. When you shoot, the lens aperture—also called the diaphragm or *f*-stop—is stopped down to a pre-determined setting by the internal camera coupling. An instant after exposure, the diaphragm opens again to its full aperture for continued viewing with the brightest image. This may sound commonplace because you are used to it, but not too many years ago, many fine lenses were not automatic. You controlled aperture size *manually,* by turning the aperture control ring on the lens.

There are still a few *pre-set* types around with two rings on the lens barrel. You set the lens opening you want on one ring, and just before you shoot, you revolve the other ring to stop the lens down to the pre-set opening. Then you have to open the lens again manually to view clearly. Pre-set lenses are a drag to use, and fortunately manufacturing technology has advanced so that automatic-diaphragm lenses are reasonably priced in every focal length. Only a very few lenses, mostly those of very long focal lengths (telephotos) are still pre-set, which is a minimum handicap. You usually shoot rather slowly with such lenses because your camera is on a tripod.

A few SLR cameras still include a metering method that requires you to view with the lens closed down to the *f*-stop at which the picture will be taken. This gives a darkened image that is annoying in subdued light. Fortunately, wide-open metering has been adopted by most camera manufacturers.

Walk into a well-supplied camera shop, look at the shelves full of single-lens reflex cameras and there's instant confusion. Pick up any current issue of a photography magazine and examine the ads. In a few minutes you will see a mind-boggling variety of magnificent metal, glass, electronics and persuasive claims. This profusion requires that you be informed before you select an SLR. Write or ask for literature. Compare features, prices and systems. Be ready with questions and don't buy until the answers satisfy you.

I can't pick an SLR for you, but here is some guidance for your research.

SLR EXPOSURE SYSTEMS

In the ads, meters are "superbly accurate," or "two systems in one," or "solid-state." Statements about the merits of through-the-lens (TTL) metering are both amusing and informative, but the truth is they all work. I doubt if anyone knows for certain which cameras have the most accurate and foolproof metering method, but there's no need for frustration because photographers own everything on the market and find individual choices satisfactory to use. More important is a comparison of metering systems using needles or indicator lights, and an evaluation of hand-set versus automatic methods for shooting those zingy negatives and slides that make your heart beat faster.

Hand-Set Exposure—This method is also called manual operation or *match-needle* metering, though not all hand-set designs use needles to indicate correct exposure. Some use tiny red and green lights or arrows seen within the camera finder to indicate over- or underexposure. These light-emitting diode (LED) systems are becoming more popular, and are often used with electronic shutters as discussed just a few lines ahead. Whether your camera has a needle or lights doesn't matter. What does matter is learning to use the camera's meter carefully and accurately for right-on exposures. You can be sure the camera metering system is practical even if you must in rare instances have

Cannon AE-1 is a shutter-preferred automatic-exposure camera that is lighter and smaller than previous Canon SLRs.

Canon AT-1 is similar to the AE-1, but is non-automatic with a match-needle exposure system.

it adjusted by a repair expert. Only dependable equipment can survive long in today's very competitive SLR market.

The operating procedure may influence your choice of camera. I think it's always worthwhile to shoot a sample roll of film in any camera you are considering buying. You may have to expose it in the store and out on the sidewalk with the salesman watching to make sure you don't escape with his precious merchandise. Running a roll through at various focusing distances, shutter speeds and lens openings can tell you a lot about how the camera feels—a lot more than you'll notice by playing with it at the counter.

Manual exposure adjustment is mechanically simple. First set the film speed for the type of film you are using on the control dial. There should be a switch to turn the meter on and off— to activate a needle or indicator lights in the viewfinder—because if left on all the time, battery life is expensively short. A few brands place LED lights at the bottom. By turning the aperture or *f*-stop ring on the lens barrel to open or stop down the lens, or by changing shutter speeds, you arrive at a combination of *f*-stop and shutter speed which the built-in meter tells you is just right for the light and your subject. Either the meter needle is centered or LED lights glow at you according to the camera design. For each shot you may have to check the exposure indicator and readjust *f*-stop or shutter speed. Other considerations may cause you to change both.

Automatic Exposure—Anyone who has experience with a camera such as the Pocket Instamatic or Polaroid is accustomed to the automatic or electric eye (EE) exposure method. In these cameras, sensors—usually beside or behind the lens— measure light reflected by a subject and set the lens aperture automatically to match the shutter speed of the camera which is often non-adjustable. You take pictures confidently, depending on the camera for correct exposure. In the simplest sense, you push the button and the camera does the rest. However, automation is not foolproof and there are occasions where over- or underexposure may spoil the finished print or slide.

In the SLR field, automatic exposure is more sophisticated, a lot more expensive, and more dependable, *providing* you realize that *your brain* must be coupled to the sensitive meter cells and

Canon F-1 offers a super-fast 1/2000 top shutter speed.

The Fujica AZ-1 can be purchased with any of 3 lenses according to your preference: a 50mm *f*-1.8, a 50mm *f*-1.4, or a 43mm to 75mm zoom lens. The *f*-1.4 and zoom are at extra cost.

Konica Autoreflex T-3 is shutter-preferred automatic with multiple-exposure lever.

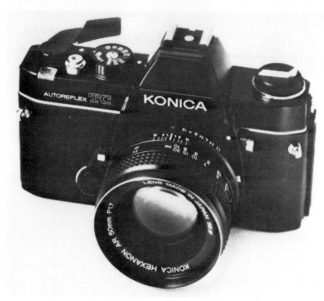

Konica TC is scaled-down compact with shutter-preferred exposure.

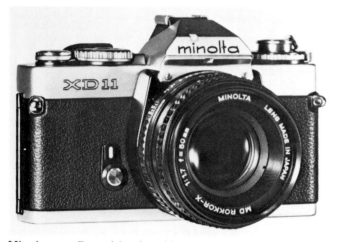

Minolta was first with selectable priority. A switch on top of the XD11 is used to select shutter-priority, aperture-priority, or manual control of exposure.

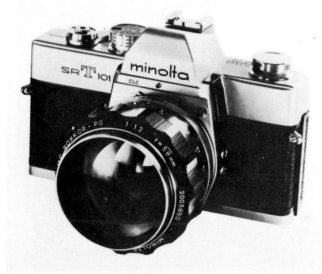

Minolta SR-T 101 is part of a series that also includes the SR-T 100 and SR-T 102.

circuitry to achieve predictably satisfying exposure results.

This should not sound perplexing when you remember that the slickest computers or billion-dollar spacecraft are worthless unless under the control of human intelligence. Automatic exposure is relatively new to the SLR field, match-needle models having been introduced and refined first. However, more and more manufacturers are now making automatic SLR models, while continuing to sell match-needle models in most cases.

Before describing the two major methods of SLR automation, I must admit feeling a little self-conscious because of my partiality towards SLR automatic exposure. For a dozen years I used one brand of camera that eventually included a built-in match-needle meter. Its exposure measurement was very reliable, though I had other mechanical problems with many models. In time I switched to an automatic SLR, the Konica Autoreflex T, which was first in the field, introduced in 1967.

I think automation is truly superior to hand-set exposure for convenience and speed of shooting, and I said so in another of my books—the *Konica Autoreflex Manual* (Amphoto, New York, 1974).

At the same time I know very well the enormous number of *non-automatic* SLR's in use today by enthusiastic and skilled photographers. My leaning towards the automatic system in no way degrades the value or efficiency of any other type of single-lens reflex. You need only check any photo magazine to see outstanding pictures taken with a great variety of non-automatic cameras all over the world.

Now that I have relieved my conscience, let's look at the ways automation is achieved and how it works. Today there are three kinds of automatic operation. If you set the shutter speed and the camera sensing devices choose and set a lens opening to match, it's called a *shutter-preferred* system.

If you set aperture size and the clever camera measures the amount of light and then sets shutter speed for you, it's called *aperture-priority*.

With any kind of automation, the advantage appreciated by the average user is this: You can shoot all day with minimum changing of camera controls unless you are shooting a scene with special problems such as a face against the sky, action, or you desire a particular depth-of-field effect.

The price for this convenience is money. You decide first if you need camera automation and then choose the kind you prefer.

When only two kinds of automatic operation were available, shutter-preferred or aperture-preferred, there was great and unending debate about which system is better. The debate is unending because there is no firm answer—it depends on personal preference and what you intend to shoot with your camera. Shutter-preferred advocates say *you* are the best judge of shutter speed so you can stop action when you choose to. Aperture-preferred fans say it's better to control depth of field by setting lens aperture yourself.

The third kind of automatic operation is *selectable-priority.* By a switch on the camera, you can select shutter-priority, or aperture-priority, or manual control of both shutter and aperture. This obviously offers the best of both systems and allows the user complete flexibility.

Most automatics can be converted to manual operation by the flick of a switch or aperture ring. In other words, if you wish to turn off the automation and set your own exposure because of unusual lighting or subject, it's a cinch. On most brands, when you switch off the automation, the built-in meter is still your exposure guide. Very neat.

Automatic exposure can be really convenient for night shots because otherwise you must guess the exposure with cameras that don't measure light and set exposure automatically. It is uncanny to aim an electronic SLR marvel at a dimly lit scene. You hear the shutter click open, and when it snaps closed, the camera has accurately set its own exposure.

For long exposures, you may need to correct for reciprocity failure, which can be done by changing the film-speed dial setting. Check the film data sheet. To give one stop *more* exposure, divide film speed by 2.

Aperture-preferred camera bodies usually offer the advantage of using existing lenses in the manfacturer's line or made by other companies. Because automation is in the body, the automatic diaphragm mechanism in the lens that works on non-automatic cameras also fits onto and works

Compartment case for the SR-T 101 is typical of case design for SLRs.

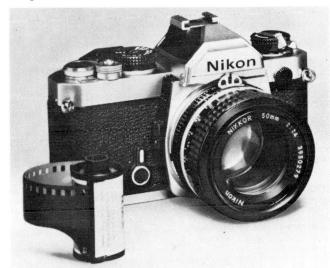
Smallest and lightest of Nikon cameras, the FM uses LED indicator lights for readout in finder.

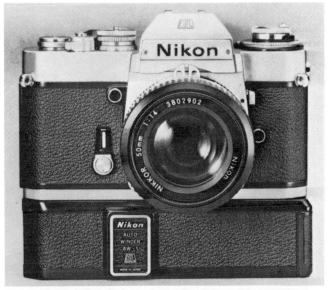
Nikon EL2 is first automatic in that line, and accepts AW-1 auto winder shown attached.

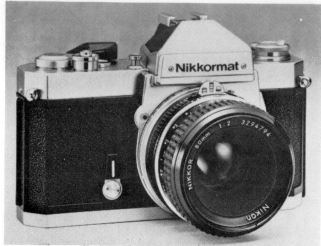

Nikkormat FT3 provides aperture readout in finder and all-metal shutter with X-sync at 1/125 second.

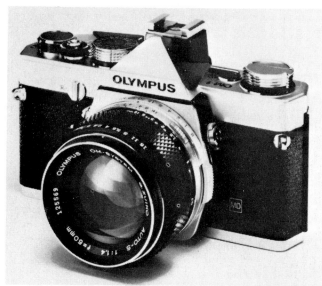

Light-weight Olympus OM-1 set the pace for miniaturization of many SLRs.

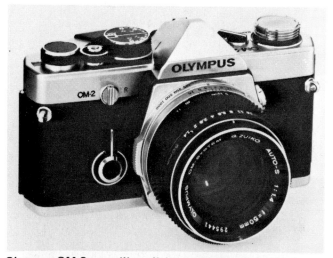

Olympus OM-2 uses silicon light-metering cells which face the film to measure the light actually falling on the film. It is aperture-preferred automatic.

with these EE models. However, shutter-preferred SLR's are less expensive to manufacture because of their more conventional mechanical shutters. If you are just getting into the SLR field, and do not have to consider scrapping lenses you already have that may not work with a shutter-preferred body, you can save money.

In any case, the question, "Can you trust an automatic SLR?" is no longer a serious consideration, even among professionals. The answer is a definite yes, and my opinion is an expression of seven years' experience with automation.

OTHER SLR CONSIDERATIONS

On the basis that you are familiar with how a single-lens reflex camera operates physically, let's briefly examine other items that can be important in your choice of a camera.

Weight—You may have noticed some SLR's weigh more than others. Though there is no predictable relationship among weight, size and the quality of prints or slides you can expect, there is a comfort factor involved. Put any camera you are considering around your neck and get the feel of it. A few ounces more or less probably will not be noticed, but there's a terrific difference in weight between the Nikon F2, for instance and the Olympus OM-1. The latter is dramatically smaller and lighter but variations in weight are detectable among many brands. Professionals who usually carry two cameras around their necks at the same time are particularly sensitive about weight.

Finder—Though most SLR's offer a bright clear image through the finder, some are more convenient to focus for some people, and some are easier to use by photographers wearing glasses. Check the fine-focus ability of any camera you find appealing and be sure you like the way the finder fits your eye and the focusing display you see. If being able to change the focusing display for different needs seems important to you, choose a brand offering this option.

If you can't seem to focus sharply by looking through the finder lens and turning the focusing ring, there's a simple remedy. Clip-on or screw-in auxiliary finder lenses will help you see the image you are focusing on. You might need one of these,

even if you don't wear glasses or only wear them for far-seeing, such as driving. Your eye really has to look closely when you focus an SLR. If the standard array of auxiliary lenses does not fit your own eye correction, there are firms which grind finder lenses with your very own correction.

Some SLR's won't let you see the entire finder image if your eye is spaced away from the finder lens. If the camera you've fallen in love with is one of those, a corrective finder lens will let you use the camera without your glasses.

Handling—The basic design of most single-lens reflex cameras and the placement of controls are similar, but there are differences. Handle a camera, focus it, view through several lenses even though you may not purchase them at the same time, and do some mock photography without film in the camera. Is the film-advance lever convenient and fast enough for you? Can you operate the shutter-speed dial and the aperture ring without seeming to be all thumbs? Does the lens focus smoothly or is it a bit hard to turn? Will you be able to load the camera easily? Is the shutter-release button in the right spot for you, and does it depress with just enough tension? How does the camera *feel* in your hands as you operate it? All these items should be evaluated above and beyond words of praise from a salesman or the established reputation of the brand in question.

Black or Chrome Body—Once upon a time when photojournalists thought they would be less conspicuous with black-bodied cameras, they spent plenty to have their equipment de-chromed. Black bodies are a standard item today from most manufacturers, but whether you should pay the extra money for one is a matter of personal taste. As far as I can tell a black camera is largely a status symbol.

Brand Name—As in any other field, there are cults of people who swear by one brand. Champions of certain cameras may have found a specific brand very dependable and optically excellent. Their reasons are firmly based. Other advocates may be swayed by the glamor name of the brand having seen persuasive advertising or admirable pictures credited to a camera brand in magazines.

Avoid buying any brand of camera just because you know it carries with it the charisma of popularity. It may very well be outstanding in most respects, but it may cost more than you

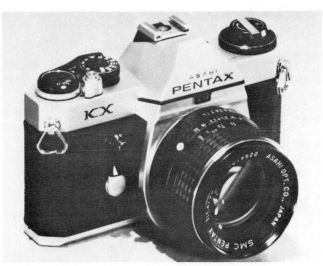

Pentax K-series cameras are first Pentaxes to use K-mount lenses.

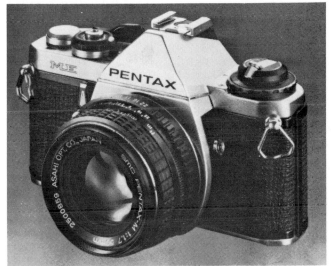

Pentax ME is automatic; MX model is manual. Both are compact, accept auto winder, and use new K-mount bayonet lenses.

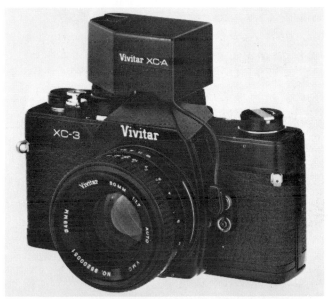

Vivitar XC-3 is a manual camera until XC-A aperture-preferred automatic exposure control unit is attached.

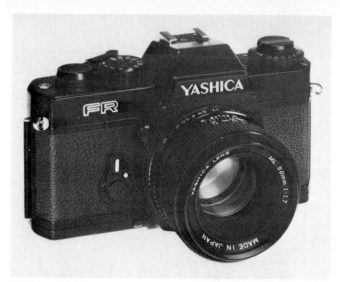

Yashica and Contax cameras use the same lens mount, therefore both brands of lenses can be used on both cameras.

As for brand longevity, most have been around quite a while which means sales records have been good enough to keep a company in business while introducing new models occasionally. Repairmen can usually get parts for obsolete cameras but it is annoying to have a brand that disappears from the marketplace soon after you buy it. Recommendations from camera shop operators and sales people are useful, but keep in mind they may be prejudiced for one or more reasons. Perhaps the best testimonial for any brand and model comes from a friend who can steer you toward an SLR he has enjoyed using, but can warn you of its shortcomings.

Camera Systems—In addition to lenses of various focal lengths available for specific cameras, many manufacturers proudly offer an extensive array of accessories to broaden your horizons, or turn you on to new photo techniques. Included among the items in a complete system are close-up lenses, lens extenders, bellows attachments, copy stands, microscope adaptors, filters, auxiliary finders, slide copiers, motors, and auto-winders.

Almost all of the above list can be purchased from more than one manufacturer to fit the average SLR—except a motor-drive or an auto-winder. These two accessories are made specifically by the manufacturer for its own SLR. A motor-drive is a very specialized unit which is attached to the SLR body. It is battery-powered, and batteries are stored either in a handle or case beneath the motor, or in a separate case with connecting cord to the camera body.

With a motor, you can shoot between 3 and 9 frames per second continuously. Switch the unit to make single shots and you can expose a frame at a time—by depressing the shutter button once for each frame. Motorized photography is a big advantage for sports and action, or for any situation where a fast sequence of pictures is desired. It is very convenient to shoot quickly without taking your eye from the viewfinder to advance the film and cock the shutter after each shot. Many professionals use a motorized camera for a majority of their work including portraits, because it helps capture expressions they might otherwise have missed while winding.

In the past few years camera designers have been able to combine exposure automation with

really want to spend, it may be too heavy or bulky for personal comfort, or it might not operate in *your* hands as comfortably as another brand less glamorous and popular. Make your own decision, and the heck with glamorous brand names if you are satisfied otherwise. Every SLR advertised and sold today is capable of excellent performance once you are familiar with it.

In addition you should seriously consider the repair record and the length of time any specific brand of camera has been around. Camera salesmen and repairmen will often level with you about frequency of repair if you probe carefully. Some brands are simply more durable than others. Shutters, film advance, meter accuracy and automatic diaphragm mechanisms are most likely to give you trouble in any SLR. Lens sharpness is uniformly pretty good, and you can always exchange one lens for another if you show a dealer inferior results as proof of your complaint.

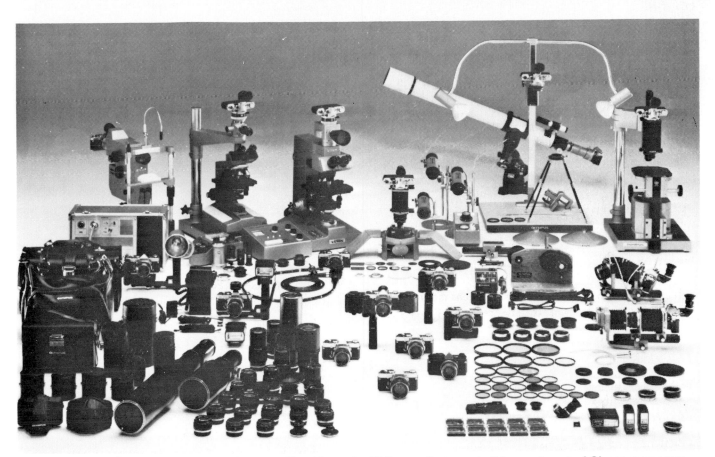

An example of the wide variety of equipment offered by major SLR manufacturers is this assortment of Olympus cameras and accessories. You'll find several other brands with similar back-up hardware.

motor-driven operation—a real step forward.

Several camera systems now include mini-motors called *auto-winders.* Although a motor-drive costs $500 and up, an auto-winder averages under $200, and is much lighter in weight and very compact. All auto-winders will shoot single frames and do the film-advancing for you, between shots. Some will also shoot continuously at about 2 frames per second—not as fast as a motor-drive.

Today a motor-drive has become a specialized item, while the auto-winder is a blessing for the average SLR user.

If a camera manufactuer has a comprehensive set of camera accessories in its SLR system, you have reasonable assurance of quality in that brand.

CHOOSE YOUR WEAPON

By now it should be apparent that the single-lens reflex 35mm camera you own or contemplate buying has a lot going for it. Through-the-lens viewing is a natural for close-up photography, is instantly adaptable for any lens you can name from the fisheye super-wide-angle to big-Bertha telephotos 1,000mm or longer, and is terrific for portraits and everyday photography at home or on the road. There are plenty of 35mm black-and-white and color films available everywhere, quality enlargements or slide projection are routine, and there is hardly a picture-taking challenge the SLR can't meet. On top of everything, camera designers continue to dream up exceedingly clever electronic, mechanical and optical innovations to expand your photographic capabilities if you like to experiment.

Control is the name of the SLR game, meaning that you, the photographer, are in charge of focus, exposure, depth of field, shutter speed and lens focal length to enjoy the ultimate in photographic excitement and accomplishment. Today's SLR offers control in each category that would have made the best professional green with envy 20 years ago!

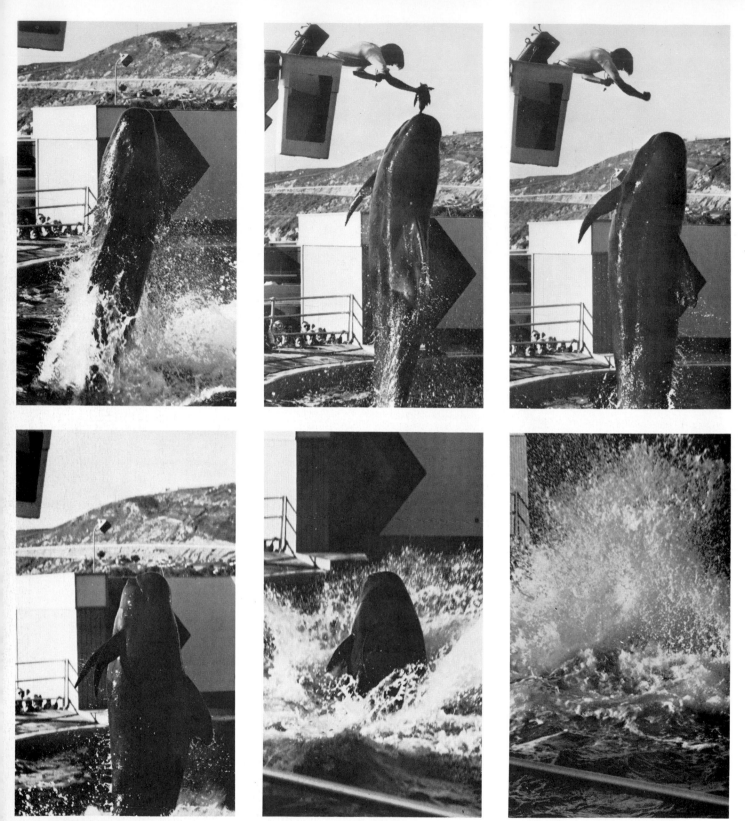

Motorized SLRs make sequence photography possible, such as the feeding of a pilot whale at Marineland of the Pacific. These are six frames taken with an Olympus OM-1 and it's motor-drive. You can shoot almost as fast with an auto-winder—available for an increasing number of SLR brands.

What makes a good picture? INTIMACY

How deftly the SLR can be focused very close to people. The result is a feeling of intimacy we are not used to seeing in the average picture. Other pictorial qualities, such as emotion, can be allied with intimacy to achieve outstanding images.

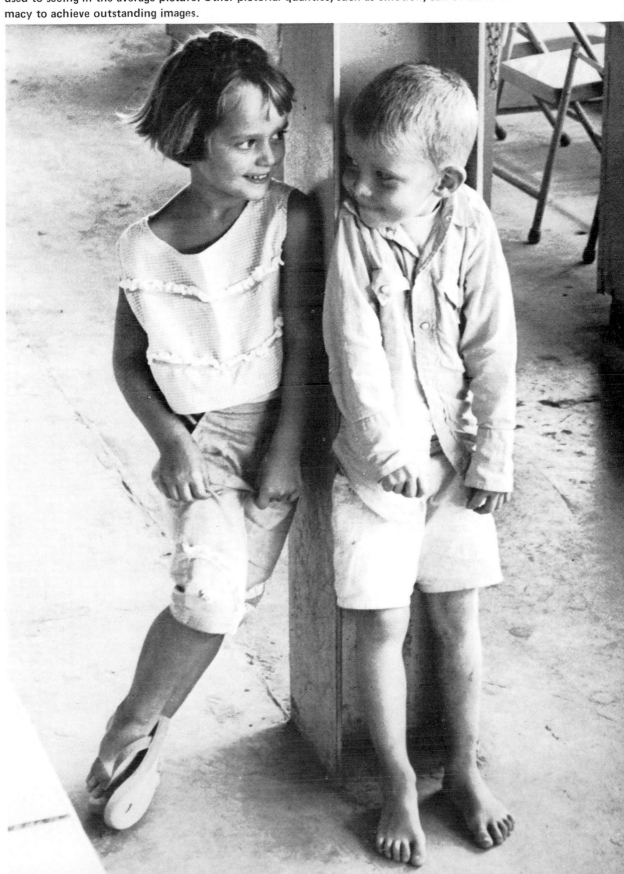

What makes a good picture? HUMAN INTEREST

Human interest is a broad-spectrum term applied to many kinds of pictures, sometimes when no other description comes to mind. Involved are all the emotions and impressions that attract viewers to look twice or linger over an image. A scenic shot or a close-up of a butterfly is not dependent on human interest in the same way this situation is. The photographer is taking the model's name and number at a publicity event, so he can send her some slides, probably. His Nikons are attached to a brace and can be fired simultaneously, with or without the electronic flash. At his waist is a separate powerpack for the EF unit.

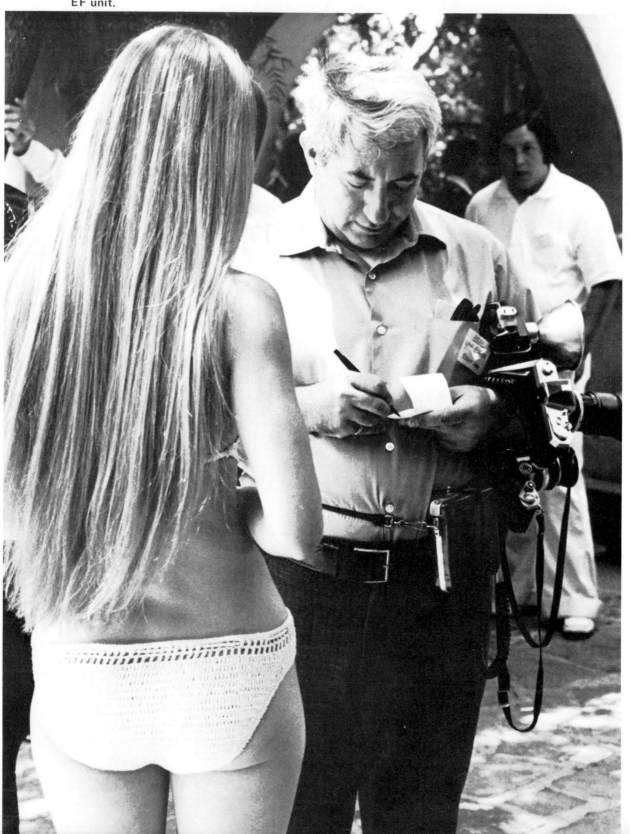

Long and short, wide and narrow—from lens makers such as Tamron you can get nearly any lens to fit your camera.

A photographic lens is an assembly of ground and polished pieces of special optical glass called *elements,* fitted together in a metal container called the *lens barrel,* according to a specific *formula.* A lens gathers and focuses rays of light which pass through it to project an image onto film in the camera. For many years lens designs were worked out through slow and methodical mathematics to improve sharpness, increase speed or light-gathering power and develop new focal lengths.

It used to take months to create new formulas due to many technical considerations we don't have to worry about. With the advent of the computer, lens designers now come up with new and far better formulas—sharper, more versatile and less costly to manufacture—and also take only hours of electronic computation.

When choosing and using lenses for a single-lens reflex camera, there are a few terms you will encounter regularly. Let's examine these one by one, because they will not only influence the kinds of lenses you buy, but also are important so you will be able to get the kind of pictures you really yearn to take.

FOCAL LENGTH

This characteristic of a lens is expressed in millimeters, and represents the distance from an optical point in the lens to the film plane. In terms of pictures, focal length determines how much of scene will appear on film from a given distance. Using a 50mm lens for comparison, its angle of view is 46 degrees; a 28mm lens spans 74 degrees and a 135mm lens views only 18 degrees of a scene. There is a similarity between lens focal length and the magnifying power or binoculars, as you can see in the photos.

From the *same* camera location, as focal length increases, the scene coverage decreases. The image is enlarged while the total area you view is reduced. Obviously if you want to reach out to

Independent lens makers offer a wide range of lenses to fit all popular brands of SLR. These lenses are available in two forms: *fixed mount* accessory lenses, which are mechanically the same as factory lenses of that brand and mount on the camera the same way. A fixed-mount assessory lens fits only one brand of camera or type of mount. The other type of accessory lens uses an *adapter* between lens and camera. With a different adapter, you can mount the same lens on a different camera brand or mount type.

Shown here is the Vivitar Automatic TX Lens System which uses adapters to fit the lenses to all popular brands of SLR. This lens series includes focal lengths from 24mm to 400mm and also 3 zoom lenses. Vivitar offers a similar range of lenses with fixed mounts to fit most brands of SLR cameras.

shoot a distant landscape, magnifying ability of longer focal length lenses is an advantage. Conversely, if you must include a wide area in your picture, and cannot or prefer not to move backwards, a short focal length lens is the answer.

Moving the camera closer or farther from a subject, can accentuate perspective in meaningful ways. Both horizontal and vertical lines appear to converge towards a perspective vanishing point, depending on your lens focal length and camera angle. You have seen tall buildings photographed to look as though they slant dramatically upwards, or railroad tracks seeming to meet at a distant point. These effects, plus the relationship of objects in front or back of each other, can all be employed and controlled by proper choice of lenses.

Weird unnatural effects can be produced by unconventional focal length or distance from a subject. Have you ever seen somebody's face in all its comic distortion as photographed by a wide-angle lens from only 12 or 14 inches distance? Or maybe you recognize the telephoto—long focal length—appearance of a street scene where distant buildings, cars or poles seem almost as large as those closer to the camera. These are both prominent examples of how lens focal length influences perspective.

21mm

This lens series was shot one Sunday morning in downtown Los Angeles, from a tripod in a carefully selected location. I actually chose the spot by the 200mm composition first, and figured that as I widened the view, what would be, would be. It may not be apparent, but I waited for foot and vehicular traffic in some of the pictures to improve their interest, even though this was an exercise. I've seen too many of these lens comparison series that end up with a clock tower and start with an empty street.

28mm

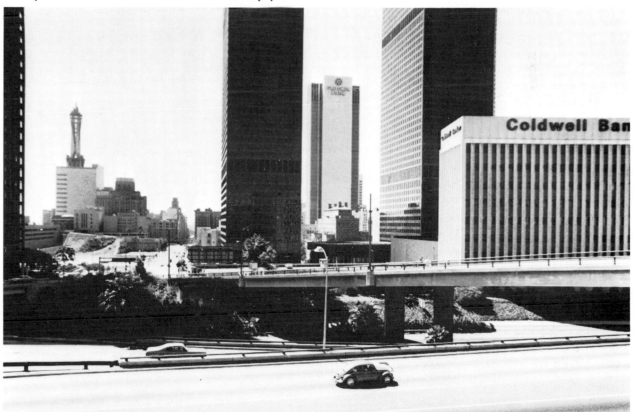

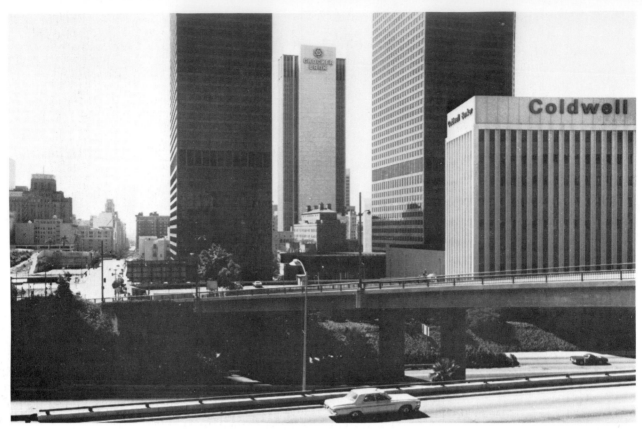

35mm

50mm

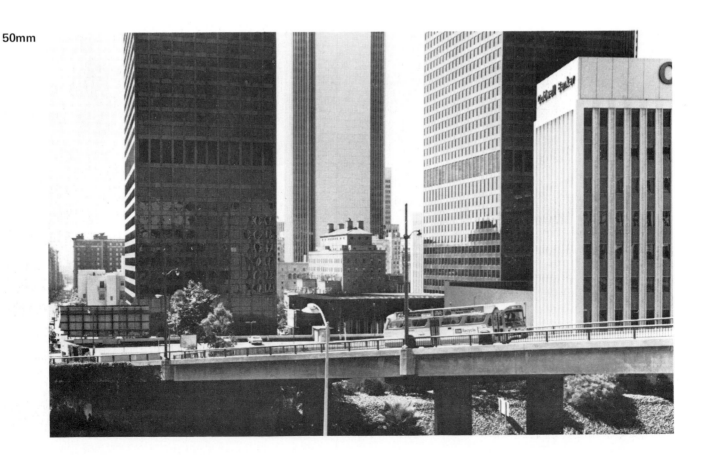

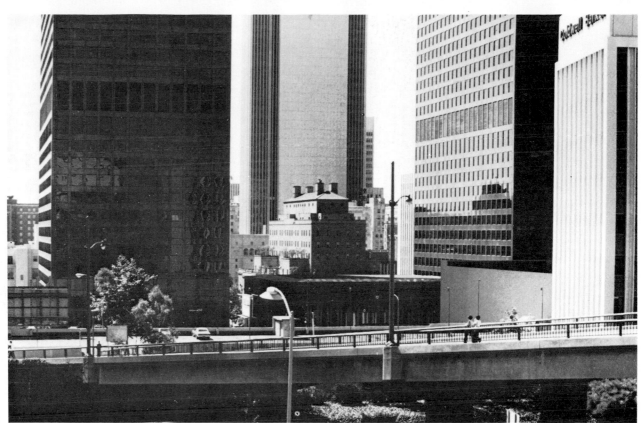

85mm

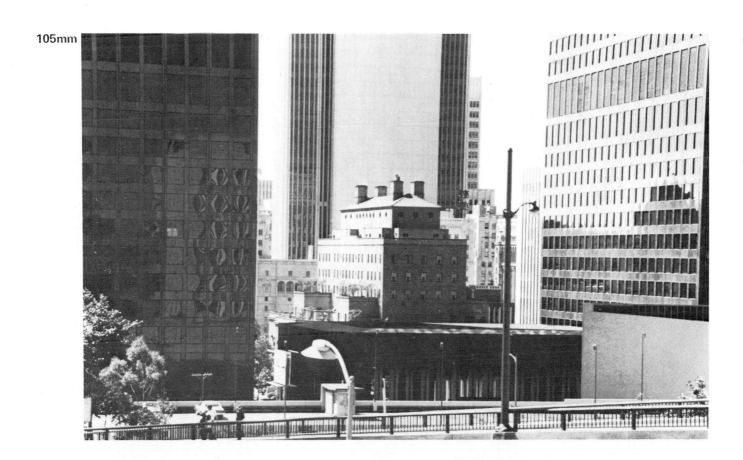

105mm

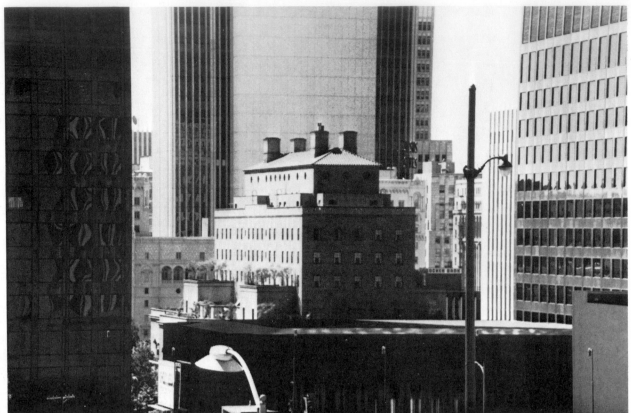

135mm

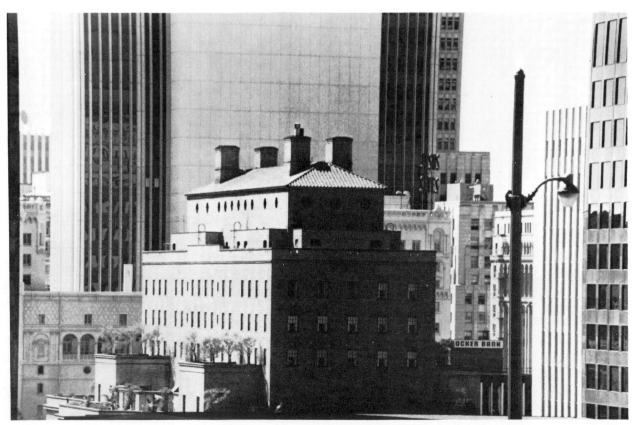

200mm

30

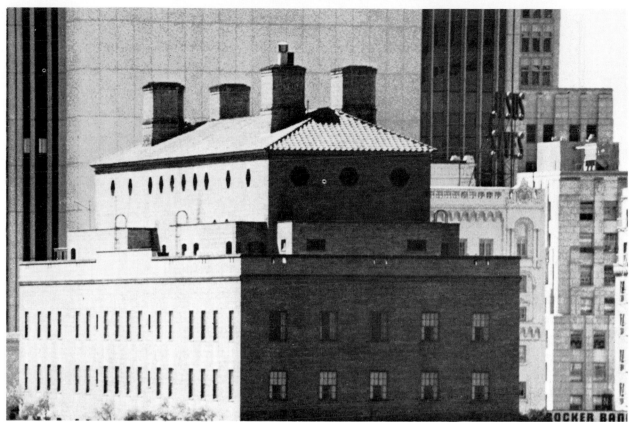

300mm

DEPTH OF FIELD

Depth of field is the distance between the nearest and farthest objects in a scene that appear to be sharply focused on a print or slide, or in the SLR finder. I'll call depth of field d.o.f. from now on. Three factors determine how much d.o.f. you get in any picture taking situation: Aperture, focal length, and focusing distance.

Aperture—The smaller the lens opening or aperture, the more d.o.f. you get in a photograph—no matter what lens you are using. It is an optical absolute that the area in *acceptably* sharp focus in front of and behind the point of best focus increases as a lens diaphragm is stopped down. To check this, look at the barrel of any lens for your SLR. Close to the camera body you see engraved a double series of f-stops, one on each side of the center focusing-index mark. As you focus the lens, the number indicating distance in feet from the camera falls opposite the index mark. Depth of field for any lens opening is indicated between the f-number on the left and its twin on the right. For instance if you focus a 52mm lens at 7 feet, the 5-foot figure falls opposite f-16 on the left, and the 11-foot figure is opposite f-16 on the right. If the

lens opening is set at f-16, 5 to 11 feet is the approximate d.o.f. when focused at 7 feet. Objects will be acceptably sharp between 5 and 11 feet from the camera . . . a six-foot d.o.f.

The double f-stop series on the lens mount is called the depth-of-field scale, and you will notice that I used the words *indicated* and *approximate* in the above description. These are qualifying words, because really *precise* d.o.f. measurements must be made by mathematical computation according to complicated formulas.

Printed d.o.f. tables for every SLR lens are available from some manufacturers or in technical data books. You need not carry such tables around for reference, but look at the sample table here to get some idea of what a lens will do at a given aperture and distance. Learn to use the d.o.f. scale on your lens because it is extremely handy when you care about how much distance from near to far will be acceptably sharp in your pictures.

Studying the sample table, you will quickly notice how d.o.f. decreases as you use a larger aperture—smaller f-numbers. This helps explain a lot of things you may have seen in pictures and didn't realize, such as very shallow d.o.f. in situa-

Distance scale / f setting	1'6"	2'	3'	5'	10'	15'	30'	∞
f-1.4	1'6.12"	1'11.8"	2'11.5"	4'10.4"	9' 5.6"	13' 9.7"	25' 6.6"	169' 9.2"
	1'6.13"	2' 0.2"	3' 0.6"	5' 1.7"	10' 7.2"	16' 4.9"	36' 4.2"	~∞
f-2	1' 5.9"	1'11.6"	2'11.3"	4' 9.8"	9' 3.1"	13' 4.3"	24' 0.2"	118' 3.5"
	1' 6.1"	2' 0.4"	3' 0.8"	5' 2.4"	10'10.6"	17' 1.2"	39'11.8"	~∞
f-2.8	1' 5.8"	1'11.5"	2'10.9"	4' 9"	8'11.9"	12' 9.6"	22' 3"	84'11.6"
	1' 6.2"	2' 0.5"	3' 1.1"	5' 3.4"	11' 3.2"	18' 1.4"	46' 1.4"	~∞
f-4	1' 5.6"	1'11.4"	2'10.6"	4' 7.7"	8' 7.4"	12' 0.6"	20' 0.4"	59' 6.4"
	1' 6.4"	2' 0.6"	3' 1.7"	5' 7"	11'11.2"	19' 11"	59'11.6"	~∞
f-5.6	1' 5.5"	1'11.2"	2' 10"	4' 6.2"	8' 1.9"	11' 2"	17' 8.3"	42' 6.8"
	1' 6.5"	2' 1"	3' 2.3"	5' 7.2"	12'11.2"	22'10.7"	100'1.3"	~∞
f-8	1' 5.4"	1'10.8"	2' 9.1"	4' 4.1"	7' 6.8"	10' 1"	15' 0.7"	29'10.2"
	1' 6.6"	2' 1.3"	3' 3.4"	5'10.9"	14' 9.5"	29' 7.2"	~∞	~∞
f-11	1' 5.2"	1'10.4"	2' 8.2"	4' 1.6"	6'11.3"	8'11.8"	12' 8.4"	21' 9"
	1' 7"	2' 1.9"	3' 4.8"	6' 4.2"	18' 0.6"	46' 9.7"	~∞	~∞
f-16	1' 4.8"	1' 9.7"	2' 6.7"	3' 10"	6' 1.2"	7' 7.2"	10' 1"	15'
	1' 7.3"	2' 2.9"	3' 7.6"	7' 3"	28' 7.6"	~∞	~∞	~∞

Depth of field table for a 50mm lens, courtesy Honeywell Pentax.

tions where there was not much light and the photographer set his lens close to the widest opening. You can be sure pictures with sharp focus from a nearby foreground object all the way into the far distance were taken at relatively small apertures or with short focal length lenses, or both. Simply stopping your lens down from f-4 to f-8 can assure one person behind another will both be in focus, rather than only one, depending on your distance from them.

Focal Length of the Lens—The shorter the focal length of a lens, the greater d.o.f. it produces at any given aperture, compared to any lens of longer focal length. You can reverse this optical law by saying that the longer the focal length of a lens, the less d.o.f. it produces at a given aperture. Let's list lens focal lengths in categories to compare their d.o.f. characteristics:

Short focal length lenses, also called *wide-angle lenses,* run from super-wide 15mm and fisheye types, through 21mm, 24mm, 28mm and 35mm. Different manufacturers make some or all of the above focal lengths for their own cameras, or for a variety of SLR's. If you cannot get all of those listed for your brand of camera, don't worry, they are so similar that 21mm or 24mm lenses are nearly interchangeable for practical use.

Medium focal length lenses include the so-called *normal* range from 50mm through 57mm. The *normal* label is applied when the focal length of the lens is close to the diagonal of the image area on the negative. 35mm negs are about 2" on the diagonal—approximately 50mm. This is considered a pleasant median focal length for this picture size.

Long focal length lenses, also called *telephoto lenses,* begin about 85mm and run to 200mm, 300mm and as long as a strong man is able to lift without a block and tackle.

Shortly, I will evaluate all three categories of focal length in terms of practical photography, and discuss which lenses might be most useful to you. But first I want to return to focal length and its influence on depth of field.

Knowing that a wide-angle lens will give you more d.o.f. at any aperture than a telephoto lens will at the same aperture and from the same camera-to-subject distance, you begin to conceive where and why certain lenses are more useful than others. In crowds, in small rooms or any tight space, or for more inherent d.o.f. when shooting a scene or still life, choose a wide-angle lens. Even without being stopped down to f-16— the smallest opening on most SLR lenses except

for the macro close-up type—you get good-to-fantastic d.o.f. with 21mm, 24mm, 28mm and 35mm lenses.

In situations where you want relatively shallow d.o.f., such as a portrait with an out-of-focus background, choose a medium or long focal length lens, and shoot at medium to large apertures. With experience you know that a 135mm lens at ƒ-11 from a distance of about 5 feet will give you a nice sharp image of someone, but distracting objects behind the person appear softly focused.

And of course, when you need the magnifying power of a telephoto lens, especially if you can't move closer to a subject, there is no substitute for 135mm or longer. After about 200mm, SLR lenses tend to become pretty heavy and bulky to tote around casually, but these types are all sold with their own cases and shoulder straps to make them more comfortably portable.

There will be a lot more about lens focal length in terms of depth of field and application to a variety of picture subjects as we get further into the book.

Focusing Distance—The closer you focus on any scene or object, the less depth of field a lens produces at a given aperture and focal length. In reverse, as camera-to-focusing-point distance increases, d.o.f. also expands.

Suppose you focus at 5 feet with a 50mm lens set at ƒ-8. Depth of field is only about 19 inches—from 4'-4" to 5'-11". Now move back to 10 feet and focus on the same subject. With the lens opening still at ƒ-8, d.o.f. has increased to more than 8 feet.

Knowing about d.o.f. and how to control it helps you choose where you will place your camera, which lens will be most effective for a particular subject, and what lens opening will be feasible for the d.o.f. needed to accomplish the photographic feat you're tackling. If you think in meters, you'll be pleased to note the depth-of-field markings are in meters as well as feet.

Depth of field seems to be one of the least-understood principles of photography, but it is neither tricky nor mysterious. Being able to control it gives you a lot more mastery of images than you could hope for with a less sophisticated camera. It becomes easy to visualize how much of a picture will be sharp. If you shoot a distant scene focused at or near infinity, you'll have complete

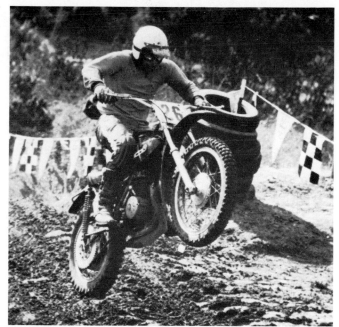

A long-focal-length lens such as a 135mm allowed James Mandeville to stay out of the way while capturing peak action at a motocross race. His Kodak/Scholastic award picture was shot at 1/500 at ƒ-11.

sharpness at any aperture if nothing is closer to your lens than about 100 feet. If you shoot a face in a crowd and want selective focus—which I also call selective out-of-focus—you'll use a fairly large lens opening, depending on your distance to the person. This will blur the background so it is noncompetitive with the main visual interest.

DEPTH-OF-FIELD PREVIEW

Most single-lens reflex cameras include a lever or button to stop down the lens before shooting so depth of field can be visually checked or previewed. It is obvious that this feature cannot provide a completely precise impression because a finder image is small, but it is visually very useful when you also refer to the lens d.o.f. scale. Just recently I had an assignment to shoot a series of people holding movie cameras for a magazine layout. In each picture I needed to be sure, because I was pretty close, that faces and cameras would be in sharp focus. In addition, background figures had to be out of focus because I wanted them less important and unrecognizable. Consequently, before almost every setup I used the d.o.f. preview lever on my camera, and adjusted focus to achieve selected sharpness. I could also have referred to the d.o.f. scale, but previewing was faster and accurate enough.

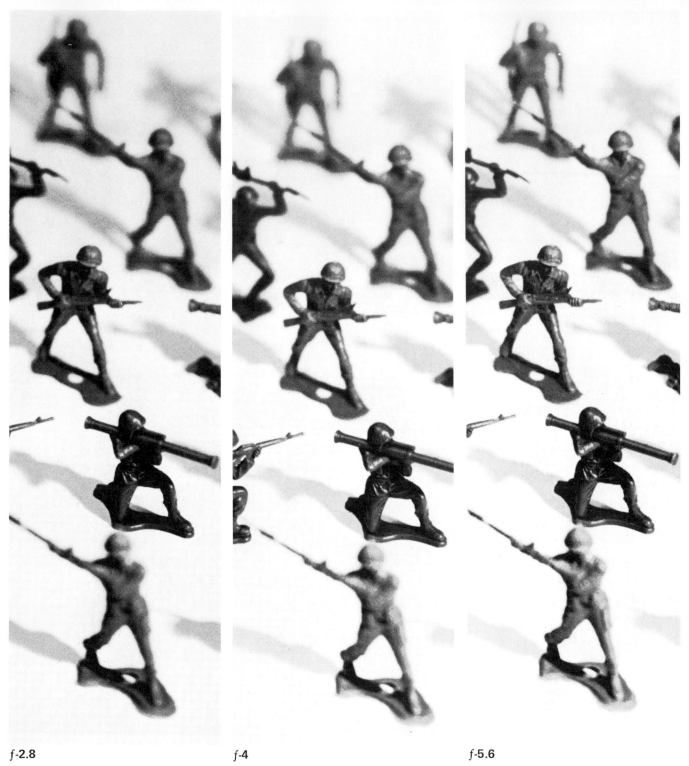

f-2.8 f-4 f-5.6

This series was shot with a 100mm lens to show how depth of field increases as lens aperture becomes smaller. Also noticeable in the original prints, but perhaps not in reproduction, the kneeling figure with bazooka is not as sharp at f-2.8 when the lens is wide open as it becomes in later pictures when the lens is stopped down. Sharp focus increases faster *behind* the kneeling figure on which the lens was focused, than it does in front of it, illustrating another optical law.

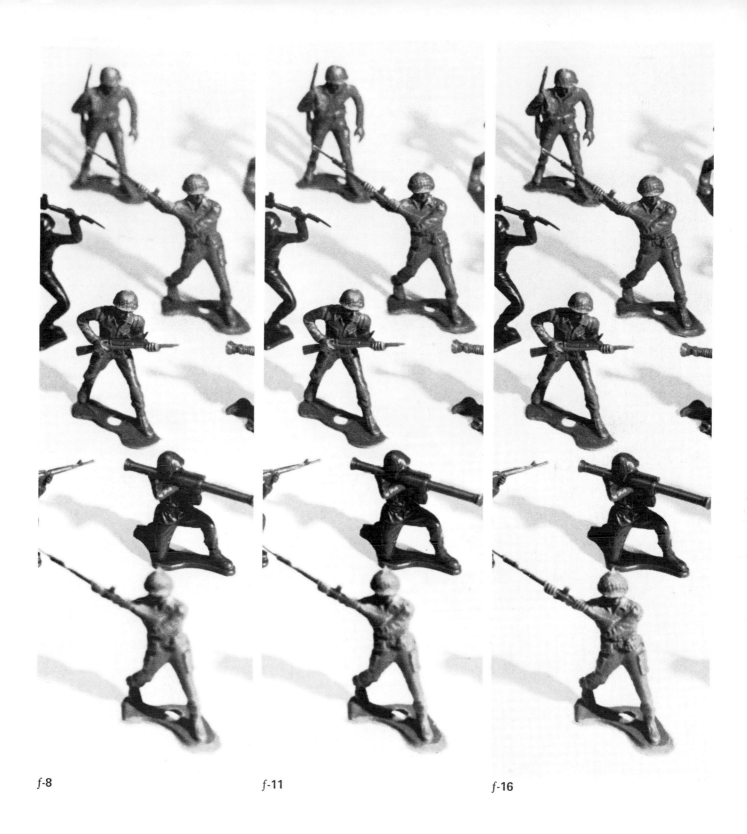

f-8 f-11 f-16

A short-focal-length lens such as the 21mm gives you full depth of field or overall sharpness even when the foreground is close and background is distant. The crowd shot was made at f-16 and the front figures were only about five feet away. Lens focus was set using the d.o.f. scale on the barrel.

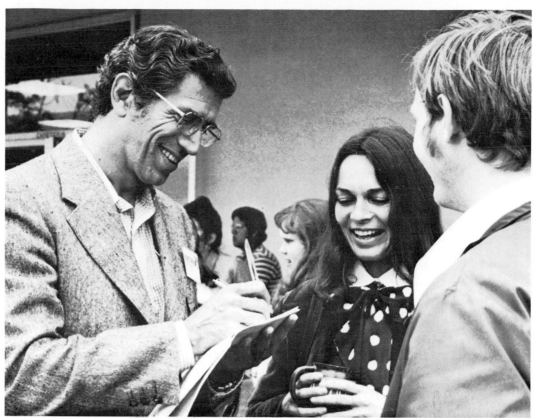

A medium-focal-length lens such as the 85mm keeps you at a modest distance from people and provides useful depth of field at the same time. Actor Joe Campanella was signing an autograph for a couple of fans.

While taking pictures of movie cameras in use I often checked the d.o.f. scale on my 55mm macro lens to be certain the foreground would be sharp and background out of focus.

Lens aperture is operated by a mechanical linkage. Here, aperture is about halfway open.

Typical 21mm lens unreality, shot for a purpose by Ernest Reshovsky as part of a magazine layout. Faces close to a very wide-angle lens become distorted, but here a medical point is emphasized in a story series.

In this winsome portrait by Kodak Newspaper Snapshot Contest winner Garald Tieman an ƒ-3.5 aperture assured shallow depth of field and an out-of-focus background. Lens was a normal 50mm and speed was 1/250.

When shooting a *distant* scene, if you focus between 50 feet and infinity, complete sharpness is assured providing the lens is stopped down from full aperture. This New York shot was made with a Yashica 60mm *f*-2.8 macro lens at *f*-16. On a slower color film the scene would have been as sharp even at *f*-5.6.

THE RULES

Here's a fast rundown condensing the pertinent points you need to remember about depth of field to help you get better –and predictable– pictures:

For good depth of field and overall sharpness:
1. Choose a wide-angle lens.
2. Use a small aperture with any lens.
3. Focus carefully, checking d.o.f. visually with the preview button and/or check the d.o.f. scale on the lens.

For less depth of field to assure specific out-of-focus areas in your picture:
1. Use a fairly large aperture, such as *f*-2.8 or *f*-3.5 if lighting conditions permit.
2. Choose a longer-than-normal focal length lens, such as 85mm, 105mm or 135mm, especially for portraits when you want a soft-focus background, and shoot at a medium aperture such as *f*-8 depending on film speed.
3. If your film is so fast that you must stop down to *f*-16 in bright sun making selective d.o.f. very difficult, use a neutral-density filter over your lens. You'll read more about these in the next chapter. They decrease the brightness of a scene without affecting color, giving you more latitude to choose lens openings or shutter speeds.

Shoot some d.o.f. exercises, varying *f*-stops and focus to be thoroughly familiar with the control you have over this capability of your lenses.

LENS SPEED

You have heard about fast or slow lenses and wondered if they had special wheels or motors. Of course the reference is to their *f*-number ratings because an *f*-1.4 lens has four times the light gathering ability of an *f*-2.8 lens. In effect you can shoot a given film at a four-times faster shutter speed at *f*-1.4 than you can at *f*-2.8 under the same lighting conditions. Therefore, the term *fast* is applied to lenses with smaller *f*-numbers, and lens speed describes the light-gathering ability of one lens compared to another.

The series of *f*-numbers is easy to construct if you remember just two of the numbers, 1.0 and 1.4. Double them alternately as shown below and you have the whole series.

1.0 1.4 2.0 2.8 4.0 5.6 8.0 11 16 22

The number 11 is not exactly double 5.6 but close enough and easier to remember than 11.2.

If you also remember that each step from one *f*-number to the next allows twice as much light

In poor light a lens has to be used wide open or close to it. This hand-held view of Salzburg at twilight was taken on Plus-X with a 50mm lens at f/2 and 1/8 second.

through the lens, you can easily figure exposure adjustments and combination of ƒ-number and shutter speed.

Each larger aperture lets in twice as much light so the same exposure will result with a shutter speed that is twice as fast. The combinations ƒ-11 at 1/30 and ƒ-8 at 1/60 produce exactly the same exposure.

Camera lenses are rated in ƒ-numbers determined by the size of the maximum diaphragm opening. By closing down the aperture you can adjust the lens to a higher ƒ-number. An ƒ-2 lens, for instance, means its largest aperture—wide-open—is ƒ-2. The smaller the ƒ-stop number, the larger the lens opening. Does this mean the fastest lens you can buy for your SLR—it also contains

the most amount of glass and consequently weighs more—is really the best investment? For the practical reasons detailed below, the answer is no. Let's look at the aperture ratings of popular SLR lenses, and find out when fast or slower lenses are more appropriate to your needs.

ƒ-1.2—Though some special super-fast lenses in the 50mm range are even faster, this large aperture serves very well for comparison with those that follow. Unless you expect to shoot pictures of a black cat in a coal mine by candle light, a lens of this speed isn't worth the extra money in my opinion and its size and weight are drawbacks to a majority of photographers. Besides, it is a mere 1/3 of a stop faster than ƒ-1.4. Too many people buy such huge hunks of glass as status symbols.

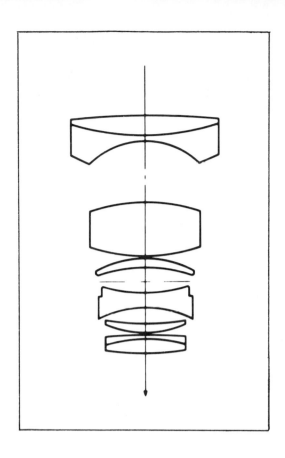

These Rokkor large-aperture lenses use glass elements as shown in the cross-section drawings at left. Lens shown above is 35mm f-1.8. Lens below is 58mm f-1.2.

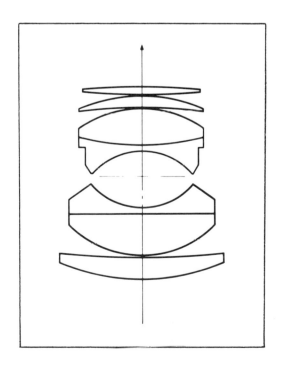

f-1.4 or *f*-1.5—A far more popular fast lens for many brands of SLR, it is also a lot more practical. A typical *f*-1.4 57mm lens weighs 10 oz., while an *f*-1.2 in the same focal length weighs 17 oz. No lens is as sharp at largest aperture as when stopped down even a small amount. This is something to keep in mind when you are considering which normal lens will best suit the types of photography you do—or hope to do.

f-1.7 or *f*-1.8—At this speed, standard for the 50mm lens sold on a majority of SLR's, I think the average user has the best compromise between weight and size, price and practicality. A typical 1.8 lens weighs about 8 oz. and some are designed with a deepset front element so you need no lens hood to protect against stray light rays that can degrade your negatives or slides. There is a 1-stop difference between *f*-1.4 and *f*-2, and a 2/3-stop difference between *f*1.4 and *f*-1.8. For the average photographer, *f*-1.7 or *f*-1.8 is plenty of speed, even in dim light. There is a limit how dark a place can be before you need a tripod or flash anyway. At *f*-1.8 and 1/30 sec. with an ASA 400-speed film, you are just about at that limit. I have several 50mm and 52mm lenses. Though none is faster than *f*-1.7, I rarely find this to be a handicap—even with slow Kodachrome.

f-2—This aperture is 1/3 of a stop less than *f*-1.8, and for those with an *f*-2 50mm normal lens on your SLR, everything I said about the *f*-1.8 applies.

f-2.8 and *f*-3.5—A number of lenses in the 28mm, 35mm, 100mm, 105mm, and 200mm categories are designed with these more modest apertures because it is lot more sensible. Were these lenses faster, they would also be heavier and bulkier. However, if you can afford and wish to carry an *f*-2.8 lens rather than the same focal length in *f*-3.5, the 2/3-stop advantage of the *f*-2.8 is worth the investment. There are situations with slow film and fading daylight when you want to shoot almost wide-open. If you are used to the speed of an *f*-1.8 or *f*-1.4 lens, the relative handicap of *f*-2.8 will not seem as serious.

f-4 and *f*-4.5—A few macro close-up lenses and a lot of telephoto lenses are designed with these apertures because in general they offer all the speed you need for pictures at these focal lengths. Besides, a 300mm lens, for example, with a theoretical *f*-2 aperture would weigh 12 pounds or

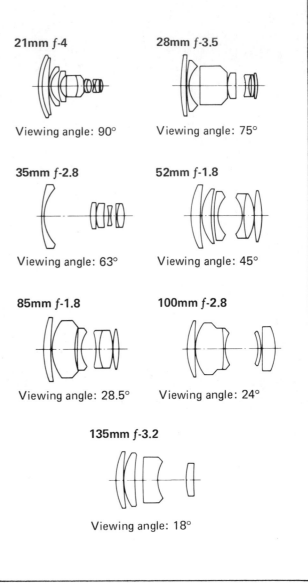

21mm *f*-4 — Viewing angle: 90°

28mm *f*-3.5 — Viewing angle: 75°

35mm *f*-2.8 — Viewing angle: 63°

52mm *f*-1.8 — Viewing angle: 45°

85mm *f*-1.8 — Viewing angle: 28.5°

100mm *f*-2.8 — Viewing angle: 24°

135mm *f*-3.2 — Viewing angle: 18°

Cross-sections of typical SLR lenses, courtesy of Konica Camera Co.
Formulas vary considerably from one manufacturer to another. Each lens is designed for sharpness, minimum aberrations, light weight. The longer the focal length, the fewer the elements required for that formula, except for zoom lenses which may have 16 or 18 glass elements in three or four groups.

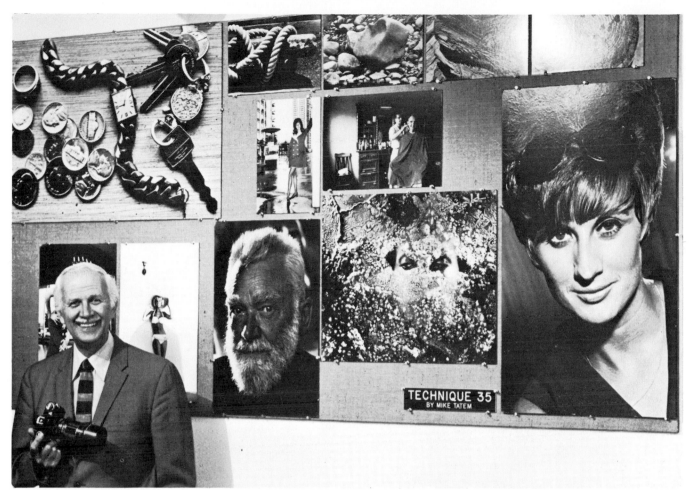

Copying printed matter or detailed photographs helps test a lens. Shoot from a tripod at a series of *f*-stops. This shot of photographer Mike Tatem and his work was not a lens test, but symbolizes one! Mike shot those good pictures with a Pentax.

more if it could be made at all. Who needs it?

Don't buy the larger-aperture lenses in the store because you think they will make you appear more "professional." Spend your money on more film, get more pictures to enjoy, and come back from shooting without pains in your neck from carrying monster lenses.

LENS SHARPNESS

If you examine cross-section diagrams of typical SLR lenses, you see various shapes and sizes of elements. Those that touch are cemented together, while others are mounted in the lens barrel with significant air spaces between them. Shapes and placement of lens elements are part of a formula to achieve sharpness and accurate color, while avoiding *aberrations.* The latter are small imperfections within the lens which you really need not be concerned about today. In truth, modern camera optics are so good and so carefully manufactured and inspected that getting a "lemon" is rare.

Of course not all SLR lenses achieve the same sharpness. If you study technical reports about lenses in photographic magazines, you will see all sorts of numerical evaluations. I suppose these tests are meaningful to precision-minded photographers, but you won't be laughed out of your camera club if you are not familiar with such charts, graphs and optical data. You will hear that an XYZ lens is "the sharpest thing on the market," or that the ABC lens is supposed to be "inferior" to others. I listen to self-proclaimed experts once in a while who tell me that their XYZ lenses are really sharper than my brand, but I am never shaken by these claims.

My concern is with results. I buy a lens and take pictures with it. I test it on a tripod and shoot whatever is handy, varying *f*-stops and including a

few frames at widest aperture. I may copy a newspaper page to check lens *resolution,* another name for *sharpness.* I make a few 11x14 prints or simply project the slides on my 50x50 screen, and if the pictures are acceptably sharp from corner to corner, and the color looks normal, I'm happy. Perhaps there are better lenses than mine, but who is going to make that judgment? None of my friends or clients ever complains that the definition in my pictures is inferior, and I'm satisfied.

Chances are a $50 lens will not be as sharp as a $150 lens of the same specification from a different maker. You *should* expect more quality for more money, but today's computer-formulated, precision-made optics are generally a joy. Production methods are so refined that you can't always be certain an expensive lens will be better than a medium-priced one. Learn to get the best, most appealing images from the lenses you have, and stop wondering if you should mortgage your home to buy that new series you see advertised beguilingly.

LENS COATING

All SLR lenses are coated with a thin chemical film to help reduce reflections from the glass surfaces and to increase the amount of light passing through the lens to the film. Internal reflections, sometimes known as *lens flare*, will cause a reduction of sharpness and contrast in a photographic image, especially when you are shooting almost into a light source.

You may have seen one or more ghostly images with five or six sides on your pictures when you pointed your camera near the sun. These reflections of the iris diaphragm bounced around inside your lens and finally appeared on film. If it were not for coated lenses, such annoying reflections would be about ten times as destructive.

Where lenses were once given a single anti-reflection coating, manufacturers have found multiple layers are even more effective. You read about these super-coated lenses in ads, and tests have shown they *are* superior. But several billion pictures were successfully made before multi-coating came along, and several billion more on single-coated lenses will make photographers and their families happy in years to come. Many photographers continue to use conventionally coated lenses that seemed terrific before multi-coating was developed.

Ray Shaw, a Lompoc, CA high school student, aimed his SLR at the sun and got a decorative pattern of diaphragm images, even with a coated lens. The angle at which you shoot into light sometimes produces an iris image that coating can't prevent. If such is the case, try to make the phenomenon work in your favor. Ray's photo won Kodak/Scholastic prize.

WIDE-OPEN SHARPNESS

As mentioned above, a photographic lens is less sharp at full aperture than when stopped down. Many lenses seem to show their best sharpness by optical test methods between f-5.6 and f-8. However, you need not shoot everything at those f-stops from now on, because the difference in images taken at f-8 and f-16 are usually not apparent to the naked eye. Nor should you completely avoid photography at your lens' widest aperture. So what if it seems slightly less sharp wide open—the pictures you can take that way more than compensate, because otherwise you wouldn't get them at all.

LENSES FOR EVERY PURPOSE

After all the technical notes are out of the way and you understand optical concepts as they affect photography in the nitty-gritty sense, you buy and use a lens to get satisfying—even prize-winning—pictures. Your original lens is probably in the 50-57mm range, and you start wondering sooner or later, usually sooner, what is the next focal length you want, need or can't do without. The answer cannot come from me or anyone else, because there is no best second or third lens for your SLR. All kinds of lenses are available for every picture-taking purpose, and as a former industrial designer I learned "Form follows function."

Here are some of the main reasons for using the variety of lenses available today.

Wide-Angle Lenses—As mentioned before, the 21mm to 35mm range allows you to include more of a scene or subject from a restricted viewpoint where you cannot move back easily. You probably can't show very much of your living room with a 50mm lens, but a 28mm or wider takes in at least two walls and maybe three. You get depth-of-field advantages with a wide-angle, even when shooting at fairly large openings such as f-5.6 in late afternoon or any time when the light is medium-dim. Choose a 35mm or 28mm lens as your first wide-angle, because this focal length is applicable to more situations the average SLR owner will face. Try both on your camera and compare before making up your mind. Some professionals consider the 35mm lens "normal" for the kind of work they do, which says something for its versatility.

Once you have a 28mm or 35mm, and you feel a realistic need for a 21mm or 24mm, keep in

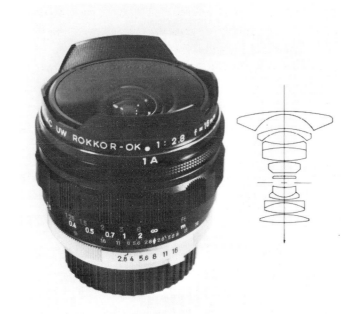

Super-wide 16mm f-2.8 Rokkor fisheye lens shown above bends perspective and distorts space, as shown below. The leaning hotel tower is under construction.

Vivitar 24mm f-2.8.

Rokkor 28mm f-2.5.

mind these two focal lengths tend to exaggerate perspective. This quality can be an asset when you want to be a little different and you can use it for pictorial impact. It can also be a liability when people or objects at the edges of your scene look somewhat lopsided.

While a 21mm lens is a novel and useful tool, a 15mm, 17mm, 18mm or fisheye lens that covers 180 degrees is an optical freak valuable chiefly for effects. If you can justify buying such a lens because it will give you opportunities for controlled distortion that pleases you, go to it. Just remember that wide-angle lenses are usually inappropriate for portraits because they make all noses look bigger than Jimmy Durante's. The shorter the focal length, the more bizarre the faces you photograph from fairly close distances.

If your subject matter runs more to interiors and groups, a wide-angle lens may be the logical choice for the second one you purchase.
Telephoto Lenses—As I said earlier, any focal length from 135mm to the longest lens you can lift is in the telephoto class. These are the "reach-out" lenses, terrific for scenics and action best photographed from a distant vantage point. For travel, sports and compacted-perspective effects, a telephoto is a must. But before you buy one of

Vivitar 35mm f-2.8.

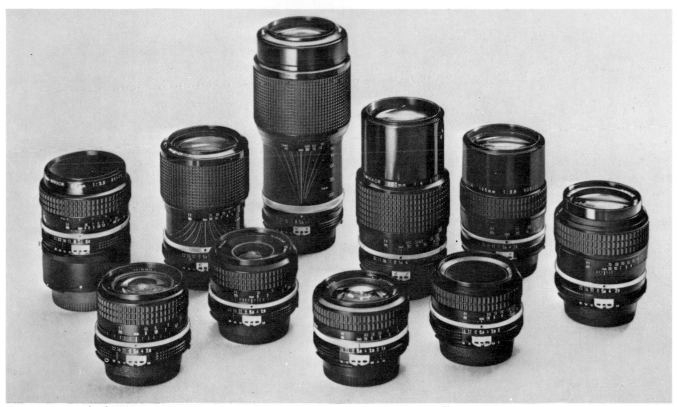

Auto-Indexing (AI) Nikkor lenses mount on AI-type cameras more easily than earlier models.

these, consider the next group very seriously.
Zoom Lenses—Years ago when zoom lenses were first introduced, they had a reputation for lack of sharpness. Now with computer-designed optics, zoom lenses are just as sharp as single-focal-length optics. What's more, there is such a fantastic variety of zooms available in short, medium, and long ranges that I recommend you check them over before buying *any* other lens for your SLR, at least any longer than 35mm.

A zoom lens changes focal length and thereby image size when you shift elements within it. This is accomplished either by revolving a ring on the lens barrel, or by a push-pull motion of a ring control. Both methods of zooming are easy and efficient, and though the push-pull mode has strong partisans, both means of zooming are about equal in convenience.

Among the *short-range* zoom lenses are those which include focal lengths such as 35-100mm, 45-135mm, 50-150mm, 65-135mm and 70-150mm. In this group are all the focal lengths you need from medium-wide-angle to semi-telephoto. A short-range zoom weighing about one pound is heavier than a single-focal-length such as a 100mm weighing 10 oz., but its versatility is well worth the

extra ounces to me. Short-range zooms typically have maximum aperture of *f*-3.5 or *f*-4, making them slower than lenses of fixed focal length in similar categories. But having an infinite variety of image sizes at your fingertips is worth the sacrifice in speed. These lenses all cost more than the average single-focal length, but are worth the money for the photographic agility they offer. As you can probably tell, I am very partial to the short-range zoom as a highly desirable asset to SLR photography. If my enthusiasm is contagious, look carefully at these lenses before your equipment budget is wiped out.

Among *medium-range* zooms are combinations such as 70-210mm, 80-200mm, 75-200mm, and 75-250mm. This group is heavier, and runs more into the telephoto class where it has its own special appeal for distant picture-taking when you can't move closer, such as parades, auto races, and wild animals. There's also great portrait potential in the 85-135mm range which is part of this category. Lenses weigh in at 2 to 3 pounds and are carried in their own cases with shoulder straps. You may not care to be burdened when you want to travel light, but in many situations a medium-range zoom cannot be matched—especially with a macro mode.

47

Vivitar 35-105mm *f*-3.5 zoom.

Rokkor 135mm *f*-3.5.

Vivitar 200mm *f*-3.

Vivitar 600mm *f*-8 lens uses a mirror combined with glass optics.

In both the short- and medium-range zoom categories are now *macro-zooms.* By turning a macro ring on some models, you can set the lens for a larger-than-normal image at one focal length only. Another type of macro-zoom allows you to focus closely at any focal length, an even greater advantage. In other words, you not only have a choice of image sizes via zooming, but you may also shoot flowers or faces large and clear. Before buying a lens of this type, find out exactly how it works and how large the image is at the " macro" setting.

Rokkor 300mm ƒ-4.5.

Vivitar 400mm ƒ-5.6 Automatic.

Long-range zoom lenses include combinations such as 50-300mm and 85-350mm, with more weight and increased ability to reach out farther. These, like long telephotos, are specialized tools for the strong-backed photographer who also carries a tripod and is willing to invest hundreds of dollars.

Variable-Focal-Length Lenses—Once you focus a zoom lens sharply on a specific point, it stays in focus whether you enlarge or reduce the size of the image you see in the finder. For maximum precision, you should focus first with the zoom at its longest focal length, and then change to a wider angle.

Another type of zoom, designed usually in the 35-100mm or 40-135mm range, is called a variable-focal-length (VFL) lens. These must be re-focused each time you change image size. The

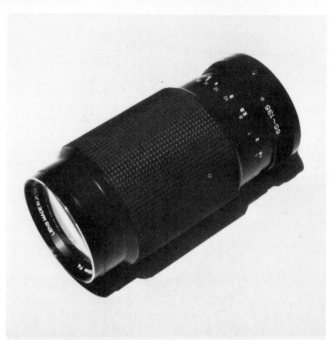

VFL has one advantage over a conventional zoom: It can be made with a larger maximum aperture such as *f*-2.8, compared to the usual *f*-3.5 of a zoom. However, because the diameter of the glass elements is increased, the VFL is heavier and more expensive than any zoom of similar range. The VFL is made by only a few companies. A conventional zoom seems preferable to me.

Macro Lenses—Chapter 12 pays homage to the macro lens for close-up photography because this is a highly useful special lens. A macro—sometimes called micro—is designed to extend out mechanically a longer distance than the average lens to allow focusing only a few inches from a subject. An extender supplied with some brands allows

Hexanon 65-135mm *f*-4 zoom.

Vivitar 70-210mm *f*-3.5 zoom has "macro-focusing" capability. Cutaway drawing shows how it is designed. Center elements shift to change focal length.

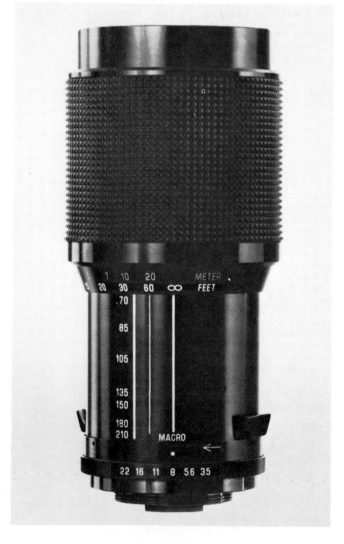

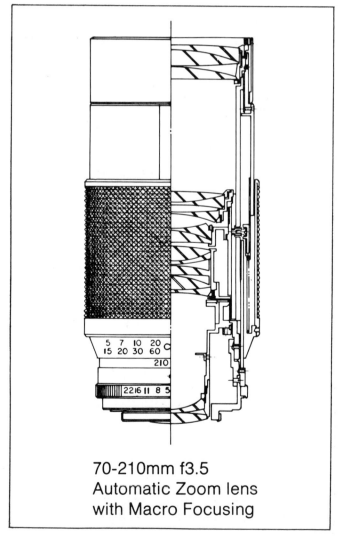

70-210mm f3.5
Automatic Zoom lens
with Macro Focusing

getting as close as one inch. A macro lens has a very deep-set front element to avoid flare and improve image detail. The average focal length is about 55mm, and a macro may be used as a normal lens. While many brands are made with largest aperture of *f*-2.8 or *f*-3.5, some are *f*-2 and none of these would be a drawback for average photography. When you have taken pictures of insects, stamps, jewelry or enlarged detail of any subject, you will appreciate the usefulness of a macro.

Special-Purpose Lenses—For some camera brands, Nikon, Canon and others, there are special-purpose lenses such as one designated PC for "perspective control." It allows you to keep vertical lines vertical in architectural shots. Minolta also makes such a lens with a rising front element described in a Chapter 14 case history.

In the Nikkor GN lens the aperture is synchronized with focusing distance for flash photography. As you focus closer to a subject, the aperture diminishes according to the GN or "guide number" you have set.

Tele-Converters—These are short-barrel, simple optics to mount between a lens and SLR camera body to extend or multiply focal length. A 2X converter doubles and a 3X converter triples the focal length, making a 50mm lens behave like 100mm and 150mm respectively. When the focal length is multiplied by 2 or 3, the *f*-number is multiplied by the same factor causing a significant light loss. This is no handicap in bright light, but can restrict you indoors. The optical quality of converters is usually inferior to average camera lenses, which means that a 100mm lens will make sharper images than a 50mm lens with a 2X converter. Converters are much less expensive than additional lenses and lighter to carry around as well. Their sharpness may be totally acceptable to you for many picture-taking situations.

LENSES ARE JUST EQUIPMENT

Camera lenses are the optical "eyes" giving your SLR its image-making ability. Lenses are important, but of higher priority is the vision you apply when looking through them. Your sensitivity in capturing the three-dimensional world on two-dimensional slides and prints is the key to lens and camera effectiveness. Don't be overly involved with equipment. The challenge of photography is all around you. What *you* get on film is the payoff.

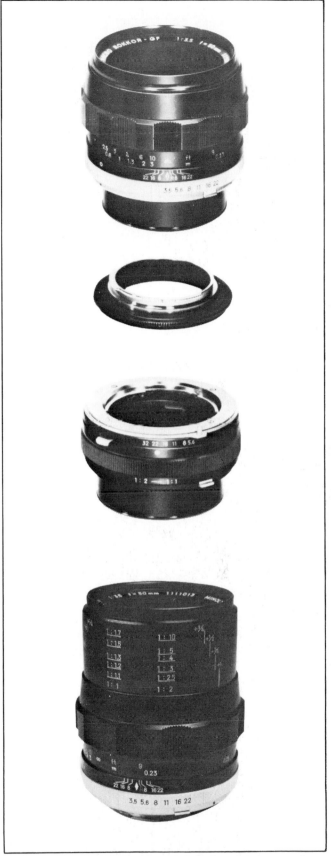

Rokkor 50mm *f*-3.5 macro set at infinity at the top and racked out all the way at the bottom. Extender tube allows even closer focusing. Reversing ring permits mounting lens in reverse position with bellows equipment.

What makes a good picture? **CAMERA ANGLE**

Look up, look down, view from a precarious angle, and magnetize the attention of your audience. When it's easy to shoot a subject head-on, do it and then look for a more dramatic angle with the same lens or a different one. Ernest Reshovsky chose a 28mm lens to make this eye-catching photograph of Jerry Lewis on a TV sound stage. The stool is not as high as it seems, but was elongated by the lens which foreshortened the man, making his feet larger than his head. Receding lines from the bottom corners are also responsible for making this an outstanding picture. Careful focus assured hand and head sharp at f-8.

What makes a good picture? **CONTRAST**

How many varieties of contrast can you name? Here's a list: large against small, light against dark, bright color versus subtle, strong and weak, high and low, old and young, fast and slow, near and far. You can expand on those without difficulty. In this unusual picture by Dennis Pylkkanen the birds stand out strongly against the dark background, and the edge-lighted rock is part of the pattern. Dennis shot Ektachrome-X in his SLR, but the slide is monotone because the color was subdued. The shot won a Kodak Newspaper Snapshot award in the Anchorage *Daily Times.* Look for contrasts—you may have the basis for a good picture.

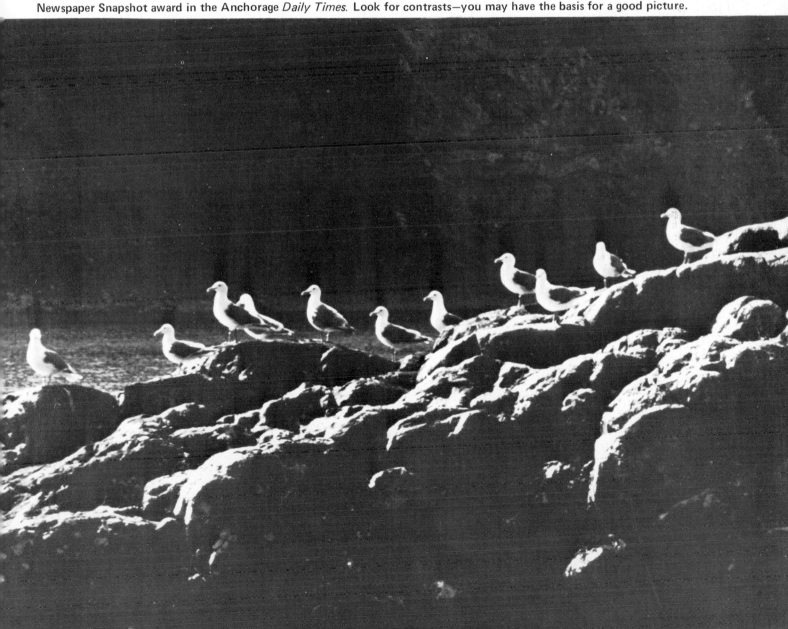

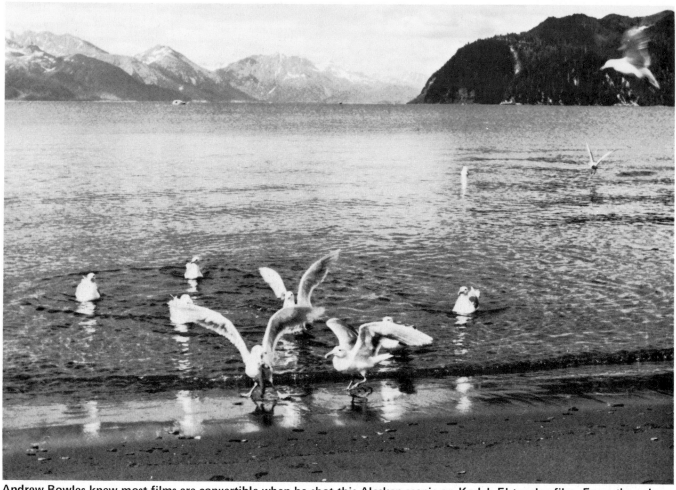

Andrew Bowles knew most films are convertible when he shot this Alaskan scenic on Kodak Ektacolor film. From the color negative this b&w print, color prints and excellent slides have been made, as a result of Mr. Bowles winning a Kodak Newspaper Snapshot Contest prize. Lens was 50mm; exposure was 1/125 at ƒ-11.

A photographer chooses film to fit certain requirements, though sometimes it seems like people buy the kind of film that sells best, or just take whatever is offered. Choosing film for the job at hand greatly improves results and makes everything easier.

COLOR OR BLACK-AND-WHITE?

Partisans of one or the other seem a lot more locked into their choice than they are about foods, styles in clothing or TV programs. You hear, "I only shoot color slides," or "I like color prints to show around—none of that projection stuff for me." Favorites are fine, but there's no reason to deny yourself the pleasures or advantages of a different type of film when it can expand pictorial opportunities.

Color-slide films are delightful if you enjoy editing them into sequences and giving slide shows that move along with snap and variety. Color-negative materials have a bit more exposure latitude than slide films—meaning that you can under or overexpose a little more and still get a good print. Some slide and print films are now as fast as black-and white—b&w—films.

Black-and-white films seem to be the forgotten medium of photography these days. However,

every student of photography learns the craft shooting, developing and printing b&w pictures because there is full control over exposure, processing, print quality and final cropping. In case you are unfamiliar with *cropping*, it means to cut off or eliminate extraneous parts of a picture to improve the composition and tell the story more directly.

When you shoot with b&w films there is a definite creative advantage in developing and printing the negatives yourself—but it's not absolutely essential. In most medium-size and large cities there are custom photo labs where patience and awareness on your part can encourage professional printers to come up with enlargements that please you. If you really get immersed in the art of photography, you'll feel the urge to do your own pictures, which usually means having a darkroom at hand or renting darkroom space from a camera club or commercial outfit. Once you develop the skill that b&w printing requires, it will help improve your picture-taking abilities with any film in all sorts of situations. You *see* more directly and move closer in to your subjects, when you have cropped your own prints, and that adds up to more effective color slides too. If your experience has been mostly with color photography, think of black-and-white as a kind of "finishing school" where you polish techniques and gain the personal pleasure of making photographs to hang or show. Certainly, you don't have to give up color to dig b&w, and if you have two camera bodies, it's easy to load and shoot both kinds of film in the same situation.

FILMS ARE CONVERTIBLE

That means you can have color prints made from slides, or color slides made from color negatives. Good color prints are so easy to obtain from negatives—and may look better than those made from slides so you should consider using color-negative film in many situations where you may have been using slide film. Black-and-white prints from color negatives are easy to do and black-and-white negatives of color slides can be shot with a slide-duplicator or other home set-up.

The only thing you can't expect is color slides or prints from b&w film, unless you tint them by hand, which—although once a popular phase of this hobby—is now outdated.

Black-and-white photography may not be as popular as color, but the disciplines are valuable. Your ability to shoot fast films and make prints easily in a home darkroom add to b&w advantages. Model is actress Celeste Yarnall, and we were doing some experimental portraits during a break on a fashion job.

FILM SPEEDS TO FIT YOUR NEEDS

Photographic films are rated in ASA—American Standards Association—numbers according to their speed, which means their sensitivity to light. It's the silver in the film emulsion that forms an image when developed. When silver grains are very tiny, or fine-grained, film is slow, sharpness is excellent and contrast is relatively greater than it is in faster films. When film is medium-fine-grained, it is somewhat faster, sharpness is good and contrast is slightly decreased. Fast films are more sensitive to light because their grain pattern is larger. Fast films produce sharp images, but image sharpness

Grain? What's grain? It's an obsession with inexperienced photographers until they discover that unless you boost film speed in high-energy developers or enlarge only a portion of a negative, or both, grain is rarely a problem. The arrival of the Queen Mary in Long Beach, CA was made on Tri-X rated at ASA 400 and developed in Microdol-X. Had this print been 11x14 or larger, grain would still not be objectionable.

or definition decreases more noticeably in big enlargements than with fine-grained films. Graininess is no big deal under appropriate circumstances, and fast films are well worth this mild sacrifice when you can shoot in dim light at shutter speeds allowing you to hand-hold the camera with little or no image blurring. Contrast is relatively less with fast films, a welcome asset in bright sunlight with its dark shadows and brilliant highlights.

Slow films are rated roughly from ASA 25 to 80. Medium-speed films range from ASA 100 to 200, and fast films from 200 up. Your choice depends on several things, especially the amount of light—or light level—you'll be shooting in, and the possible movement of your subject. For instance, for a still-life picture with your SLR on a tripod, a slow film can be ideal. You can use a medium or small aperture with slow shutter speed and not worry about camera or subject motion.

Shooting a basketball game indoors, you would benefit by a fast film allowing a shutter speed of 1/250, even at *f*-2 or *f*-2.8.

Portraits made with floodlights may call for a medium-speed film to allow an exposure of 1/125 at *f*-5.6 or *f*-8, to avoid blurring due to subject movement.

DIN is a European film-speed rating (Deutsche Industrie Normale) and all films are rated either in ASA or DIN. This rating also appears on the cassette itself, as well as on the box and on the instruction sheet inside.

When it's possible, fit your choice of film to the subject and the kind of light you have. It's not always so simple. For that reason, a lot of photographers stick to one or two speeds and brands of film to fit a majority of circumstances. This may seem like a compromise, but it's good to become very familiar with a few films so you know how they react in many kinds of light and under a variety of contrast conditions. Carry extra rolls of film, slower or faster than your favorite, just in case you have to change because the picture situation requires it.

As an example, you're on a trip, the day is bright, so you shoot with a slow film such as Kodachrome 25, Agfachrome 64 or Kodacolor II. There's no problem with exposure at 1/125 or 1/250 because apertures range from *f*-8 to *f*-16 for very bright subjects. In the afternoon you happen across a local rodeo or gymkhana, and unluckily,

Choose a slower film for bright outdoor shooting, and a faster one indoors when daylight filters through a window as it did for Emily Wheeler of Fairfax, VA, who won a Kodak/Scholastic scholarship with a portfolio including this expressive portrait. She used Tri-X in her SLR at *f*-6.3 for 1/125.

the sky clouds over. With a slow film you would worry about depth of field at fast shutter speeds to catch the action, so you switch to a faster emulsion. At ASA 160 or even ASA 400 for b&w, you can shoot at 1/500 at *f*-8 and stop action without much d.o.f. problem.

NOTES ABOUT 35mm FILMS

Fast or slow, prints or slides—what do film characteristics mean to you?

The Old Standbys—Kodachrome 25 (K25) is the color-slide film used as a comparison standard for other types and brands. Its hues are bright—*saturated* is the technical term—and its contrast is strong. Kodachrome 64 has very similar hues and contrast, but K25 is grainless and K64 shows a trace of grain in large blowups. If K25

SOME COLOR FILMS AVAILABLE FOR SLR CAMERAS

Slide Films

Name	ASA Rating	ASA in 3200°K Light w/80A Filter	ASA in 3400°K Light w/80B Filter
Agfachrome 64	64	16	20
Fujichrome R 100	100	25	32
Kodachrome 25	25	6	8
Kodachrome 64	64	16	20
Ektachrome 64	64	16	20
Ektachrome 200	200	50	64

Slide Films for Artificial Light

Name	ASA Rating	ASA in Daylight w/85 Filter	Notes
Kodachrome 40/Type A	40	25	Balanced for use w/3400°K floodlights. ASA 32 w/3200°K bulbs and 82A filter.
Ektachrome 50 (Designated Professional film)	50	With 85B Filter in Daylight 40	With 81A Filter w/3400° floodlights. 40
Ektachrome 160	160	100	125

Negative Color Films

Name	ASA Rating	ASA in 3200°K Light w/80A Filter	ASA in 3400°K light w/80B Filter
Agfacolor CN	80	20	25
Fujicolor	100	25	32
Fujicolor F-II 400	400	100	125
Kodacolor II	80	20	25
Vericolor II	100	25	32
Vericolor Type S	100	25	32
Kodacolor 400	400	100	125
3M Color Print Film	80	20	25
Eastman 5247*	100 (Daylight or tungsten; processing lab corrects slides or prints)		

* This is professional motion picture film sold by various companies in 36-exposure rolls. Processed negatives are printed as slides or prints, depending on company and individual request.

is too slow under lighting conditions you prefer, use K64 when high color saturation is your goal. A faster film allows higher shutter speeds for action, and better depth of field in lower light levels.

The E-6 Family—Ektachrome films are now designated as Process E-6, while discontinued types of the same brand were E-4. The new emulsions are sharper, have less grain and truer color, compared with previous Ektachromes. You can still develop Process E-6 in your own darkroom, if you want to take the time and buy the chemicals. Kodachrome must be processed by Kodak or other companies using expensive automatic machines.

The latest Ektachrome films offer an ASA 200 daylight speed and an ASA 160 tungsten speed, both higher than their E-4 equivalents. There are *two types* of Ektachrome films, however, with the same speed ratings. Those marked *Professional* must be stored in refrigerated conditions and processed quickly after exposure. They're for pros with critical color requirements. Agfacolor 64 looks like Ektachrome, but is warmer.

Color Negatives for Prints—There are some differences in color-negative materials. I prefer Vericolor II for its print quality over Kodacolor II, but you need to look close to see the difference. The advantages of Kodacolor 400 for photography in dim light without flash seem obvious, and K400 prints are excellent. Whatever film you choose, keep in mind that the business of processing and printing color negatives is highly competitive, with cut-rate prints available from roadside stands, camera shops, drugstores, and by mail.

All color prints are *not* alike! For a few cents extra you are likely to receive more accurate color and more careful framing of your pictures. Prints are made automatically on a mass-production basis, but some companies have higher standards of quality than others. You need not be satisfied with faded-looking prints when you know the color was there in the original scene. Compare prints from Kodak and other processors, complain when appropriate, and when you find a service that pleases, stick with it and hope it will be consistent.

If you invest in color enlargements, do some more research. In larger cities, there are custom labs that work for amateurs and professionals, or you can order prints through camera shops and by mail. The less you pay, the more likely you are to be disappointed. Of course, if you want to invest in

SOME BLACK-AND-WHITE FILMS	
Name	**ASA (Daylight or Tungsten)**
Fujipan K	125
Ilford Pan F	50
Ilford FP4	125
Ilford HP5	400
Panatomic-X	32
Plus-X Pan	125
Tri-X	400
Kodak 2475 Recording	1,000-32,000
Kodak High Contrast Copy 5069	64
Kodak High Speed Infared	(Check film instructions)

paper, chemicals, and special filters, you can make color prints in your own darkroom from negatives or slides, but that's all covered in another HP Photobook, *Do It In The Dark*, by Tom Burk.

Eastman 5247—Several companies load this Eastman professional movie film into 35mm cartridges, and sell them by mail. You may shoot 5247 at ASA 100 in daylight or tungsten light and the slides or prints made from it will be color corrected when processed. If you mix light sources on one roll, use an 85 filter with daylight, and no filter for tungsten. EK5247 is negative film. Slides made on Eastman Duplicating Film are excellent, similar in color quality to Ektachrome 64. I've also made good b&w prints from these negatives on Polycontrast papers.

BOOSTING FILM SPEEDS

Kodak and other labs offer special processing for Ektachrome 160 (to ASA 320) and Ektachrome 200 (to ASA 400), giving you higher film speeds for low light levels or action. This is called *push processing*, provided through special mailing envelopes by Kodak, or by arrangement with a custom lab.

BLACK-AND-WHITE CHOICES

Eastman Kodak dominates the film market in the U. S. and no other brand may be available at drug stores or film outlets that are not camera

Actually, it doesn't pay to be rigid about film choices. Richard Curtin photographed this charming child on Kodachrome at the edge of a porch, and had plenty of light to expose at f-4.5 for 1/60. Depth of field with his 50mm lens was just right so he could be selective about sharpness. His picture won a Kodak Newspaper Snapshot award.

This placid scene photographed by Markku Rakkolainem of Amery, WI, won Kodak/Scholastic prize. Exposure was f-8 at 1/15. Can you visualize the effect if the horizontal line formed by the shoreline was higher or lower?

An underwater housing may be available as standard equipment for your SLR, or can be custom-made for some brands. High Speed Ektachrome boosted to ASA 400 gives you more speed and depth of field here as well as on dry land when light levels are low. Kodak photographer Neil Montanus shot this near Grand Cayman in the British West Indies. The diver's camera housing has exterior controls to set shutter speed, f-stop and focus.

Tri-X was the natural choice of photographer Gene Daniels on Academy Awards night. Gene used a Nikon F and included my wife Barbara at left with her Pentax at the ready. She was also covering the arriving stars who faced the Hollywood camera corps en masse. Exposure was 1/60 at ƒ-5.6 with a 28mm lens.

shops. However, Kodak films are so reliable and cover such a full range of speeds that it's nice to find good film everywhere, even if other brands aren't available.

A lot of professional photographers rely on Tri-X in their SLRs, because it has less contrast for sunlight situations, and tolerable grain in 8 x 10 enlargements. Panatomic-X is more contrasty, but extremely fine-grained. Plus-X is a perfect compromise, and I've come to love it outdoors or anywhere I don't need ASA 400. If you can find Ilford HP5, it compares very favorably with Tri-X.

PUSH PROCESSING

Push-processing a b&w film such as Tri-X is simple in your own darkroom. You rate Tri-X at ASA 1,000 or ASA 1,200 and up to ASA 1,600 for Ilford HP5 by setting the camera film-speed dial to the desired speed rating. Develop it in a high-energy formula such as Acufine or UFG. Custom labs offer this service routinely, so check their advice and prices when you get into b&w available-light photography. Available light means whatever there is when you want to shoot a picture—cheerfully called "available darkness" sometimes.

High-energy developers do increase graininess, but little enough to ignore in favor of being able to shoot without floods or flash in natural-light situations—usually indoors. This topic is covered in detail in Chapter 9.

When you rate a cartridge of film at a higher speed number, shoot the entire roll that way. Otherwise developing the film becomes a major problem.

FILTERS FOR COLOR FILMS

Name or Number	Type of Film	Lighting	Uses
Skylight (1A)	Daylight	Daylight	To reduce bluish tint of the light in shade or on overcast days; makes shadows warmer, more natural
80A	Daylight	3200°K floods	Converts daylight film for use with 3200°K bulbs
80B	Daylight	3400°K floods	Converts daylight film for use with 3400°K photoflood bulbs
80C	Daylight	Clear Flash	For use with clear flashbulbs (rare these days)
81	Daylight	M2 flash	A yellowish warming effect
81A	Type B	3400°K bulbs	Corrects Type B film for use with 3400°K bulbs
82A	Type A	3200°K bulbs	Corrects the 200°K difference
85	Type A	Daylight	Converts Type A film to daylight—very useful
85B	Type B	Daylight	Converts Type B film to daylight—very useful
FLB	Type B	Fluorescent	Eliminates blue-green tint caused by fluorescent lamps
FLD	Daylight	Fluorescent	Eliminates blue-green tint caused by fluorescent lamps; preferable to FLB/Type B combination usually
ND	Any type	Any light	Neutral tinted in varying density such as 2X or 4X to reduce light intensity without altering colors
Polarizer	Any type	Any light	Eliminates most surface reflections; darkens blue in sky without altering other colors

FILTERS FOR BLACK-AND-WHITE FILMS

Filter Number	Color	Suggested Uses
K1 or No. 6	Yellow	Absorbs some blue, darkens sky slightly
K2 or No. 8	Yellow	Absorbs blue, darkens sky, produces more contrast between sky and white clouds
K3 or No. 9	Yellow	Darker yellow for additional contrast between sky and white clouds
X1 or No. 11	Green	Creates pleasing flesh tones in portraits with sky background; lightens greens in landscapes
X2 or No. 13	Green	Lightens foliage color; good for portraits in tungsten light, especially ruddy men
G or No. 15	Orange	Produces dramatic dark skies; good for seascapes
23A	Light red	Darkens both sky and water; not recommended for portraits
25	Red	Very dramatic sky effects; moonlight can be simulated with slight underexposure
C5 or No. 47	Blue	Accentuates haze and fog
ND	Neutral density	Serves to reduce film speed without altering color or tonal range
Polarizer	Neutral	Eliminates most surface reflections; darkens blue sky without altering other tones

Without a filter blue sky may not appear with enough contrast especially when there are clouds. When the air is clear in the Southwestern U.S., skies show up darker than they do in the Eastern U.S., and this isn't a partisan comment. However, a filter for b&w films is useful anywhere to assure good separation for clouds.

The same piece of sky photographed with a K2 yellow filter darkens the blue nicely and makes the sky stand out. Using an SLR with built-in meter, additional exposure for the filter is given automatically when you set the meter needle, or when you use an EE system.

Using a higher-than-normal film speed with push processing allows you to capture on film the natural ambience of a place that would be considerably modified by adding artificial light. I usually make 8 x 10 prints for my clients, and grain is either negligible or non-existent from Tri-X rated at ASA 1,000 and processed in Acufine. If grain shows, it belongs there and is expected, becoming a characteristic of natural-light situations. Grain will also be apparent when a small portion of negative is enlarged to 8 x 10.

Whatever b&w or color film you choose, become familiar and comfortable with it under many circumstances. Gain experience with several brands and types, and you'll know better what you like.

Contrast similar to the K2 filter is also produced by polarizing filter with the advantage of being able to turn it as you view through the lens to vary the darkness of blue sky. The polarizing filter is also suitable for color film.

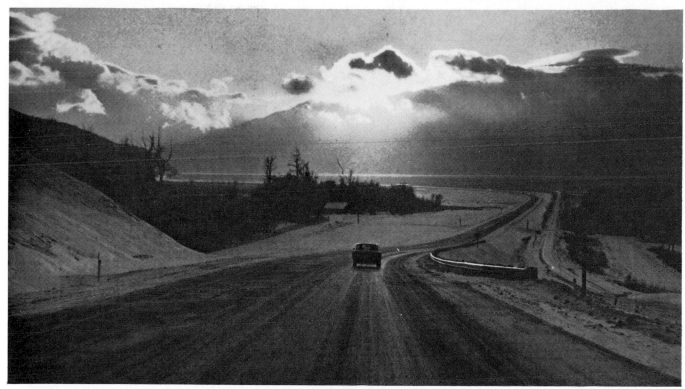

Jeanell Bitgood of Anchorage, Alaska used a K2 yellow filter with Kodak Panatomic-X film to accentuate the clouds in this moody scenic of a lonely road. She leaned from a car window with a 35mm lens on her SLR and exposed at 1/125, f-8. Camera's meter indicated f-11, but she opened up one stop to get more foreground detail.

COLOR-SLIDE PROCESSING

It's pretty uniform around the country I think, but if you are not satisfied, complain. Some labs are not as careful as they might be about keeping their chemicals fresh, which causes strange tints or a slightly faded look to slides. Watch out for scratches, too, an annoying warning that lab technicians are slobs. There is no excuse for scratched film. Change to another lab immediately.

ROLLING YOUR OWN

Some b&w films are supplied in 50-foot and 100-foot rolls which you store in a bulk loader and roll up to 36 exposures into 35mm cartridges at your convenience. There is a definite saving of money with bulk-loaded film, but one hazard: SCRATCHES. Unless you keep the felt lips of the bulk-loader dust-free, and use cartridges only a few times so they will be clean and light-tight, you may get scratches on your film that make any economies worthless. If you shoot at least 8 or 10 rolls of film a month, bulk loading may be advisable; otherwise, factory-loaded film seems worth the extra cost.

HOW TO USE FILTERS

New 35mm SLR enthusiasts often get caught up in a sort of filter mania, thinking that dramatic effects they may produce are a sure secret of pictorial success. Filters have a definite place in photography, but no mystic properties requiring you to carry bunches of them in your gadget bag. There are filters to convert color film from daylight to indoor lighting or vice versa, and there are filters for effect and to reduce film speed. Filters you should know about are listed in the accompanying tables.

As an antidote to filter-mania, let me recommend the basic types you are likely to use:

A Skylight filter is necessary with color slide films to shoot in shade or under an overcast sky. It is *not* necessary with all color-negative films for the same conditions, so experiment with and without and compare results.

Neutral Density filters are essential to effectively slow down fast films by reducing the amount of light that comes through the lens. They give you more control over shutter speeds

Filters and skies go together like ham and eggs. A polarizer helps darken the sky in this b&w picture taken on Plus-X Pan near sunset.

and *f*-stops so you can control depth of field. "Neutral" means they do not affect or alter colors. They just reduce the amount of light by a factor— 2x means the light is cut in half, 4x means it is cut to 1/4.

A polarizer is very handy to cut reflections and darken skies, and you can watch its effect through the viewfinder with color or b&w films.

A special "Fluorescent" filter with daylight color films does a pretty good job correcting for the color of fluorescent lights, which otherwise turn everything green. There's also a "Fluorescent" for tungsten films.

A star-effect filter for special effects is in my kit. I also carry conversion filters when needed, such as the 85 filter used to convert Type A color film for use in daylight.

Buying Filters—Dozens of sizes and brands are available in three forms: gelatin, solid glass and laminated glass. Gelatin filters come in 2-, 3-, 4-, and 5-inch squares, are cheapest, easiest to scratch and hardest to handle. You cut a circle of gelatin to fit your lens, and mount it in an adaptor ring that screws into the front of the lens. Glass filters are more durable, but should be handled carefully

as you would a lens. Laminated filters—gelatin between two pieces of glass—may be more precisely colored than all-glass, but the difference is not important.

You can buy step-up or step-down rings to fit one size filter to a slightly smaller or larger diameter lens. If you put on a filter smaller than the lens, make some test shots to be sure it doesn't vignette your pictures. Most SLR lenses are marked with the millimeter measurement of the inside front thread. If you lenses are uniform in diameter— as many modern systems are today—one filter will screw into many different lenses.

Stack-pack Your Filters—Glass filters are sold in nice plastic cases to protect them, but a few of these take up too much room in a gadget bag. Discard the cases and buy a set of male and female caps to fit your filters. Screwed together they become a neat stack-pack that's easy to separate and use.

Experiment—Sooner rather than later, a photographer should be familiar with the effects of each filter he/she owns and operates. Experiment is the name of the game. Shoot some pictures with each filter under several lighting conditions. Decide

from your slides or prints how you like the results, or why you are disappointed. Use a few colored filters with color films for unusual tints to add mood and visual interest to the *right* subject. A yellowish tint on a sunny scene can amplify the feeling of sunlight, but a magenta filter on the same subject may seem awkwardly out of place. Look in magazines for pictures by Pete Turner. He's a master of added-color-effects that work with dramatic impact. Pete often duplicates his favorite slides and experiments with colored filters to give them an individual moody feeling.

The filter frolic is one of photography's many added dimensions which you should try when you have gained confidence with your SLR.

RULES FOR USING FILTERS

In many books on photography two kinds of rules are offered as guides to using filters. One set of rules seems rather complicated and relates to exposure corrections when you put a filter over your lens. A filter that stops light rays which are not red will obviously let the red ones through. We call it a red filter because that's how it looks. Because it is stopping light of other colors, the film is not receiving as much *total* light as it would without the filter.

You can read about how much you have to change the exposure controls on a camera to compensate for the loss of light due to a filter but that doesn't apply to a modern SLR with metering behind the lens. It's a big advantage—the internal metering automatically compensates for whatever filters you are using and you don't have to worry about it.

The other kind of rules relates to the effect on the photographic image due to the color of a filter. You still have to think about that.

If you are shooting color film, a color filter will change the color of the image. A blue filter makes a bluish picture. You can judge the effect just by holding the filter between your eye and the scene and looking at the result.

With b&w the rule is: *A filter lightens its own color.* That means a lighter shade of gray, obviously, because b&w film records images as tones of gray. In the case of a red filter, any red-colored thing will not be affected much by the filter because it lets red light pass through. Anything which is not red-colored, such as blue sky, will be affected because the filter stops some of the light and these objects appear darker than they would if the filter were not used. That's why red and yellow filters darken blue skies in b&w prints.

A practical application of color filters in b&w photography is to alter the relative gray-scale brightness of colored subjects. This rose, photographed without a filter, is about the same tone as the leaves.

A red filter lightens the red rose and darkens the leaves, for more visual contrast.

A green filter lightens the leaves and darkens the rose. These rose photos are from the book *Understanding Photography* by Carl Shipman.

What makes a good picture? **INNOVATION**

Somehow the shoes of our children have meaning and evoke a tender emotional response. This innovative composition will tug at the heart strings of any parent. The empty shoes here, the child in the distance—venturing out.
Taken with a Tiffen split-field lens accessory which focuses close in the lower half, far away in the top half. Photo courtesy of Tiffen Optical Company.

What makes a good picture? **DRAMA**

The word *dramatic* can only be applied to photographs that have outstanding eye-appeal and impact. When it's there, you don't need a label; the viewer knows it. Drama is created by various items such as lighting, emotional excitement, human triumph or tragedy, and action. There's tension in the child's expression which contributes to the drama here. Taken in St. Mark's Plaza in Venice, Italy where pigeons seem to be everywhere. Exposure was 1/500 second and *f*-8 on Plus-X.

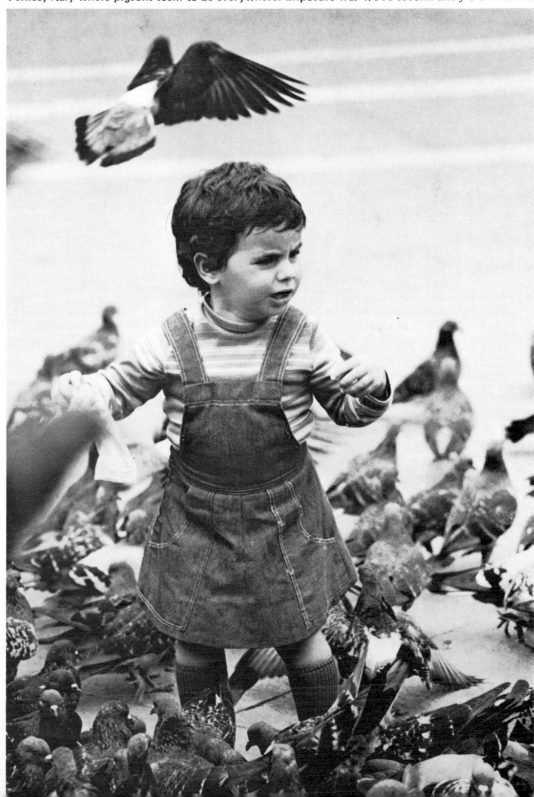

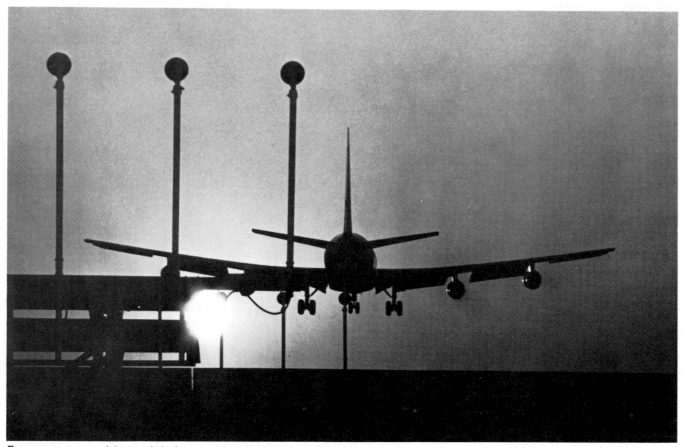

Exposure, composition and timing were involved in this photograph of a jet about to land at Los Angeles International Airport for the cover of a book about air-traffic control. I exposed for the sun, expecting a silhouette, and composed by waiting for the plane to fly into position. I was somewhat restricted by having to place the sun partly behind the barrier, or I would have shot when the jet was a bit higher. Lens was 135mm, and exposure on Tri-X was 1/1000 at *f*-8.

Photographic exposure is determined by a simple formula:

Correct shutter speed + correct lens opening for a specific film speed equals ideal exposure for a specific combination of light, shadow and subject reflectivity.

Before the early 1960's, getting good exposures on negatives and slides was a serious preoccupation of photographers. Exposure meters were separate from the camera, and you had to fiddle around, pointing the meter this way and that. Finally, you made a compromise average of readings the meter indicated for bright and shadowy areas of the scene. Once this skill was mastered, a photographer could be reasonably certain of good exposures.

Many advanced amateurs and professionals today prefer to calculate exposure with hand-held meters. Ansel Adams devised what he called the "zone system," for tight control of highlights and shadows in black-and-white negatives. The system includes developing compensations and techniques as well.

I mention it here, not because you should study Ansel's book *The Negative* but so you'll be familiar with the depth into which one can delve to mix photographic art and science.

Around 1960 manufacturers of single-lens reflex cameras began incorporating exposure meters into them. Light-sensitive cells were placed behind the lens, behind the mirror, within the prism dome or wherever designers thought they

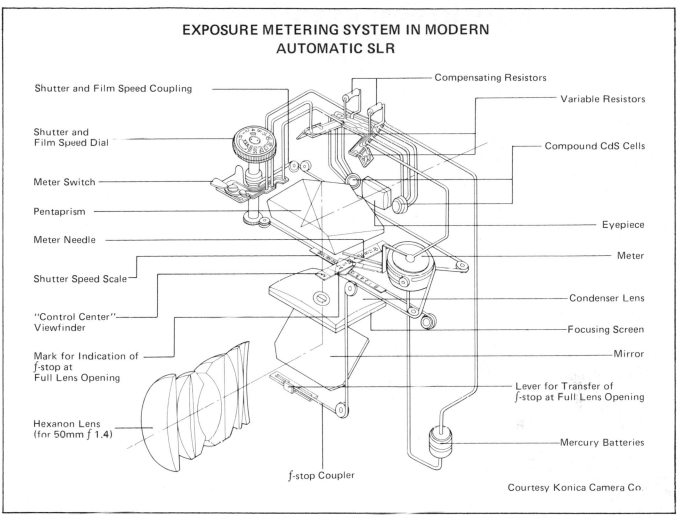

EXPOSURE METERING SYSTEM IN MODERN AUTOMATIC SLR

Shutter and Film Speed Coupling

Shutter and Film Speed Dial

Meter Switch

Pentaprism

Meter Needle

Shutter Speed Scale

"Control Center" Viewfinder

Mark for Indication of f-stop at Full Lens Opening

Hexanon Lens (for 50mm f 1.4)

f-stop Coupler

Compensating Resistors

Variable Resistors

Compound CdS Cells

Eyepiece

Meter

Condenser Lens

Focusing Screen

Mirror

Lever for Transfer of f-stop at Full Lens Opening

Mercury Batteries

Courtesy Konica Camera Co.

Schematic diagram of the exposure metering system in a modern SLR, the Konica Autoreflex T3. Similar sophisticated systems and components make most SLR's a pleasure to use because they take so much guesswork out of photographic exposure.

would work best. Today there are a variety of systems, photocell materials, metering devices and other ingenious ideas. All sound fantastic in colorful full-page ads.

Most of them work like this: An image consisting of light rays passes through the lens of your SLR. A portion of the light is detoured to strike exposure-meter cells which convert light intensity into electrical energy. Neat little electronic components measure this energy—strong for high-lights and weaker for shadows—and translate their findings to an exposure display seen in your camera's finder. You adjust the shutter-speed dial or aperture ring until the meter needle is centered, or proper lights are displayed. If your camera is automatic, it even makes the exposure adjust-

ment for you. You can check the f-stop or shutter speed indicated by automatic-exposure systems and if the settings seem okay, shoot.

Some camera metering systems have two sensing cells. One reads a small area and the other evaluates over-all light and shadow. Their combined combined readings are averaged by transistors to guide you to correct exposure. Not all camera meters have the same sensitivity, accuracy, ease of operation or durability. But built-in meters make life a lot easier.

LOOKING AT LIGHT

Ideal exposure means *you*, with the *assistance* of your SLR meter, have set a lens opening and shutter speed to do what you are trying to

Front light, typical of flash-on-camera, caught actress Julie Andrews at a formal event when no other type of lighting was feasible. In front light, modeling of facial features is usually lost or minimized.

Top light is what you expect from the sun high overhead in summer months around the noon hour. It didn't stop this young model at a publicity event from using *her* SLR on a visiting lion cub. Exposure for such a scene is difficult because highlights are so bright and shadow detail suffers. Camera exposure meters do as well as they can, but you must expect blocked areas such as the lion cub's tummy where reflectivity was greatest.

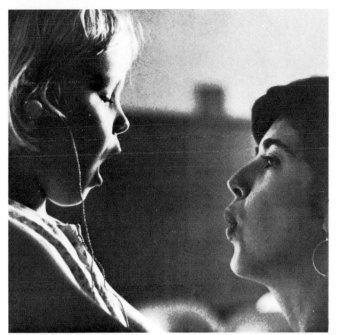

Sidelight from the right outlined the form of the child's face more beautifully than if it had come from any other direction. You don't need this caption to know that the child had hearing and speech difficulty and is being helped by a sensitive teacher. The photo was made for United Way of America and appears in a Kodak publication called *Help Your Community . . . Through Photography*. I recommend you read it because it is loaded with tips about picture-taking and some fine examples, too.

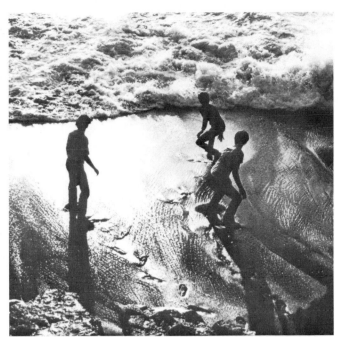

Backlighting makes important subject matter stand out from the background and gives sparkle to textures such as the breaking waves shot by Mark Miloslavich for the Kodak/Scholastic contest. Mark did not make exposure compensations because shadow detail is not important to this picture. His SLR meter indicated 1/1000 at f-11 on Plus-X Pan film, and that's the way he shot it.

Indirect light means it is diffused or reflected. An overcast sky is usually fine for portraits, and indoors a ceiling of fluorescent lighting spreads illumination well. Notice in this charming and well-timed photograph by Ernest Reshovsky that there are no strong shadows on the floor because the light was diffused. Ernie rated Tri-X at ASA 1200, shot at f-6.3 for 1/125 and developed in Acufine.

accomplish in each photo you shoot. Obviously, this doesn't happen every time you take a picture, but it's the goal. Why doesn't it happen consistently? Well, lighting conditions can be rather tricky, and human intelligence must learn to guide electronic components for more pleasing exposures.

Indoors or out, light sources are usually directional, and your awareness of this fact can help guarantee ideal exposure more often.

Front Light—is best exemplified by flash on the camera or a subject looking directly into the sun. In front light the illumination is flat: There are few if any shadows to show form. Front lighting by sunshine on a distant mountain flattens its contours into one pictorially dull mass. Faces in front light are also less interesting than if light comes from an angle or from the side. If you have heard the advice, "Shoot with the sun coming over your shoulder," ignore it. If not you will be using a version of front light that is less flattering and comfortable than if you place the subject with *his* side or back to the sun.

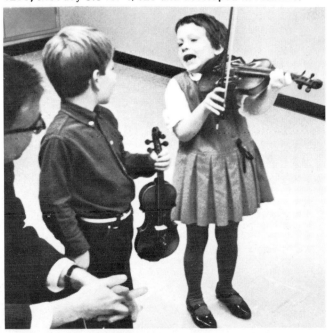

This high-contrast scene in Switzerland has tonal values from white snow to black earth. The SLR built-in meter will average this brightness range to determine an exposure, and film latitude can often handle high contrast. In a scenic view, highlights should be properly exposed even if shadows are slightly darkened in prints or slides. As you become familiar with one or two films, you are better able to make exposure adjustments for high contrast.

Top Light—means the light source is almost directly overhead, casting dark shadows under eyes and showing only a limited version of form. Top light is great for shooting sculpture, but at high noon on a summer day, faces, landscapes and seascapes are certainly not seen at their best.

Sidelight—makes people and things more interesting, because form and texture are seen with better emphasis. Even if shadows are slightly dark, sidelighting can add drama to subjects and scenes. A mountain range photographed in sidelight, especially in early morning or late afternoon, is more visually stimulating because shadows show form sharply.

Back Light—is often the way to outstanding pictures because it is dramatic and exciting. With your subject "against the sun" or with a floodlight behind him or her, there are strong highlights around the face and head, or light along the rim of a face to separate it very well from the background. Back lighting is the most difficult to

expose because contrast may be strong and camera meters can be tricked and I will get into this problem shortly.

Indirect Light—comes from a reflecting surface or when the sky is overcast. Over the years people have often asked me, "How can I shoot when there's no sun?" I tell them it's an ideal time for portraits because subjects don't have to squint, and you don't have to fight contrast created by strong directional light casting shadows. Reflected light is such a joy for portraits and some types of still-life that I'll go into more details about it in Chapter 7.

LOOKING AT CONTRAST

I have emphasized the direction of light because it influences exposure. The difference of intensity between highlights and shadows—expressed as *contrast*—also affects exposure. Overall contrast can be measured as the numerical ratio between the brightest and darkest areas of a scene. Let's

say that light reflected from a white shirt is 10 units. In this theoretical picture the same light falls on black pants but they only reflect one unit of light. Therefore the contrast ratio at its extreme is 10 to 1.

By putting light into the shadow areas of this scene, we can increase the 1 unit to 4, for instance, while the white highlights remain at 10. In this way, the contrast ratio could be decreased to a more restricted 10 to 4. Putting more light into the shadows with a reflector or flash unit is called *fill* lighting.

These examples illustrate the task that film must perform under the control of your brain and with the help of your camera metering system. For a straight interpretation of the scene, the brightest and darkest parts must appear in the final image as distinguishable tones—and of course all of the scene brightnesses in between. If you are shooting color, the problem of color rendition is just added onto the basic problem of getting the contrast range of the scene onto film.

PHOTOGRAPHING CONTRAST

The exposure problem looks complicated until you take it apart and find that the pieces are simple. One aspect is the contrast range discussed above such as 10 to 1 or 4 to 1, or whatever the scene is. This range has to fit the capability of the film you are using or some of the tones will be lost. When a film can accommodate a wider range of tones than the scene produces, that film is said to have some exposure *latitude.*

Suppose the scene has *more* contrast range than the film can handle. The light from a white shirt exceeds the range of the film and causes overexposure where the shirt is imaged on the film. In the resulting print the shirt will appear "washed-out." There will be no visual separation between the whitest white and other shades of white that are a little darker. You won't be able to see the buttons on the shirt or texture of the fabric or other details. We call this *blocking* the highlights.

A similar thing can happen in dark areas of the scene so they all go black on the print and no detail is visible.

If a scene has a *range* of brightness then it also has a center or *average* brightness somewhere near the middle of the range. This is an important idea. Let's suppose that by guess or by golly an

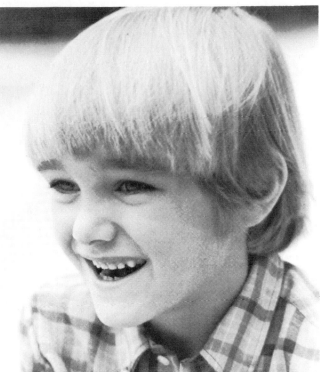

A low-contrast situation occurs when lighting is fairly flat, such as an overcast day or in fog. This boy's features appear clearly with just enough shadow to give form and depth. Notice that the portrait quality is emphasized by going out of focus just beyond the face. Soft lighting is often flattering to older people and you should learn to use it. You may be surprised how bright such a situation can be; trust your camera's meter even if it seems to indicate underexposure. On Tri-X this portrait called for 1/250 at ƒ-11.

exposure is made which blocks some of the highlights and some of the dark areas. You can't see the buttons on the shirt and you can't see the stitching on the pants. Everything in between is just fine though and the picture is about as good as you can do under the circumstances.

Maybe not. What you were trying to get was a good image of the black pants complete with stitching, texture and wrinkles. You missed, so try again. Obviously to solve this photographic problem you must be willing to block up the highlights more to preserve detail in the dark areas. Remember the range of the film is limited.

To do that, you *move the center* of the exposure so more of the bright tones exceed the range of the film and the dark tones are pulled up into the range of the film. In practice, you open up the lens more or leave it open a little longer so more light gets in from each part of the scene. Shirt gets worse, trousers get better, but that's what you are trying to accomplish.

You can start thinking now that an exposure meter tells you where to put the center of the scene brightness range.

A BAD SCENE

While you are marinating that thought, let's look at a scene most films can't handle. The white shirt and black pants in uniform illumination such as *both* in direct sunlight or *both* in shadow isn't too bad. A lot of films can do a decent job with tolerable blocking at one end or both.

Now move this guy so the shadow of a building falls across his legs at about the knees. The contrast range between white shirt and *sunlit* pants is still 10 to 1, but the range between sunlit shirt and pants in shadow is a lot higher. Film can't hack that. Even if you have exposed properly, from the knees down there won't be any visible detail. Because blocking in dark areas typically results from shadows the problem is commonly referred to as loss of *shadow detail.*

If you have this problem you can't really solve it in the camera, but brain power will. Put some fill light in the shadows—or move the subject—or shoot from a different angle—or wait until the sun is at a different place in the sky—or whatever your clever scheming intellect tells you is shrewd to do.

THE DUMB EXPOSURE METER

If you are still hanging onto the shadowy notion that an exposure meter locates the center of the scene brightness range, let's throw some fill light at it. Exposure meters don't see an image of the scene. They are myopic as well as stupid. They see a blur consisting of light from all parts of the scene all mixed and blended together.

What is that? It has to be the *average* light from the entire scene. All the different brightnesses put in a pot and stirred up gives the average brightness of that scene. When an exposure meter does that, and some do, it's called an *averaging* meter. If you want to impress somebody you can say it's an *integrating* meter.

There are SLR metering systems which are two-percent smarter than a simple averaging meter and I'll tell you about them pretty soon. For now let's apply the averaging meter to several photographic problems.

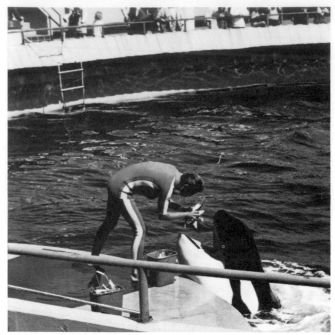

Sunlight from the right at a fairly steep angle dominates this outdoor scene at Marineland of the Pacific. This is a typical outdoor lighting situation most photographers face often. Shadow detail is lost because bright sun means high contrast. Exposure with a 100mm lens was 1/500 at ƒ-16 on Tri-X rated at ASA 400.

AVERAGING METER VERSUS AVERAGE SCENE

Welcome to the land of good conditions. An average scene is people outdoors with some dirt and some greenery. And things like that. It has a middle brightness which winds up as a middle tone in the picture. Because the scene is average, the brightest part is just the right distance from the middle tone and it fits on the film without blocking. You know the dark parts do the same thing. No blocking at either end.

An average scene is fun city for an ordinary exposure meter. It can handle the brightnesses every time, laying the image onto the film with surgical precision. You'll say, "Hot dog!" and your friends will all say, "Gee whiz!"

But an averaging meter doesn't work well on non-average scenes. It doesn't know that. Also, because it can't see very well, it doesn't know an average scene from a non-average scene. YOU HAVE TO KNOW THE DIFFERENCE!

THE DOMINANCE OF HIGHLIGHT OR SHADOW

Going back to the scene we used as an example, suppose there's a fairly light background behind the person in the white shirt, or a lot of light-colored objects in the scene. In this case the camera meter senses a dominance of bright tones, causing it to indicate a smaller f-stop or higher shutter speed than it would for the average average discussed previously. This will produce slight underexposure that gives you detail in the white shirt, but darkens all the other tones slightly more than you saw them naturally.

In reverse, if the situation includes a dark background or objects that cause the meter to indicate a larger f-stop or slower shutter speed, you will get slight overexposure. There may be detail in the darker tones but the white shirt is washed out.

In both cases the scene was not average but the meter acted like it was. Where there is a light background such as sky or beach the meter thinks the average brightness is too high and wants to stop down the camera.

Suppose you are photographing a model against a brick wall and have found an exposure setting that gives perfect skin tone. Now put a white backdrop behind the model. Now put a black backdrop behind the model. The exposure for the model—to get those good skin tones—should be the same in every case no matter what the background.

An averaging meter is influenced both by the model and the background so it will give you one good exposure setting with the brick wall and then two different ones, both bad.

Here's where your brain takes over to analyze the scene and decide if it is predominantly bright or dark. If highlights dominate, you can override the exposure setting indicated by the camera meter by opening the aperture half an f-stop or a full f-stop thereby getting a better balanced exposure. If dark tones and shadows dominate, do the reverse: Close the aperture half an f-stop or a full f-stop to decrease exposure because the meter was overly influenced and overcompensated for shadow areas. What the meter indicates would become overexposure.

Bruce Geist of Phoenix, AZ won a Kodak/Scholastic award for this backlighted portrait. He opened the lens an f-stop more than the meter indicated. Although the highlighted hair "burned up" and lost detail, the face and main portions of the picture are fine.

In other words, you can't expect the meter to "know it all," nor can you expect film to stretch its tonal range to meet every imaginable range of brightness. You *can* expect more ideal exposures when you are sensitive to the influence of contrast and the direction of light.

BACKLIGHTING

One of the most common high-contrast situations you'll meet is backlighting. Rather than a white shirt or bright objects to influence exposure, you are photographing into the light itself. The camera meter is tricked into indicating a smaller aperture or higher shutter speed to expose for the bright light it senses, but the total slide or print will be underexposed—unless you prefer the bright sun or the edge-lighting of a face to be dominant. If this is the case, "underexposure" is ideal exposure for the effect you're after. Otherwise you apply the talent of eye and mind to override the meter and give the picture about two f-

stops additional exposure.

As an example, your subject is standing with the sun behind her and the camera meter says to shoot 1/125 at f-11. You can open the aperture about two stops to f-5.6 and get a better exposure of the model's face. The brightest tones of a back-lighted situation will be blocked or washed out when you give additional exposure, but assuming the fleshtones or something in shadow is more important, your compensating technique will be successful.

If your SLR has an automatic-exposure system, you can switch it off, use the meter reading as a guide, and make an exposure setting manually. Should you prefer to use the automation you can reduce the ASA film speed setting and that will trick it into giving more exposure.

Doubling or halving the film-speed setting is equivalent to changing aperture by one stop. To give two stops more exposure without actually changing aperture, you divide film speed by two, and then do it again, which you've probably figured out is the same as dividing by 4 in the first place. If the rated speed is 80, setting to 40 is equivalent to opening up one stop, and setting to 20 gets another stop.

Some backlit situations may require only 1½ stops more exposure or you may develop some other magic formula. Figure the film-speed setting you would like to use and then set to the nearest one available.

Some automatic cameras let you be more honest about film-speed settings by providing a control you can use for more or less exposure with the automation still turned on. You can let the camera meter figure exposure based on its assumption that the scene is average. Then you feed in your own analysis of the situation and say, "Give it a stop less." The control will be marked something like: ½X, 1X, 2X, and 4X, where 4X means four times as much exposure or two f-stops.

You saw a control like this back on page 7 and I hinted that it had something to do with camera automation. Look again at the picture and you will see that this exposure override control is really just a second set of markings on the film-speed control.

METERING ON WHAT YOU SHOOT

It should be apparent that if you don't let the exposure meter see light or dark backgrounds it will give better suggestions about exposure settings. If you are going to make a portrait against sky background, walk right up to the model until what the camera sees is mainly the face. Make the exposure setting, back up to where you intended to stand all along, and shoot.

Unless you stop it from dithering around, an automatic camera will set itself for the face-only reading but then change to take in sky again as soon as you let it look at sky again. As I mentioned earlier, some auto cameras hold a meter reading and exposure setting when you depress the shutter button halfway. You do that while you are walking back to where you want to stand.

Remember that a dumb exposure meter expects to see the average brightness of an average scene and will figure camera settings accordingly. Caucasian skin is about one stop brighter than that mythical average average. So to be precise about it, when you meter on light skin open up one stop more.

SUBSTITUTE METERING

Does anybody know what average average brightness is? Kodak knows! In several Kodak publications which you can buy at friendly places there is an 18-percent gray card. This is what a myopic exposure meter *thinks* is out there. The average middle-tone of gray in the average scene is the shade of that 18-percent gray card.

If you buy a gray card and put it in the scene to meter on, then it won't matter if the scene is average or not. The exposure setting will put the face tones and all the other brightnesses of the scene right where they would be if the scene were average. That's handy!

If you can't get over to the scene for some reason, or if your camera is on a big heavy tripod and you're tired, you can do substitute metering from where you are. Put the gray card in the same light as the scene is receiving and meter on it.

If curiosity overwhelms and you look on the back side of the gray card, you see a 90 percent white card. Those percentages are the amount of light reflected by the card. When it's dark outside you can substitute-meter on the white card remembering that it is reflecting five times as much light.

Because the couple was just emerging from under the arch over this Swiss street, I knew they would be in silhouette if I exposed normally for the main background scene. Aware photographers are ready to shoot quickly by setting camera controls ahead of time, so they need to make fewer adjustments when faced with a photo opportunity.

5 x 18 = 90. To compensate, divide film speed by 5, or open up about 2 stops or double exposure time.

I urge you to buy a gray card and then go out to play with it. Compare gray and white card readings to what you see around you. White shirts give about 90-percent readings, dirt, grass and asphalt pavement are about as bright as the gray side. Your palm reflects about one stop more light than an 18-percent gray surface. Maybe.

When you get familiar with reflectances of common objects you can do substitute metering even when you have lost your gray card.

SMART EXPOSURE METERS

Two percent smarter. Some exposure meters look at everything but ignore the edges of the scene. They assume you put the subject of interest smack in the middle of your viewfinder and they meter *mostly* on that. If you don't like to take pictures that way, you can meter that way to get the settings and then take the picture any way you choose. This type of smart meter is called *center-weighted* because it assigns more "weight" to center brightnesses when figuring exposure settings.

Some exposure meters look mainly at the bottom of the viewfinder image. They assume the top half of your picture is going to be bright sky so they don't let the top of the image affect the meter reading as much.

Some exposure meters do different things according to what lens you have on the camera. With a wide-angle lens the meter is bottom-weighted because if figures you're getting a lot of sky. With a normal or long lens, it's center-weighted.

Some exposure meters say, "Heck with it," and meter only on a small spot near the center of the finder. The metering area is shown by a circle or rectangle visible in the finder. It averages within the spot, but the area is small so you can meter on light and dark areas or on a face if you choose. If you meter on the light and dark areas, set the controls about halfway in between. If you meter on skin, you already know what to do.

Some cameras offer two kinds of metering, small-spot and averaging, with a switch so you can choose which.

Because you have to supervise the meter and override it when the scene is not average, it's important for you to know what kind of meter and metering pattern your camera has. For example, if it's bottom-weighted you don't have to worry much about sky because the meter is not paying much attention to sky anyway.

I'm surprised that some camera instruction books don't say much about the metering pattern. If you are curious about what your meter does, stand inside a room and look out the window through your SLR. Move the camera so the window occupies top, bottom, center and sides of the viewfinder and watch the exposure display. You'll get a pretty good idea of the viewing pattern of the light-reading cells.

EXPOSURE IS MORE THAN EXPOSURE

If the only consideration was just getting the right exposure on the film we could stop here. However the two basic exposure controls, shutter and aperture, also affect other things as you know. Shutter speed determines how well you can stop a moving subject or how much you can jiggle around when taking a shot, or both. Aperture affects depth of field. So you usually don't just pick a pair of settings which together will result in correct exposure. Instead you normally choose shutter speed *or* aperture appropriate to the subject matter, then adjust the other control for proper exposure.

Camera Movement—Even though most SLR's are equipped with shutter speeds "fast enough to stop a moving train," as the old saying goes, blurred slides and prints caused by camera movement continue to plague many photographers. Why? Primarily, because people don't hold the camera steady enough or because they choose too slow a shutter speed.

In the illustrations you see methods of holding an SLR horizontally and vertically. You'll find your own minute variations of these positions, and a shooting technique that feels comfortable and is speedy and efficient. When you first get an SLR, practice shooting with it before it's loaded with film. In a dry run, as you get the feel of the camera controls, learn to grip your camera firmly, but not tightly. Too firm a grip creates muscular tension, and anxiety also plays a part in basic camera jiggle. Relax and enjoy your SLR. Think of it as a hand-held tool that becomes part of your anatomy, just as the finder becomes an extension of your

This and the next two pictures show the three main ways of holding an SLR while shooting. Right-hand index finger depresses the shutter release, while lens is focused with the left hand which can be moved to grasp the other edge of the camera after focusing. Some photographers cup the lens in left hand all the time while shooting.

In this vertical position the right hand and index finger hold the camera and depress the shutter release as they did in the horizontal position. The left hand cradles the camera and focuses the lens.

An alternate vertical position holds the SLR in the right hand at the bottom, using the thumb to depress the shutter button and the left hand to focus. This may be more comfortable than the other vertical position with the right arm lowered, but you must get used to shooting with your thumb.

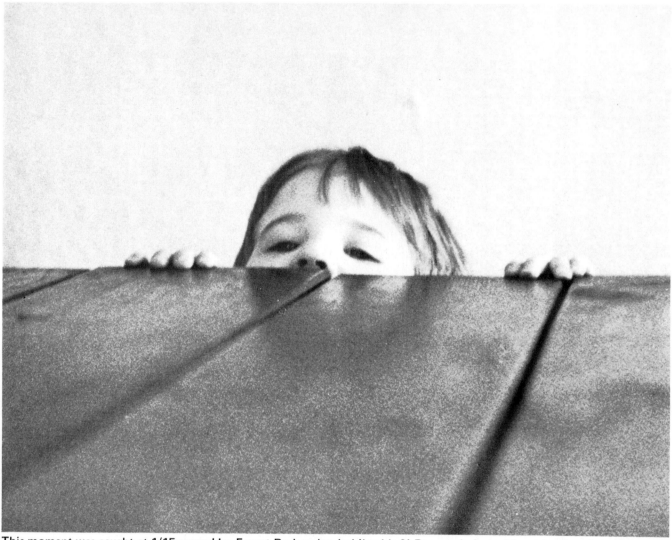

This moment was caught at 1/15 second by Ernest Reshovsky, holding his SLR securely but without tension that might shake the camera. His son Mark was only about two as he peered across the table top. Ernie caught that fleeting moment with a normal 50mm lens at *f*-2.

eye and brain. In a little while, you'll be handling the camera almost unconsciously, as naturally as you breathe.

By tucking your left elbow into your rib cage, you give the SLR a firmer stance as you shoot. Learn to hold your breath automatically and briefly as you shoot to assure steadiness. In addition, *squeeze* the shutter release button, don't snap it. If you have ever fired a rifle, remember the instructions were the same: Hold your breath and squeeze the trigger. You'll be surprised how much a part of you this action becomes with a little practice.

Get rid of the "never-ready" case often sold with an SLR, and you'll carry less weight while holding the camera more comfortably. While advancing the film, move the camera slightly away from your eye if necessary and immediately back to position. Try holding the camera upside down when using slow shutter speeds. With the back of the body flat against your forehead, less jiggle may result. However, if depressing the shutter release seems awkward in this position, forget it.

Average Shutter Speeds—Even if you generally use a slow film such as K25, make a habit of setting the shutter-speed dial at 1/125 in daylight situations. This might be called an average speed for average subjects, and it's fast enough to neutralize minimal camera shake that exists because you're an animate creature.

Fast Shutter Speeds—When in doubt about how fast a subject may move, choose 1/250 or faster

Shutter speed played an important role in this picture. I was sitting in a whirling teacup with the young man at Disneyland, and wanted the background blurred to symbolize movement. I used a neutral density filter to slow down Plus-X Pan film, shot at **1/60** and *f*-**11**.

as insurance against blur. A subject coming toward the camera or moving away from it moves less in the film frame in a fraction of a second than one moving across the viewfinder field. Therefore 1/125 may be sufficient for a youngster riding his bike toward you or at an angle, but 1/250 or 1/500 may be necessary to stop motion going across your viewpoint. More about this in Chapter 8.

It seems obvious that sports activity, moving cars, children playing, and other mobile subjects have to be exposed at 1/250 or faster whenever possible to assure sharpness. I've found that 1/1000 is valuable for fast-moving subjects such as racing cars. Try 1/500 for many action situations. A teeny bit of blur sometimes adds believability to your pictures.

Slow Shutter Speeds—It has often been said that 1/30 second is the slowest you should hand-hold an SLR. This is a good rule for most people. Compared to even slower speeds, 1/30 seems fairly fast but it allows plenty of leeway for camera shake and subject movement. Inevitably, you will use 1/30 and with experience discover it provides reasonable sharpness almost consistently. However if you are not a person of steady nerves, 1/60 may be the slowest you can expose without a tripod or other firm mount.

It has also been demonstrated that successful pictures can be made at 1/15, 1/8, and 1/4 in the right circumstances. The latter include subjects that are still, a firm place to lean your back or elbows, and a practiced technique in which you have confidence. I have taken innumerable pic-

A portrait can be made in a home "studio" using indirect light from windows on two sides of a room. In this shot the model, lovely Sandra Holle, was lying on a carpeted floor. With a 50mm lens and Plus-X film, exposure was 1/125 at f-8. The negative was slightly diffused during enlargement to soften and flatter the subject.

Backlighting is tricky because you must make mental computations based on the SLR meter reading. I opened the aperture about 1½ stops for this scene, switching the automatic-exposure system to manual so I could shoot at *f*-11 and 1/125 on Tri-X.

tures at dusk and at night, or indoors in poor light, at speeds slower than 1/30 and many of them were quite satisfactory. I have also had camera shake and subject blur under such circumstances. So my advice is: Experiment with slow shutter speeds whenever possible, but don't expect good results until you are handling the camera firmly and naturally. Expect some blur, and shoot plenty of alternative pictures to assure one or two reasonably sharp ones. Slow shutter speeds are the source of many exciting photographs not easily possible otherwise. Practice makes perfect.

Remember the trick of using the self-timer lever to operate the shutter at slow speeds when you have the time and opportunity. This technique helps stabilize the camera when you don't have a tripod handy because you don't wiggle your finger to punch the shutter button.

SHUTTER SPEED RELATED TO LENS OPENING

Keep in mind, though your SLR has a built-in meter and may even be automatic, the choice of shutter speed and aperture for correct exposure remains yours. There are always several possible combinations of *f*-stop and speed under most lighting and action situations. Think of them this way:

Shutter Speed Controls Subject Blur—A fast shutter speed freezes fast action and provides a sharper image. Settings are dictated by your need to stop action.

Lens Opening Controls Depth of Field— Smaller apertures extend the depth of field, larger openings reduce it. If you have a group of people six feet from the camera and there are six more feet from front row to back, you might need to shoot at

f-16 and 1/60 even though a faster shutter speed would be more comfortable. Settings are dictated by your need for overall sharpness from front to back of the scene.

In General—Knowing how slowly you can shoot without facing the curse of camera shake, knowing how much depth of field you must have to cover the important area of the scene sharply, knowing how fast you must shoot to stop action, all combine to influence how you set the exposure controls. *You* think about the variables, and adjust the camera accordingly to do its optical-mechanical thing. A brilliant composition can be disappointing unless you put a certain amount of theory to work through the computer behind your eyes. When your computer-brain is spinning out the answers, you are the master of exposure—and no excuses are necessary, thank you.

A Few More Observations—The direction of light often produces more or less contrast, depending on the darkness and length of shadows, or the lack of shadows under an overcast sky.

A lot of fine pictures are taken in average light with average contrast when SLR camera meters do a good job of indicating ideal exposure. You just let it happen.

In printing black-and-white negatives, and with custom handling of color negatives, over- and underexposed areas can often be given more or less printing time to improve the contrast. So, if your negative isn't perfect, save it in the lab. A good book on this subject is *Do It in the Dark* by Tom Burk.

To understand the effects of exposure, choose an average scene and one with a high contrast range. Make a series of exposures of each, starting with the one indicated by the camera meter and varying one f-stop and two f-stops more and less. Do this with color-slide film and *study* the results. Light tones will wash out quickly with overexposure, while dark tones will be first to lose detail with underexposure. Some situations may benefit by a little more or less exposure than the camera meter sensed, and things like that are the aware photographer's secret weapons.

Rejoice that SLR metering systems are so efficient they take the worry out of photography most of the time. As you learn to use your camera, your judgment will improve about what ideal exposure means to you. Even experts can disagree whether a slide is slightly dark or light, according to personal taste. Your own visual values are the ones that really matter when your perception of exposure has been polished.

If you find a series of bad exposures in a roll of film and you feel strongly that your technique was not at fault suspect the camera itself. Shutter speeds can be affected by worn parts and dirt in the works; meter components are subject to wear and tear if a camera isn't handled carefully; batteries lose their zip and exposure readings can be affected even though the meter *seems* to be operating properly; and the automatic diaphragm mechanism within a lens can fail because of a worn part. See a camera doctor immediately.

Exposure is really easy these days with a modern SLR. Making well-exposed pictures that *move people*—that's a lot more difficult!

What makes a good picture? MOOD

You can include picture elements to generate or reinforce a mood. Josh Young included the sagging fence, leaning fence post, and bare tree limbs stark against gray sky—all to build the feeling of this abandoned dwelling. Somebody lived here once. Now they have gone away.

What makes a good picture? INVOLVEMENT

It is not always possible to be closely involved with people you photograph. But if you can show them involved with each other and you have an empathetic feeling for them, the result can be striking. Photographer Ben Garza found this nursery school teacher who happened to be the mother of the child. The spontaneous expressions he recorded with his Minolta and 58mm lens are beautiful. An air of casualness mixed with the impression that you know what you are doing will usually disarm people. They will show their own involvement while you record it for others to enjoy as Ben Garza did so ably.

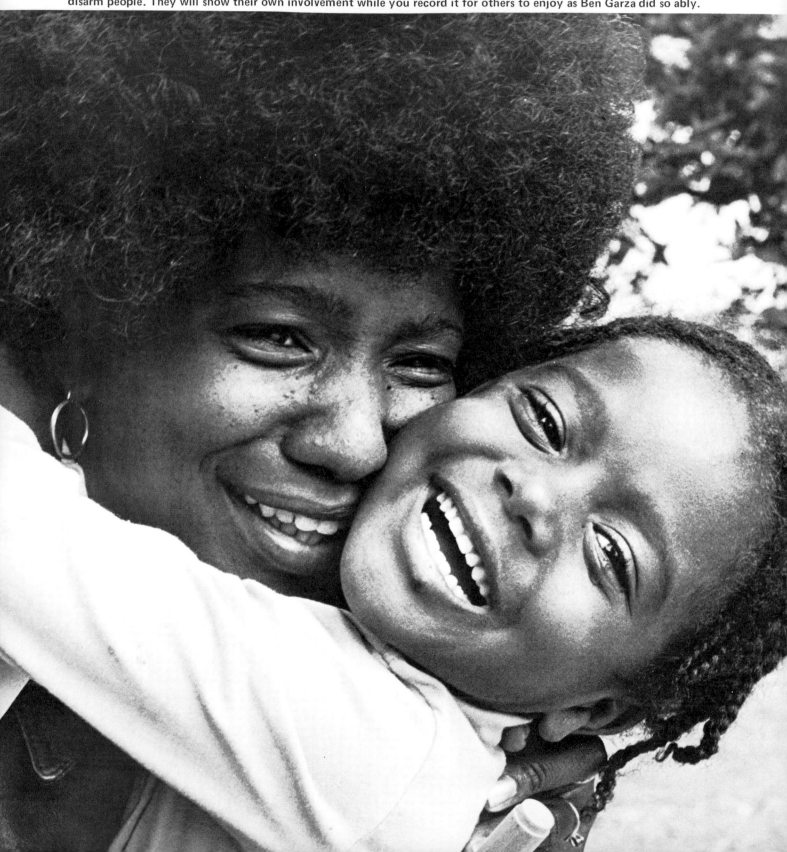

Composition is the structure of elements in a photograph. If you keep it simple, the visual message is read much faster. Here is a skiier headed downhill against a background that sets off her stance. The viewer's eye moves from her feet to her head in one direction, and along the horizon line and her skies and pole in the other direction. For a while you should always think about composition as you operate your SLR. Then it just seems to fall into place.

Every exposure you make has *some kind* of composition. It takes awareness to create excitement, elicit emotion, tell an effective story, or otherwise compose to use the positive power of photography.

Composition, according to the dictionary, is a combination of parts or elements to form a whole. Look through the viewfinder at a "whole," and it's made up of faces, figures, land forms, foliage, furniture, and things into infinity. You are eager to get pictures which express what you feel. You make adjustments for exposure, maybe

move forward or backward, to one side or another, and you shoot—before you miss the opportunity.

Later you look at slides or prints and something's wrong. People and things are not in the right relation to each other. The picture is divided in the middle rather monotonously, or there's a lot of unnecessary stuff around one or more of the edges, or there is something annoying such as a pole sticking out of a person's head. Any number of frustrating things can happen to mess up composition. Facial expressions may be awkward, something moves just as you're shooting, or the

point of the picture just isn't very clear or dynamic.

All those hangups of composition are avoidable. Look at it this way: Children with simple cameras make random images that are satisfying merely if they are sharp, or clear, and somebody is recognizable. Grownups with SLR's may also make snapshots, even sharper but no more meaningful. When you know the difference between a snapshot and a photograph with impact and content, you are a lot more likely to compose and create interesting, exciting pictures.

IMPACT AND CONTENT

Before dissecting composition into its important elements—sorry if this sounds like a chemistry lecture—let's talk about the nature of photographic images that *move people* or turn them on, making viewers react with praise and, "How did you do it?"

There are two key values within every composition you ever admired. The first is *impact*. That involves things such as emotion, color, expression, fine timing, contrasts, surprise, unusual angles or subjects, plus deft placement to capture and entertain the eye. We will look at some of these qualities in more detail.

The second value is *content*, or what the picture is all about. We take pictures to tell a story, show what happened to somebody, record people, places and things—and to create beautiful or striking images. The importance of what's in your pictures varies tremendously from a snap of Aunt Molly on her front steps to the sparkling moment when bride and groom first kiss. Sometimes unique subject matter makes a photograph outstanding, but it can be a dud even then unless you compose effectively.

Impact and content are interconnected. Think of some pictures that stick in your memory. Each of these memorable images had something unusual about it: Terrific action, brilliant or subtle color, emotional stress or enjoyment, strong patterns, nostalgia or perhaps elegant lighting. In addition, each photo was very likely a dynamic yet simple composition that could be absorbed quickly.

Impact also results from seeing an ordinary subject in a novel way. Few of us have the chance to photograph celebrities, great political events, exotic places or historic moments. Instead we must rely on imaginative seeing through offbeat camera angles, trying new lenses, waiting for

Content combined with contrast between the girl and the Lachaise sculpture are integral to the composition here. Museum lighting plus one floodlight at the right were used with my SLR on a tripod. Humorous connotations are usually welcome in pictures because they are rare.

impressive light, experimenting with films and shutter speeds, and not being satisfied with "just getting it on film." That which is unconventional to you may be old stuff to a professional, but your personality can help create something fresh and different by sticking with the subject until you are certain your imaginative vision has been satisfied.

THE ELEMENTS OF COMPOSITION

I don't like and won't use the work "rules" here because it implies rigidity. Actually, composition is based on basic principles of design. If you have studied art or design you have a headstart.

There's no doubt the dominant element of this composition is the figure of my wife standing in the stairway of an obscure historical monument that had intriguing picture possibilities. A 35mm wide-angle lens set at *f*-11 gave great depth of field.

Good seeing, or effective composition, is the same for a painting, drawing, or photograph. The artist *puts* his subject matter where it will have the most impact, while the photographer either *finds* it there or may rearrange something, move people, or move himself to achieve visual excitement. In either case, sensitivity to certain elements can make or break your picture.

The Dominant—In design, the largest, brightest, most colorful or best-placed object, form or person is the *dominant element* of a composition. In photography the dominant is often called "the center of interest"—where the viewer looks first.

The eyes are usually dominant in a portrait. In a landscape it could be a strong pattern of land forms or a prominent red barn. A player leaping to sink the ball into the net is dominant on a basketball court, and in a crowd of faces maybe one or two stand out. Expression, action, emotion, contrasting shapes and colors—any of these may be the center of interest because of their position, size or human interest. A strong line might dominate your slide or print, such as a tall tower, or the thrusting arm of a tennis player. The practiced photographer often places the dominant instinctively. If you are new at photography, look for the dominant *consciously* at first, and soon the effort will become automatic.

Subordinates—The other shapes, colors, lines, or textures in a composition are subordinate to the dominant one, but important because they support and complete the visual arrangement. Some subordinates may be almost equal in standout appeal, working closely with the dominant to achieve impact and content. For instance, the runner carrying the ball in a football action shot is dominant, but all the other players blocking for him or trying to tackle him are vital to the composition. Obviously, there are many variations of dominant and subordinates; personal taste and interpretation make some pictures more interesting than others.

Lines and Forms—Mentioned before as elements of a composition, it might be said that all photographs are made up of lines and forms. Look around your backyard or wherever you can see. Pretend you are taking pictures and practice composition in your mind's eye. Where should that tree be in relation to the swing, the patch of flowers or a nearby fence? From an apartment window, how do you see adjacent buildings, greenery, streets or people passing? If you were shooting a couple walking along the sidewalk, at what point should you make the exposure to relate them to the surroundings, and make them pleasantly dominant in the composition?

Color and Texture—Try the same exercise with more ingredients. Can you angle your camera to make a visually useful pattern of grass, hedges, brick walls, or the receding fronts of nearby homes? Does the blue sky, the red barn, the field of flowers or the color of the living room wall harmonize with and support your composition? If not,

A composition of textures in which the tree trunk is the dominant line and the roughly V-shaped path of bright leaves carries the eye to the bottom right corner, was shot by my wife Barbara Mills Jacobs. She has long been fascinated with backlighted trees, and often looks for design compositions in them.

Typical fish-eye distortion is shown in this view of downtown Los Angeles on a Sunday morning. You will see the world differently with an extreme wide-angle lens, and you may catch the eyes of photo contest judges with an unusual composition. Taken with a Konica T-3 and 15mm Hexanon fish-eye lens.

any of these may stand out too prominently. Distractions make your picture cluttered or vague in its viewpoint. We see color and texture and take them for granted, so it takes a special effort to single out each and analyze its importance to a photograph.

Space and Perspective—There is a tendency to mix these two elements of composition, though they *are* related. Perspective is the feeling of separation between lines and shapes from foreground to background of a picture. The camera translates this spatial quality to the flat surface of a print or slide. If you handle perspective dramatically, a composition can be dynamic. Think of the shots you have seen of railroad rails receding to a distant point; of a cue stick huge in the foreground, running back to a smaller pool player; or of rows of buildings or cars getting smaller and smaller into the background.

Perspective is strongly influenced by your choice of lens. A wide-angle lens increases the effect by making close things large and more distant things relatively small. A telephoto lens accomplishes the opposite by compressing a scene, making near and far seem closer in size.

The composition must still be arranged with skill to be interesting but knowing how to manipulate perspective can be a big plus in getting better images.

There's another method of implying space in addition to depicting perspective. It involves handling areas of color, or placement of lines—usually vertical—in your composition. Painters sometimes use a certain color in the foreground of a picture and repeat it again in the background. The eye moves from front color to background repetition of the color, achieving what artists call *plasticity*. A similar illusion happens when the eye moves from a vertical line in the foreground to another in the upper background area. Artists call this using *tension points*. Take a look at the work of a few modern painters, and see how they imply space without literal use of perspective. Paul Cezanne pioneered the placement of colors to give his landscape paintings an impression of space, yet many of them are done with flat patches of color deftly composed without being photographically literal.

Some of these concepts may sound rather sophisticated to you at first. Eventually, you will

Backgrounds are the bane of the photographer's existence when they are distracting or competitive with important foreground subject matter. These Cub Scouts were learning about outdoor cooking from an old miner whose pack mules were parked in the background. White tarp and horse pop out too prominently, but there was little I could do. I was using a wide-angle lens which gave me depth of field I didn't want, but I needed it for the main subjects. I'm including this illustration as one of the "horrible examples" in the book to help make you more aware of background plague. It is curable.

be able to recognize and use infinite variations of composition to shoot distinguished pictures with your SLR. Anyone can point a camera and make a record of something or somebody, and occasionally there's no choice. But the photographer who is sensitive to all the visual dimensions that a good artist uses, is well ahead of the competition.

PICTORIAL COMPONENTS OF COMPOSITION

The elements of composition define the *structure* of a picture. The pictorial components are the *subject matter* you have to work with, as you view through the finder and make continuous decisions about when to shoot and when to wait.

Backgrounds—Objectionable backgrounds are as much a hazard to good composition as careless placement of people and objects. A background should be simple, plain or out of focus, or it should play a meaningful role in the content of the photograph. It's easy to concentrate on people and activity that dominate your image, and forget to watch the background.

Especially when I'm shooting outdoor portraits, I find myself shifting the camera to avoid the "garbage" that so often pops out behind heads or figures, fouling up what would have been a good shot.

I often ask people to move slightly to improve the background. If rearrangement is not feasible, I use as large an f-stop as possible to throw the background out of focus. Switching to a longer focal length lens helps accomplish the same thing, because short focal length lenses offer a lot more depth of field at a given aperture than longer focal length lenses. Outdoors in sunlight using slow or medium-speed films also aids background control, because you can shoot at relatively larger apertures in the first place.

When the background is part of the story you're telling, it should be sharp and arranged harmoniously to support the dominant elements of your photograph. If you're shooting a sailboat on a lake, and the hills behind it *describe* the setting or offer contrast in size, shape and color, you will relate the boat to the background as carefully as possible. The same can be said for portraits of people in their own surroundings. A woman at work in her kitchen or a scientist in his lab are more interesting when what they're doing and the setting behind them can be seen clearly.

Contrasts—Compose to dramatize differences in size, shape, color and tonality. Small child in large chair, twisting road in the middle of a flat plain, bright orange against pale green, or dark form in front of light background—these illustrate what I mean. In a landscape picture, a figure or even a distant horse or dog, not only contrast with open space, but also give a feeling of life on a natural stage so the viewer can identify with the picture more easily.

Mood—Technically, mood isn't something you can manipulate as you can a figure or a viewpoint, but mood often influences composition. Shoot the scene from your living room window in broad daylight when there's nobody in the street, and it's a simple record. Take exactly the same picture without moving the camera or changing lenses when it's foggy or raining, when the sun is low or a storm has just passed, when kids are splashing in puddles or a lonely figure walks along with an umbrella. Mood helps create composition to make people admire your pictures. You must compose such a subject simply so nothing distracts from its special impact.

Framing—When you shoot from under a porch roof or from behind foliage or whatever borders the foreground, you are framing the main picture

This is an editorial portrait. The lady is an astronomer, and she's posing by a small telescope at CalTech. I've included it because the background and machinery are important in telling the story of her work, and had to be arranged accordingly. Her head is not very large compared to other elements in the picture, but notice almost all major directional lines lead to her face. Taken with a 28mm lens nearly wide open.

area. Leaves and branches from a nearby tree help frame a landscape or seascape as they decorate the sky area. When you shoot across a person or object, it can either frame the composition or become a foreground element that adds interest to your image. Keep an eye out for framing techiques the next time you see a well-shot motion picture. The camera may show closeup objects that help set the scene—such as a breakfast-table setting—then move back and away to show actors in the middle distance framed by a door or window. Framing is a pictorial device to help dramatize a subject, even if it's sometimes overdone.

This pair of pictures was taken at the same time and place, one vertical format and one horizontal. Which composition do you like better? The location was a show window with fancy home furnishings. The lens was my 50mm, and exposure was 1/250 at f-12.5. Have you decided? I prefer the vertical; its forms fill the space more pleasingly, and the air of mystery is better fulfilled. The horizontal seems split in the middle, and the right half of it is disconnected from the left. In the vertical the eye is entertained even if the mind is puzzled!

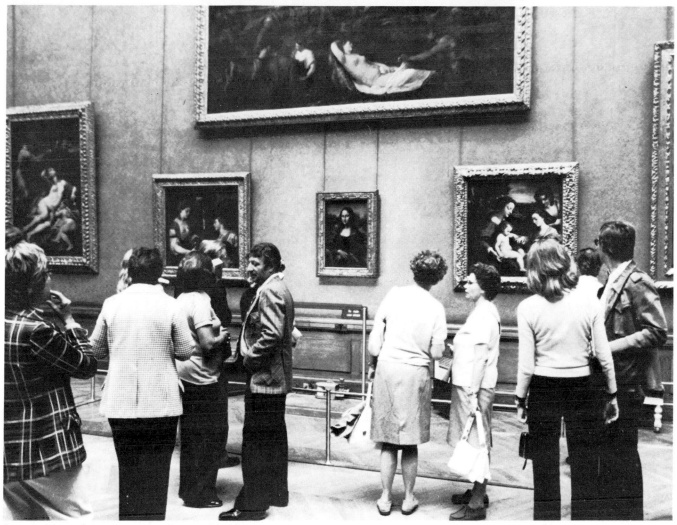

Composition of this picture is discussed in the text. Taken with a normal 52mm lens on Tri-X, ƒ-8, 1/60.

THROUGH THE VIEWER'S EYE

No matter why we take pictures, for fun or profit, for exhibition or souvenirs, we aim to make compositions to stimulate people. Toward this goal two more important items influence finished prints and slides.

How the Eye Flows—We've discussed dominant and subordinants, but where should they be in a composition for maximum impact? The answer is necessarily somewhat different for each situation, but a few more principles can be applied.

Eye flow is the path a viewer's vision follows when looking at a picture. It may start at any edge with a line or form leading into other components; it may begin with a center of interest and move outward, around, in a curved or straight path.

Years ago, traditional composition dictated an S-curve as something to seek. The eye flowed in the path of an "S" from top to bottom or vice

versa. The S-curve has been demoted in modern composition because it's too restricting, but of course it's still one of the ways the eye flows through a picture.

Let's analyze a photograph I made in the Louvre in Paris not long ago. This is merely a typical exercise to try with any of your own shots. If you are alert, your eye goes first to the famous *Mona Lisa* almost dead-centered in the rectangle. That's what everyone was discussing, so I gave the painting the most prominent place in the composition.

However, your eye may also enter the picture from the left along the row of figures, or through a similar row on the right, and then to the famous image which they tend to frame. The bottom edge of the large painting above the *Mona Lisa* tends to halt the eye and return it to the painting. The other pictures on the wall form a line that leads

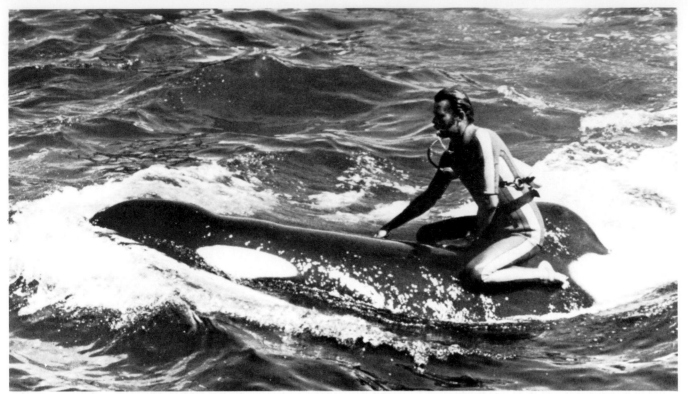

Pleasant balance is achieved by placing the man riding a killer whale below center. This also is psychologically appropriate, because the visual weight of man and beast belongs nearer the bottom than the top of the frame. Shot at Marineland of the Pacific.

to the center, as do the thin lines of pipe mounted in the floor. There is also an invisible triangle surrounding the dominant painting; it begins with the head of the woman at left edge, continues across the heads, and its angled edges run to the reclining nude figure in the large painting at the top. Even the open area from the floor at the bottom to the large frame above the *Mona Lisa* tends to influence the eye towards that masterpiece.

The flow of vision in some compositions is not so pronounced, but should be recognizable. Lay a piece of tracing paper over one of your prints, and with a soft pencil, pressing lightly, diagram the main dynamics or eye movements of the composition. If you're in doubt, take a guess. Then remove the paper and discover the flow patterns which may not have been very noticeable. You'll learn something about the design of a picture that will stay with you when you're shooting.

If eye movement comes to an abrupt halt at the center of interest, it helps accent that dominant subject. Sometimes there are interconnecting flow patterns in one picture, one of which may be more important than the others. This is normal, because pictorial elements are arranged in infinite ways that change as our viewpoint shifts.

The Importance of Balance—I was tempted to call this section "The avoidance of monotony," but stressing balance is a more positive approach.

The average person's sense of proportion or balance is usually offended by *equal* sizes, shapes or divisions. If you divide a landscape with the horizon line in the center of the print or slide, the result will probably be monotonous. If you shoot a portrait with the model's eyes dead center in the frame, the even balance is dull. Unless there is a valid reason to place the center of interest at the mid-point of a composition, you're better off with unequal divisions because they create a more interesting balance.

Lift horizon lines above the center, or lower them below it. Compose portraits with the eyes above and to the left or right of center. Try to avoid equal divisions in the design of your pictures because the average sense of esthetics finds that unexciting. If you can arrange a scene in your viewfinder to flow at an angle rather than straight, or to be off-balance in its proportions—with elements that *do* balance each other in color, tone, placement or pleasant opposition—you will achieve more successful compositions.

98

AN EXERCISE IN CROPPING

While you're shooting pictures, you are supposed to be sensitive to the essentials of composition, the dominant, the dynamics of visual flow, etc. However, for lots of reasons, not every exposure is a masterpiece. Somebody once wrote a "law" of life that if anything can go wrong, it will, and it surely applies to photography. Life doesn't always give us a second chance, but picture-taking does because there's such a thing as cropping.

Real masters of photography compose carefully. What they see in the finder, they get on the film, and that's that. I used to follow such a discipline several decades ago using a 4x5 view camera in the Edward Weston tradition, and believe me, it was excellent training. Because of that experience, today I alter fewer pictures by cropping them. Nevertheless, I know I can often improve a pictorial effect in the darkroom or by careful placement of tape along the edges of a 35mm slide, so I may be less precise. One good excuse is that I sometimes shoot a lot of pictures in a short period, and what they may lack in super-composition, they make up in spontaneity, expression, and story-telling qualities.

Here is an example of how a fairly ordinary photograph can be improved by cropping. The traditional way is by using what are called cropping L's, two L-shaped pieces of thin cardboard about 1½ inches wide and long enough in both directions to cover whatever size prints you work with. By moving each L around, you can mask one or more edges of your picture, and judge the new composition created. Then you can cut off the unnecessary edges, or make a new print of the revised format. Tiny L's or small pieces of paper from a scratch pad will help you crop a slide in the same manner. Please refer to the following numbered photos.

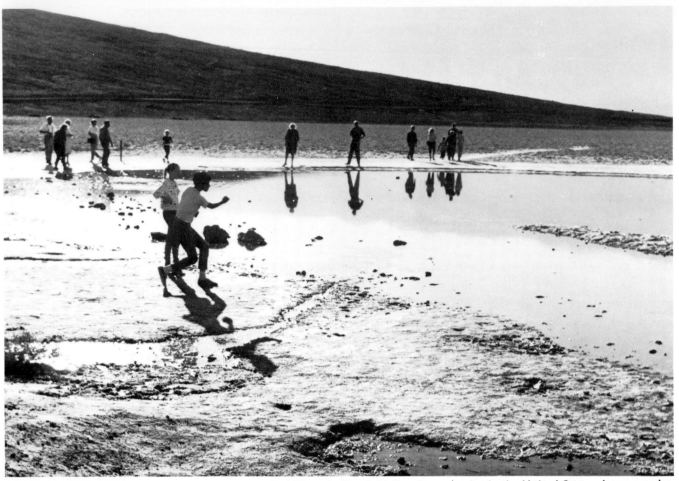

1. This is the full frame shot with a 50mm lens at Bad Water in Death Valley, lowest point in the United States. I was wandering around about 8:30 in the morning, and saw the kids in action. I shot instinctively, knowing that a longer lens would have given me less scene but better composition.

2. After shifting a pair of cropping L's around I came up with this enlargement of a portion of the scene. The kids and their shadows are more prominent, and the impression is stronger, but still nothing spectacular.

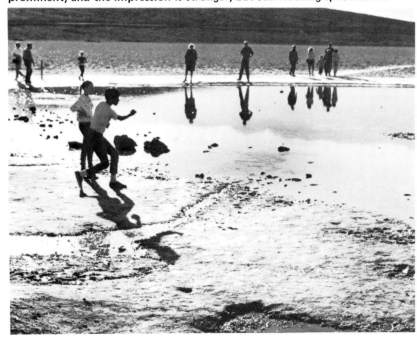

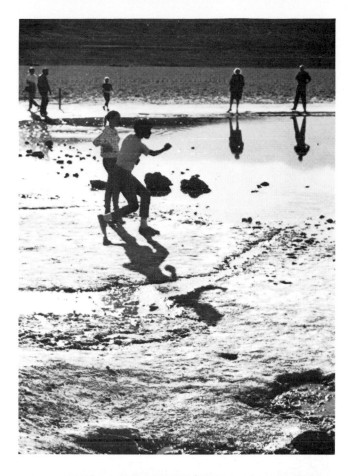

3. This is closer to a more exciting visual solution. Both the figures and the shadows are vertical, and a vertical cropping helps to accent this thrust. Some of the extraneous background figures are gone, and we are closer to the kids whose shapes and shadows dominate the composition.

4. An even closer cropping deleted more of the background and foreground, concentrating the viewer's eye more quickly and forcefully on the primary figures. This cropping suits me best, but the composition has flaws that cannot be erased. The dark horizontal area running through the girl's face and the boy's head is unfortunate. Were they seen against a lighter background, the increased contrast would have been beneficial. In addition, the small figure almost walking on the girl's head is distracting. I didn't notice it as I shot, and the picture suffers from my omission. However, the feeling I had when I saw the kid skipping stones across the water is better presented here than in any of the other version.

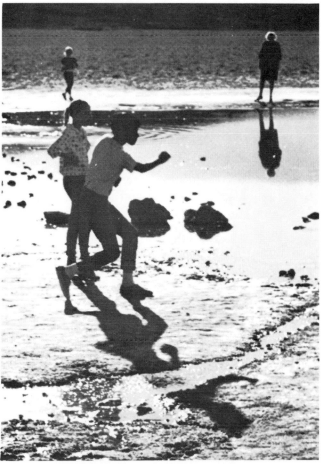

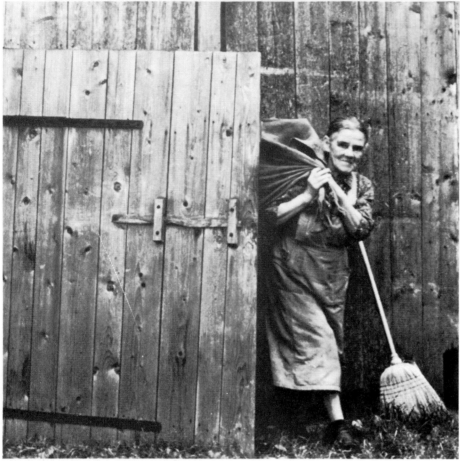

In composition, *simplicity* helps solve visual problems. William Heiden saw this "Swiss Miss" and snapped her in an indigenous setting which made this Kodak/Scholastic award winner several notches above the average snapshot.

LESS IS MORE

Analyze some of *your own* photographs this way. Be as ruthless as you can in removing extraneous matter, cutting through to the essentials for direct simplicity. Decide which elements of a picture *must* remain because they work together, and eliminate those which distract or dilute the main theme or message.

These are just words and what really counts is *vision*—precise, sensitive, instantaneous, imaginative seeing. You can make the transition. Look at famous photographs and paintings. Decide why they are composed successfully, or what may be objectionable to your taste. No image is perfect, though some are very hard to improve.

My favorite examples are photographs made by Edward Weston. He saw nature through an 8x10 camera and made contact prints of the complete negatives. No cropping. If a composition didn't suit him, he didn't enlarge parts of it, he just abandoned the whole picture. With that sort

of discrimination and highly-developed vision, Weston became a modern master whose work is worth studying.

As you become more aware of composition, and analyze a number of pictures that appeal to you, you will discover the key to everything combined is *simplicity*. The most direct and uncomplicated way you can view a situation through the SLR finder will usually become the strongest image with the most effective impact and content. There are obviously complicated photographs and paintings with many integrated forms and colors, but they only have lasting quality if they leave an almost instant impression. In a large photo contest I helped judge, many pictures were also-rans because they should have been cropped severely. The winners had strong, simple stories to tell or images to project. If you think simplicity along with dynamic or subtle eye flow and the other ingredients which comprise good composition, you'll come up with winners of your own.

What makes a good picture? DYNAMIC COMPOSITION

In this chapter I mention the photographs of Edward Weston. Once you are familiar with his compositions, there may be a tendency to feel his arrangements of lines, and forms is only applicable to careful studied camera work. This is not so, because all basic design principles influence your seeing with an SLR every time you depress the shutter button. Picasso learned classic techniques of painting before he evolved his own style, but the structure of his pictures is beautiful.

This portrait of a lady engineer emphasizes the form of her face as well as her work in a dynamic way. It was taken quickly as part of several rolls shot in about an hour. I only wish the shadow lines behind her head were slightly lower.

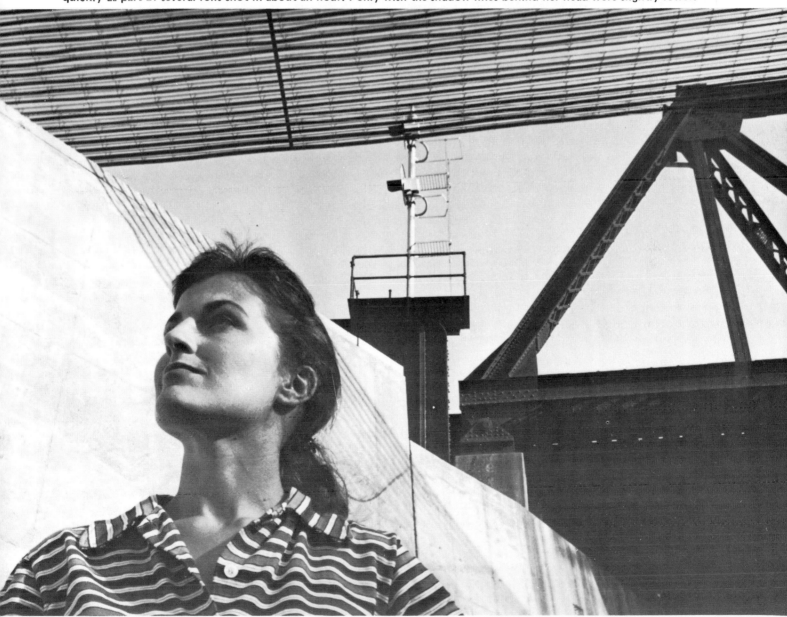

What makes a good picture? STATIC COMPOSITION

Dynamic composition implies scope or activity beyond the borders of the picture and tends to create excitement. Static composition such as this example by Josh Young is more self-contained and inward-directed, requiring nothing beyond its borders to support the photographer's statement. This photo may appeal to a different type of person than the expansive shot of the lady engineer used to illustrate dynamic composition.

There are as many variations of portrait lighting and posing possible in your own home as there are in the fanciest studio. This photograph was made with one light reflected into an umbrella and another light on the background. Taken with 65-135mm zoom and diffused in printing.

Rapport with friends is sometimes easier than with your own family, because the non-related take you more seriously as a photographer. Mother and daughter posed outdoors with the sun behind them and light reflected into their faces from a concrete deck. I disarmed them with chatter and flattery, used a 50mm lens and shot at 1/250.

Remember having your portrait made in a commercial studio? You sit quietly, follow directions, stare into banks of lights and a large camera, and usually feel self-conscious. A really good photographer helps relieve your anxiety by the way he or she talks to you and makes suggestions for posing. You should have the confident feeling that you're in good hands, and you'll come out on film looking handsome, beautiful, or at least pleasant. Professional photographers handle children deftly, too. They distract them, allowing them to act naturally within the confines of the lens.

Portrait pros not only know the technique of photography, but also are practiced in the psychology of human relations. If a subject freezes

up, they have to know how to create a thaw, or they're in the wrong business. The professional portraitist also develops a familiarity with the subtleties of lighting to make it comfortable and flattering at the same time.

I haven't been to a portrait studio for decades. Instead, I simulate my own studio conditions at home, either with floodlights, or outdoors in reflected daylight. I'm not photographed very often, but I've done dozens of portrait sittings in these ways most of you can duplicate, unless you live in a tarpaper shack on some lonely desert. Even then you can shoot outdoors. As for kids, I shoot them in their own surroundings where they are most comfortable, with and without their

parents. My own offspring I can get looking and acting like civilized human beings only temporarily.

All this happens with a certain simplicity, but a good SLR portrait is a far cry from the stand-there-and-look-at-me technique of the typical snapshot. The fact is, and you may already know it, a single-lens reflex camera and pictures of people go together at least as well as love and marriage. Some of this chapter is involved with technique, equipment, posing, and lenses. None is devoted to love and marriage.

You must begin an approach to people-pictures with intangible items such as rapport, warmth and enjoyment, all of which help to disarm the subject—who may be as nervous as a parachutist before the first jump.

RAPPORT WITH YOUR SUBJECT

In some ways, it's easier to photograph people who are unrelated or with whom you have no emotional involvement. They are more likely to accept you as a photographer, not as "my son, the shutterbug." Begin a conversation as you set up lights or prepare the camera. Ask a few friendly questions to get the subject talking about herself and the first skirmish is won. While you arrange reflectors or seek suitable backgrounds, you may appear concerned about those aspects, but your primary interest lies with the sitter. Explain what you're doing only briefly, just to bridge the time gap before picture-taking begins.

Once the shooting starts, project your geniune inclination to make the sitter look terrific. Exclaim occasionally, "That was a good one!" and mean it. Your subject's confidence will rise, while his or her self-consciousness will decrease. Suggest plenty of poses, which may only entail turning the head, twisting a shoulder or looking in a different direction. Shift the lights or reflectors for variations, but when you see a really flattering combination, let your subject know that your *combined* efforts have really paid off.

Shoot plenty of film. One roll of 36 exposure may yield five or six really good portraits, but film isn't so expensive that you can't shoot another roll or two. The odds increase in your favor with more pictures from which to choose, and if you hear, "What are you going to do with all those pictures?" the answer is, "Make you look so good you'll have a tough time picking the best ones."

Two from five-dozen outdoor portraits taken of a friend's friend in open shade with out-of-focus foliage in the background. Two rolls of 36-exposure film is hardly excessive in 30 or 40 minutes of thoughtful portraiture, because you get quality from quantity. Five rolls would be a hardship, but only five frames would be foolhardy.

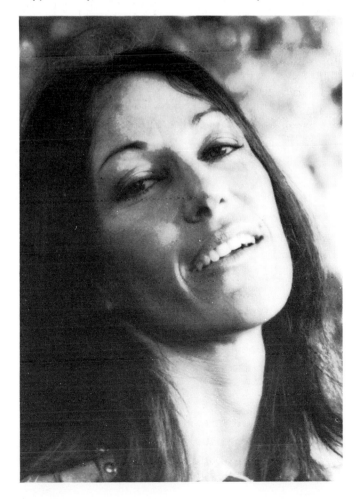

When it comes to your own kids and relatives, use whatever wiles you have to disarm them. At certain ages, children make faces, mug into the camera, twist and turn with impatience and otherwise make things very uncomfortable. Cajole them, offer food, toys, or whatever will appeal to them, according to the importance of the pictures. Getting the whole family together is even more difficult, because there are many faces to watch, and at least one person blinks, grimaces or turns away just as you snap. That's another reason to shoot abundantly. I've told people, *I get quality from quantity!*

Friend or family, the formula is the same; disarm and ingratiate psychologically. Even if you have doubts about your photographic ability, give the impression you know what you're doing. If you fumble, cover it with a line such as, "I'm making a little experiment here with" and use whatever topic that fits such as lighting, exposure, camera angle, etc.

Explain your moves to relatives, if you must, to make them sound important: "I'm using this reflector in the same way they do in big fashion studios," or "I've changed to a longer lens because it really makes faces look great." Keep talking and watch as expressions change. When people get involved with a conversation, they relax and look more natural.

SPONTANEITY

The difference between a stiff and awkward-looking posed picture and one that looks loose and easy-going, is the spontaneous response and expression of the sitter. With your psychological approach exuding confidence, people will relax—even your own wife or husband. Their faces and posture reflect relaxation. You can shoot a lot of pictures quickly with an SLR, once the exposure is set. Snap and snap again, even if you are not positive the additional pictures are better than the former ones. When you sense a stiffening of attitude or see an angle that's harsh, or lighting that distorts a face, stop and talk.

Rather than ask someone to smile—which is successful if their smile is pleasant and natural—ask them to part their lips. This leads to a kind of smile that will expand when your conversation becomes light or humorous. I often ask a person to "Smile broadly and break my camera," and I

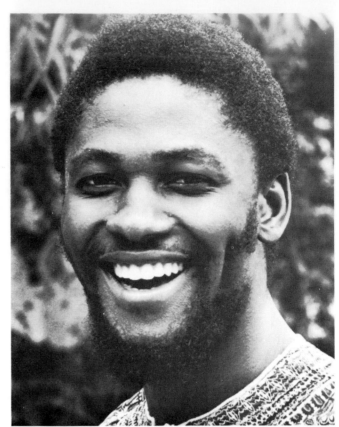

Asking someone to smile may loosen a face, or bring on self-consciousness. It's better to create a casual, happy atmosphere which is then reflected in people's faces. This young man was the subject of a picture story, and we had been talking for an hour. That he trusted me to photograph him seems evident. I used a 100mm lens because it is ideal for portraits.

purposely stay away from the camera finder so they realize I'm not going to shoot a mouthful of teeth. This action helps loosen the face, and as it returns to normal the expression is often worth shooting. Occasionally when someone has a good spontaneous smile or laugh, I simply say something that will bring it on and snap what I see. There are all kinds of looks in successful portraiture so be prepared to capture a variety of them.

Outdoors in subdued light, people are apt to be more relaxed and spontaneous than indoors with floods and reflectors. There's something pleasantly informal about a plain-wall-setting which the average person doesn't take as seriously as an indoor location. *You* know that with the proper conditions outdoors excellent portraits are possible, but lots of people think you'll merely get high-class snapshots. That's okay if they cooperate, because there's less anxiety when someone may think you're just messing around.

Planned spontaneity when people are doing their thing, but directed by your suggestions, is shown in two situations. The girl was asked to pet the horse—which she's doing with the hand you can't see—and her expression came naturally. Mother and daughter were asked to do something in the kitchen during which the child broke into laughter. They all knew I was photographing them, but were distracted enough not to seem posed.

Another aspect of spontaneity is the planned candid pose taken when people are prepared to be photographed, but are doing their thing at the same time. Candid in photographic terms means informal and unposed. The 35mm camera was once known as the candid camera. More of this in the next chapter, but here I suggest getting people or children into motion at something such as playing an instrument, singing, drawing, dancing, reading, or whatever. They know you're going to photograph them but their concentration should be elsewhere rather than on the camera. Examples might be the kids playing ball, your wife talking to a neighbor, a friend reading in the backyard or somebody at a picnic with a nice grass background. This approach is informal, lighting may not be ideal, but spontaneity is almost guaranteed if you simply shoot what's happening and let people forget you're around.

BABIES AND OTHER CHILDREN

What I've said about kids and adults is applicable to infants and young tots. Before a baby can walk, portraits are much easier. You find an uncluttered background, or spread a large medium-toned blanket on the floor or outdoor patio. Move around the child for a series or angles and positions. Lighting should be soft—indirect or reflected—so the child won't squint, and if you use a lens such as the 85mm, 105mm or 135mm, you can get full-frame head shots but stay far enough away not to seem like a looming figure. If you must shoot in sunlight, turn the baby's back to it, give additional exposure for the backlighting, and you'll have a more comfortable subject.

Everybody shoots baby pictures, some of which are comic, delightful and charming. However, with your SLR you have the ability to get close with a long focal length lens and avoid all the

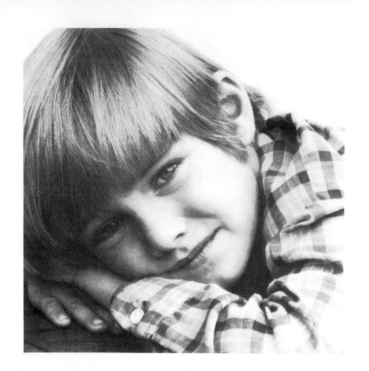

Whole books have been written about photographing babies and children because they are important and appealing at the same time. Every SLR photographer should get a few outstanding pictures of infants and kids if he moves close enough, shoots fast enough, is concerned about the background, stays alert for great expressions, and shoots plenty of film. Got the formula? Of these three shots taken at random from my files: The baby was playing by a window where either b&w or color would have been feasible. The little boy relaxed outdoors on a gray day and listened to me jabber about nothing in particular. The little girl was playing in the park and quite unaware of the camera. Have you noticed how kids tend to ignore your shooting if you are nonchalant about it?

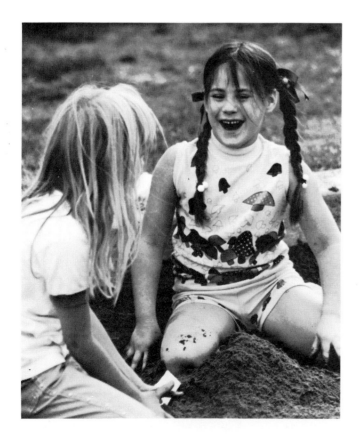

background junk that competes with the child's expression. Take advantage of this close-in point of view. Even if the light is medium-to-dim and you can't add more, shoot at f-2.8 or wider, and forget about depth-of-field limitations. Focus on the eyes and most of the face will be sharp. If the back of the head or the ears are soft-focus, it's no big deal. The background will also be out of focus and unobjectionable. Again, shoot plenty of pictures because babies are unpredictable and you have to be alert.

Discarding one in every five slides is the professional way to get quality from quantity. When I shoot for magazine clients, I put aside 15 pictures for each good one I submit. Don't be "cautious Charlie," who makes eight exposures of the baby on Sunday, 12 more 10 days later, and finally sends the 20-exposure roll out for processing a month afterwards. You don't get great pictures by saving film—only by shooting it carefully while synchronizing your eye and brain with your shutter finger.

Kids that walk and talk should be cajoled and disarmed in the manner described above. Don't lose your temper or your patience. Stalk a child at play but keep your distance with a normal or medium telephoto lens. Be unobtrusive and you'll be welcome. Ask children to pose only occasionally. Do it by saying, "Would you do that again, please?" and hope their expression and action is repeated if you missed it the first time. When a child is cranky, sweet-talk him to see if that will break the nasty spell. If nothing works, just tell your subject, "Now's not a very good time for pictures. I'll come back when you feel more like acting naturally." And quietly leave the scene. A lot of children will call you back and cooperate, because kids don't like to be rejected either. If you're not recalled, resign yourself to trying again sometime when the child's mood may be more docile. By being calm and not being manipulated, you remain master of the situation. If the kid manages to "get to you," expect disappointing pictures if you stay. Your main emphasis will be anger or resentment—not photographic truth and beauty.

LENSES FOR PORTRAITS

I've already recommended that you use longer-than-normal lenses for babies and children, to keep out of their way and seem less obtrusive while

To fill your negative with a head, a longer-than-normal lens is preferable because it "draws" a face in proper proportion. A wide-angle enlarges and distorts features if you get close enough for a full-frame image. Shot in daylight with a 105mm lens set about f-8 to throw the background out of focus.

you're shooting. Of course, if you're in a restricted spot and have a couple of children as subjects, a normal 50mm lens or even a 35mm lens, is handy and indicated. These shorter lenses are the answer to better depth of field with mobile subjects, and from a distance of six or seven feet, you can include whole figures or less without worrying about distortion. This perscription is for normal circumstances. If you have a 200mm or 300mm lens and can get a clear field to shoot friends, family or children from 20 feet away, this also can be rewarding. In other words, choose the lens to fit your needs, the temperament of your subjects, and the situation.

For more formal portraits, short-focal-length lenses are likely to distort features of a face from close-in camera positions. I'm sure you've seen the cartoon-like quality of "portraits" shot with a 21mm or 28mm from a foot or two away. A 50mm lens is kind of the break-even point. You can shoot

When you are about three feet away a 50mm or similar focal length lens is OK because distortion is limited or negligible. I asked my friend and fellow author Ed Radlauer, to hold the camera as close to his chest as possible so it would not seem enlarged in the foreground. We shot indoors by a window with light from another window to fill shadows on the right side. I chatted and he relaxed.

from about three feet and distortion will be minimal, especially if you pose the subject so his nose isn't pointed right into the lens. Black-and-white negatives can be enlarged in printing, and excess area around a face can be eliminated. Color prints can also be cropped, slides can be taped along the edges to compensate for not filling the full frame precisely.

It should be clear that one good solution to better portraits is the use of longer-than-normal lenses on your SLR. They "draw" a face in more pleasing proportions than shorter lenses. You know how a 105mm or 135mm lens seems to compact perspective, or flatten it. The same phenomenon allows you to fill the full frame of a 35mm nega-

tive or slide with a single head without distortion. Noses don't seem elongated and the rest of the face is recorded naturally. If you have not used a semi-telephoto or longer for portraits, borrow one and make some comparison shots. An extender for your normal lens will also do the trick. Even if you are shooting head and shoulders, the longer focal length lens is more flattering.

Focus on the eyes and check depth of field to be sure the nose is in focus, but if the ears begin to lose sharpness don't worry about it. Choose a smaller aperture if possible to keep ears in focus, or move the camera back a bit to increase depth of field. Keep in mind that expression and naturalness are primary, but check focus often because if someone shifts his head a few inches, sharpness can easily suffer.

If your equipment is limited, experiment with what you have. Get in closer than seems right with a 50mm lens or use a closeup attachment lens just to experience the results. Suggest a variety of poses and let the sitter move naturally within limits you prescribe. Go with the tide when it's favorable, and your pictures of people will please you as well as them.

HAND-HELD OR TRIPOD

Outdoors when people are mobile, there is likely to be plenty of light to shoot at 1/125 or faster with the camera hand-held. You can't follow a child around from a tripod very actively, so that question answers itself also.

Indoors or out, you will prefer to shoot or must shoot from a tripod under certain conditions such as: The light level requires you to expose at 1/60 or slower with a longer-than-normal lens that makes the camera less steady than usual. You're using a telephoto lens that swings and sways when hand-held and asks to be tripod-mounted. Your sitter stays in one place and your tripod-mounted camera is ready and aimed, even if your eye is not at the finder for each exposure. This is the situation a professional portrait photographer uses to advantage. If your face is not behind the camera constantly, you can talk more directly to your subject, and rapport will be improved. Sharpness of tripod-exposed pictures is almost always better than those taken with a hand-held camera. If you wish to enlarge portraits to 11x14, for instance, they will maintain definition better when

With camera on tripod, composer Bronislaw Kaper is as sharp in an 8x10 print from 35mm as from a larger negative. When camera and subject are stationary, you can give full attention to the person being photographed. Three floodlights were used here: at the left, right, and behind his head from above.

Without a tripod, using a 300mm lens, this photo of John F. Kennedy is not as sharp as possible, but in a crowd of photographers during the 1960 Democratic National Convention, a hand-held camera was a must. With a faster shutter speed, a shorter lens or both, sharpness would have been improved.

the camera is mounted. While you're shooting, you can conveniently move away from the camera to adjust lights or poses, and go back to a camera-on-tripod viewpoint that hasn't changed.

When a tripod seems too restricting, and you want to move the camera quickly or shift positions, you can hand-hold an SLR with even a one-pound short-range zoom lens on it and get sharp pictures at 1/250. I do a lot of portraits in my backyard around a large tree with an ivy-covered fence as background. In open shade with fast enough film, I always hand-hold my SLR. However, I have also used a tripod in this situation when using slow color film or when the light was from an overcast sky.

FLOODLIGHTING EQUIPMENT

In case you don't have lights yet, here are three ways to go and my recommendation. We have to cover a minor technicality first—the color-temperature rating of incandescent light bulbs.

When something glows because it is hot, such as the filament in a tungsten lamp, the color-quality of the light depends on how hot the filament is. For this application, temperature is measured on the absolute or Kelvin scale, indicated by the symbol $°K$. As you saw in the film and filter tables of Chapter 4, the type of film, the color of the light, and the color of the filter are all related. For example, when you use daylight film under indoor room light you use the specified filter over the lens to change the light so the color-balance of the film will not be spoiled.

When an object is heated just to the point of incandescence, such as the heating elements on an electric stove, the light emitted is predominantly red. If the temperature goes up, green and blue light wavelengths are added and when the object gets hot enough we say it makes white light. The sun is that hot and has a color temperature of about $6,000°K$.

The filaments of ordinary lamp bulbs won't last long at such elevated temperatures and usually run around $3,000°K$. Photoflood bulbs are rated at $3,400°K$ unless they are marked $3,200°K$. The higher temperature makes slightly more light but doesn't last as long. There is a difference in the color-quality of the two temperatures—visible on color film if you get the wrong combination.

The basic floodlight is a bowl-shaped reflector with a floodbulb in it, mounted on a light stand.

Author's lighting equipment as described in the text. At right is a reflector umbrella, in the foreground an Alligator clamp fitted with socket and handle. On the lid of the custom-made case are two quartz lights and three stands, and inside the case are more clamp-socket assemblies and reflector floodbulbs. Tape and extension cords are also included.

Reflectors are made in several sizes, but I recommend you buy at least two deep enough for 500 Watt #2 photoflood bulbs. There are also 250 Watt #1 bulbs for smaller reflectors. Better yet, spend a little more and buy #2 bulbs rated at 3,200°K which are balanced for Type B color film rather than ordinary photofloods which are balanced for Type A color film. The 3,200°K bulbs last longer and don't turn gray with age. Normal photofloods last about six hours and discolor with use to the point where they are OK for b&w but not for shooting color film.

Another convenient system—the one I used for years—is to use 3,200°K reflector floodbulbs with their own built-in reflector. Buy ordinary bulb sockets with on-off switch at a hardware store, wood handles made for files, threaded brass connectors to attach the handles to the sockets, and 15- or 20-foot lengths of electric wire. Assem-

ble your own bulb mounts, and find some Alligator clamps—a brand name—at photo supply stores. These fit around the sockets and will clamp onto light stands or almost anything else. Two such floodlight assemblies cost less than ready-made reflectors and take up less room to carry or store.

The third home lighting system—which I now use—includes quartz lamp units. They are small and compact and offer about 650 Watts illumination each. Quartz lights cost the most but because they are brighter they are more suitable for use with reflecting surfaces—such as an umbrella—where light intensity is reduced. If you are just beginning a floodlight collection, look at quartz lights first. If your budget allows, I recommend them over more conventional tungsten bulbs.

The most convenient light stands are made of aluminum in telescoping sections with three fold-out legs. Sizes and prices vary. Choose stands

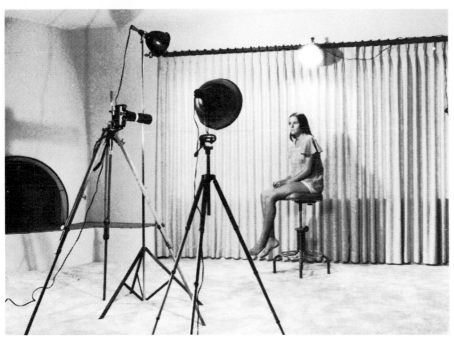

Move the furniture, find a simple uncluttered background and make portraits in your living room.

sturdy and tall enough for your purposes. Some models include projecting pins for your quartz lights or other accessories. Aluminum stands are pretty expensive, but they'll last a lifetime. Sometimes you can find used equipment and save money.

A few manufacturers offer floodlight or quartz light *kits* with two or more units packed in a carrying case. Investigate these before you assemble your own equipment because you may save a few dollars and some time. If you don't buy a kit, and want to carry your lights in a custom-made container, there are companies in most large cities who makes cases to order economically. Check your yellow pages for fiber products. Take your equipment to their shop where it is laid out and a case fabricated to hold everything compactly.

Reflectors—The easiest type to use and carry is a white, specially-coated umbrella made in various sizes. When opened to a circle or rectangle the umbrella can be attached to a light stand with the proper clamp. Then you point a light into its center approximately 18-inches away and illuminate your subject with soft reflected light. Umbrellas with trade names are more expensive, but some camera shops may carry models that are locally made and more economical.

You can also buy or make folding cardboard or Masonite reflectors on which a reflecting material such as crumpled foil has been attached. If you design your own, hinge two sheets of mounting material with heavy tape, crumple and smooth out aluminum foil and attach it with rubber cement. Such a reflector costs less than an umbrella and is light enough to carry, but is harder to set and hold while shooting. They usually produce a brighter or hotter reflected light that could be annoying to peoples' eyes.

BACKGROUNDS AND SETTINGS

Indoors the best background for portraits is a white or light-colored wall. Move enough furniture to make room for your subjects and camera with clearance on the sides to place floodlights or a reflector, if you're using them. Avoid busy wallpaper patterns or any background that will distract from and compete with your portrait. You can

attach heavy white background paper to a home-made stand on casters that can be moved anywhere, and various kinds of textured and colored background materials are available through camera shops. Remnants of fabric from a department store can also be mounted as pleasant backgrounds to give your portraits distinction.

There's nothing wrong with shooting people in normal room settings, rather than using a plain background, provided what is seen isn't too cluttered. It's nice to relate the subject to the surroundings if the person stands out well enough. You'll find many versions of this technique in what is called *editorial portraiture* in magazines and newspapers. Notice that the person usually dominates the setting and composition.

Another suitable background is a semi-transparent curtain or drapery through which daylight can dimly be seen. Remember that if you are using indoor color film and floodlights, daylight in the background will look bluish, but that's often quite acceptable.

Outdoors a plain wall or mildly-textured surface is a good setting for portraits. Foliage, trees and other natural forms are also adaptable, especially if slightly out of focus. When you can find a location opposite a reflecting wall where indirect sunlight bounces over to your subject the effect is usually lovely and lucky. Commercial photographers spend big bucks to build such setups in their studios so when you find a natural outdoor reflector, exploit it fully. If light reflects nicely at a spot where the background is not appropriate, consider making your own portable background or carry a roll of material and hang it temporarily while you shoot portraits.

Incidently, a white umbrella makes a great reflector outdoors as well as with floodlights. Use it beside a person to illuminate shadows, or in front to balance backlighting from the sun. You have to place the umbrella to one side of the camera, and sometimes you wish you could center it and shoot through a hole. Not a bad idea, and you might try it, but don't blame me if you ruin the reflector!

Related to backgrounds and settings is the color and pattern of clothing people wear when you photograph them. If you can make suggestions, ask for pastel shirts or plain bright colors for dynamic people, but avoid busy patterns and

A plain white wall in open shade is an excellent background because it doesn't compete with the subjects.

Indoors the natural background is sometimes busy and confusing, but sometimes simple enough to be unobtrusive. Ernest Reshovsky shot these delightful children with a 35mm lens by window light.

There are times when you can't be choosy about a background. Mrs. G. Trent Downing won a Kodak National Newspaper Contest award with this placid picture of a child and his duck asleep together. That black pole behind is a nuisance, but what could she do? The original was on Ektachrome-X, and a normal lens was used.

Reflected light is not always feasible for taking pictures of people, but when it is—there is no lovelier light. The young lady posed indoors near a large glass door opposite a patio where sunlight bounced around to arrive softly on her face. I used an 85mm lens and made a series of perhaps 20 shots because I knew I would not have her attractiveness and that light together again soon.

white which are either competitive or make contrast control difficult. Of course, what people wear is a personal matter, but they will be flattered that you care enough to make suggestions.

BASIC LIGHTING EXERCISES

The directional influence of outdoor light was covered in Chapter 5, and the same effects may be expected with floods or flash. However, indoors you have control over the intensity of the lights and the angles at which they are placed.

It seems to me that the average SLR photographer usually turns to flash when light levels are too low for comfort, and the flash is usually on the camera—bang into people's faces. I'll come back to my prejudice against flash-on-camera in Chapter 13. Here I want to make a plea for the pleasures of positive floodlighting before demonstrating how to do it.

Points in favor of owning and using whatever type of floods you prefer are:

You see the effects of light on people or things *before* shooting, and can make adjustments accordingly.

Two or three floods can be placed for a portrait or a group, to cover an average room nicely. One light illuminating the background makes a subject stand out with professional style.

Floods at the side or from a high angle in front of someone show far better form or modeling than one light directly into a face. The latter obliterates form, and gives washed-out features.

Mood, atmosphere, and other pictorial distinctions are possible with floods, and can't be duplicated with flash—including electronic flash (EF)—unless you have several units firing together.

You can really learn the effects of light on a face or form by manipulating floods. By observing subtle changes or dramatic contrasts of lighting you are getting into the real nitty-gritty of photography. All the other aspects we've talked about, such as action, expression, emotion, and drama are dependent on how light is used to get these qualities on film.

I hope you will be turned on to experiment with floods, even if you have to borrow them at first. In the accompanying pictures-with-captions are methods of lighting a portrait, subject to slight changes according to the face and the setting in your own pictures.

FRONT LIGHTING—One floodlight next to the camera offers the same effect as flash-on-camera. It's flat and uninteresting.

SIDE LIGHTING—One floodlight at the left begins to show the form of a face; it leaves a dark side which may be suitable for some moody portraits, but is too harsh for most faces. A light on the background gives it more sparkle.

BACKLIGHTING—A floodlight was as far behind the model as I could place it without getting flare into the lens. When light from behind the subject makes a narrow rim at the side or top of the head, it is also called rim-lighting. No light on the background here to accent the contrast of light and dark sides.

45-DEGREE LIGHTING—One flood was placed higher than the model's head at a 45-degree angle which you can determine from the nose shadow. There was no additional light on the background. Many variations of angled light are suitable for portraits. Located higher and lower, at one side or the other, depending on the face you face.

45-DEGREE LIGHT PLUS FILL—Reflected or fill light was added from the left to the 45-degree flood, softening the shadows to some extent. There was also a background light. This effect is a bit too harsh for a pleasant portrait, but is shown to illustrate this lighting technique.

REFLECTED LIGHT—By turning the model more toward the umbrella reflector, shadows on her face were softened. Only one light was used again here. Notice the highlight reflection of the umbrella in her eyes. All of these demonstration portraits were made with a Konica Autoreflex T3, a 65-135mm zoom at various focal lengths, Tri-X rated at ASA 400 and developed in Micro-dol-X, and apertures ranging from f-6.3 to f-11 at 1/125, depending on light intensity. The opening picture in this chapter was taken during the same session with the umbrella moved to the right side.

REFLECTED LIGHT—One quartz light directed into a white umbrella plus another light on the white-wall-background produced this portrait. The umbrella was at a 20-degree angle, just far enough away from the camera not to interfere with the image. Indirect or reflected light is usually preferable to direct—don't you agree?

DIFFUSION—for portraits is possible by various means including portrait diffusion lenses, diffusion accessories, softening in the enlarging process, etc. I use two layers of nylon-hose material—ladies hose, not garden hose—mounted in cardboard, to diffuse at my enlarger. I tried the same diffuser in front of the camera lens as an experiment, and this soft pleasing picture is the result. Try some of the diffusing materials for sale in camera shops—or your own—to please your models and yourself.

What makes a good picture? **PEAK ACTION**

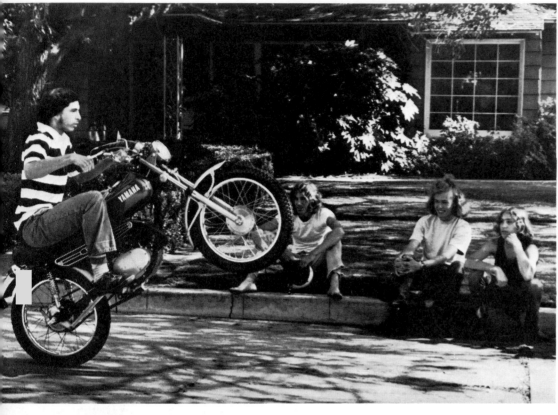

Shooting action is such a turn-on to most SLR owners, I have included five top shots in this section, rather than one. Instead of "peak action," I might have said "good timing," because the two are close allies. I shot the motorcycle "wheelie" at 1/500. Eleanor Bralver shot with a zoom lens at that precise moment when both girls topped the hurdle. As the swimmer surfaced, I stopped the water-splash in mid-air by shooting at 1/1000.

Electronic flash should not be forgotten as an aid to action photography. It freezes action and also tends to suppress background because light intensity falls off rapidly with increasing distance from the flash.

Karen Demuth of Memphis used her imagination most effectively to get this marvelous impression of a runner. She panned her SLR at 1/8 second which stopped horizontal movement of the runner's torso but allowed vertical movement of arms and legs to blur.

Action is technically and esthetically interesting because it's always a challenge and there are so many different approaches and effects.

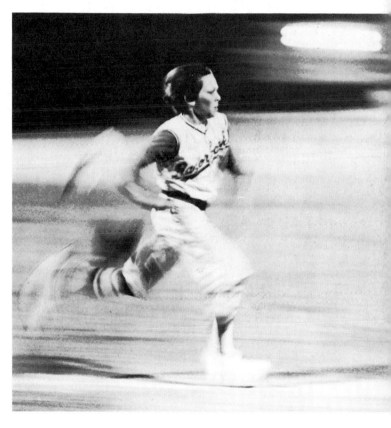

Peak action caught at the instant the model was at the top of her leap, ready to drop to the sand. It's a technique you can master, not a trick.

Peak action helps tell the story of kids playing. Shot with an 80-200mm zoom set at 200mm, 1/1000, ƒ-8 on Tri-X.

Sharp action pictures are not technically difficult with a single-lens reflex camera. You have shutter speeds fast enough to freeze moving people and things as I discussed in Chapter 5. *Timing and precise composition* of action are not easy with any camera, though the SLR is best in many categories. You follow the subject through the finder which becomes an extension of your eye and at the same time you hold sharp focus and frame the changing scene. At a special moment or a series of moments, you make exposures, watching the action continually, ready for the next peak moment.

ANTICIPATE PEAK ACTION

Did you catch the word *peak?* It has several meanings in action photography. For one, it represents the split-second when a motion reaches its apex, and a reactive or opposite motion sets in. For example, as the lovely model in the photo leaped in the air happy to be near sand and sea, I shot at the top of her leap as the action peaked.

The 1/500 shutter speed was fast enough because there's an instant when an up-and-down or back-and-forth motion stops before it reverses. If you can catch that peak when the ball just leaves the pitcher's hand—when the racer on the motorcycle lifts the front wheel as high as it will go—you not only capture the decisive moment but also are assured of a sharp image.

A second kind of peak action is the instant when something happens to tell the story explicitly. In the photo of kids playing touch football, one youngster has just managed to get the tips of his fingers on the ball carrier. A fraction of a second earlier exposure would not have shown this achievement. A moment later he would have passed behind the other boy. An image shot earlier or later would have left the question, "Did he, or didn't he?" Exposure for this was 1/1000 because the action was crossing the film plane, a consideration we'll discuss in more detail shortly.

Experience in shooting action trains you to

123

Action photography is also possible at shutter speeds such as 1/30. Wait for movement to stop momentarily; the girl's mouth paused and I snapped.

anticipate the peak moment for the most effective exposure. Even if you shoot with a motorized SLR, there's the possibility of missing the precise peak that occured *between* the average three-frames-per-second exposure time. However, using a motor is usually pretty good assurance of getting at least one good story-telling image. Read on.

Anticipation even allows you to shoot action to relatively slow shutter speeds and still get sharp pictures. To do this I have mounted my SLR on a tripod and focused on someone making a speech in a poorly-lighted room. By waiting for facial expressions that occur at momentary pauses between sentences, I could pull off the job with 1/60 exposures when flash was not permitted. Several negatives where blurred, but some were sharp enough to satisfy the client.

Look at the photo where the young celloist glances quizzically at her colleague. My camera with a 100mm lens was trained on this child because she was expressive, so I was ready when her face came alive. The picture was exposed in dim light at 1/30 and *f*-3.5 on Tri-X rated at ASA 1,000. Other frames of film were not sharp because action I thought had peaked was still in motion. I knew I would miss a few to get a few.

THE DECISIVE MOMENT

That phrase, which I hope you've heard before, is also the title of a famous picture book published in 1952. It includes 126 b&w photos by Henri Cartier-Bresson, a Frenchman who has wandered the world with a remarkable ability to see ordinary events, people and places in an extraordinary way. His secret? Timing of exposure and Bresson's uncanny ability and perception where there is human interest to report in strong visual images. These cannot be called secrets. It takes special talent and discipline to use a camera in this master's way but his approach is so direct anyone can adapt it.

It will not be easy to find a copy of *The Decisive Moment,* but in the decades that have passed, thousands of pictures in the same tradition have been published in magazines such as *Look* and *Life.* Other photographers such as Bruce Davidson, Elliott Erwitt, Alfred Eisenstadt and W. Eugene Smith have shown their work in books and much of it is related to the vision of Cartier-Bresson. Thus you don't have to find the original book to be inspired and influenced in ways to help improve your own timing and seeing, expecially where the action is.

Let me quote a few sentences from Bresson's introduction to his book. I think they help interpret his feelings about the decisive moment. He says a picture-story is, *"a joint operation of the brain, the eye and the heart. The objective of this joint operation is to depict the content of some event which is in the process of unfolding, and to communicate impressions."* Then he goes on with, *"Sometimes you have the feeling that you have already taken the strongest possible picture of a particular situation or scene; nevertheless, you find yourself compulsively shooting, because you cannot be sure in advance how the situation, the scene, is going to unfold."* In his unique way Bresson adds a thought I've tried to stress, *"You can never wind the scene backward to photograph it all over again."* You may be able to retrace steps or set an activity into motion again, but it's preferable to shoot enough, and change angles often in the first place.

Thus the decisive moment as we can benefit by it, to see and capture people we know or strangers, making instances of time stand still on film to enjoy and share later.

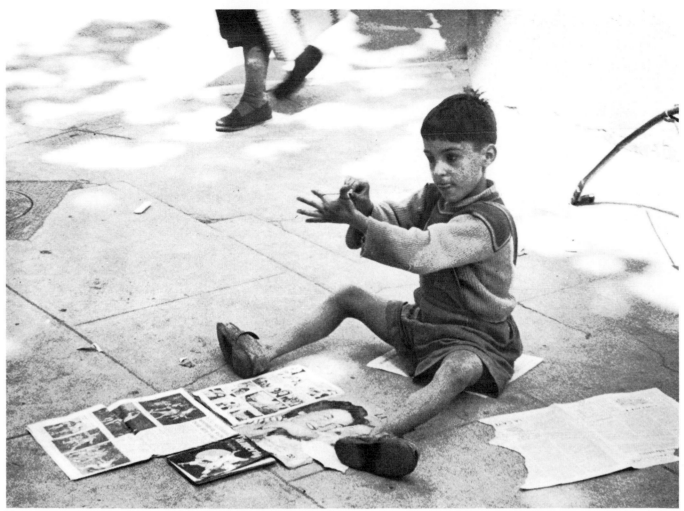

Not a Cartier-Bresson photograph but with the same flavor of *The Decisive Moment* it was shot in France and coincidentally printed by the same lab in Paris that did Bresson's work. My camera was ready as I passed the boy slinging spitballs and I caught him a second before his rubberband snapped one into the air.

If I may digress a moment, while I quote from Henri Cartier-Bresson, here are a few of his observations on composition. *"The photographer's eye is perpetually evaluating what the camera does is simply to register upon film the decision made by the eye."* He says, *"Composition is not an afterthought, but must inevitably stem from intuition when we are out to capture the fugitive moment, and all the interrelationships involved are on the move."*

Not many photographers can tell and see it as deftly and well as Cartier-Bresson. You can also learn to fuse skill and feeling into images, action or mood, portraits or close-ups, to excite yourself and move others.

THE ANGLE OF ACTION

In Chapter 5 I explained briefly: Action crossing your field of view covers more film than when the object or person is moving at an angle or coming directly toward you. This means you must shoot crossing action at a higher shutter speed. You'll find 1/1000 second is usually fast enough for most action, while 1/500 and 1/250 are okay when someone or something approaches the camera at an angle or from straight ahead. If you have sufficient light to use 1/500 or 1/1000 no matter the direction of the action, be my guest. You will be more certain that the action image is sharp and you'll be investing in insurance against camera shake.

ANYONE CAN DO IT

I want to show you a few pictures taken by my son Barry when he was 14 and 15 years old. He's picked up some photographic principles from me, but he has read and studied very little. I've tried to stress holding the camera steady, framing

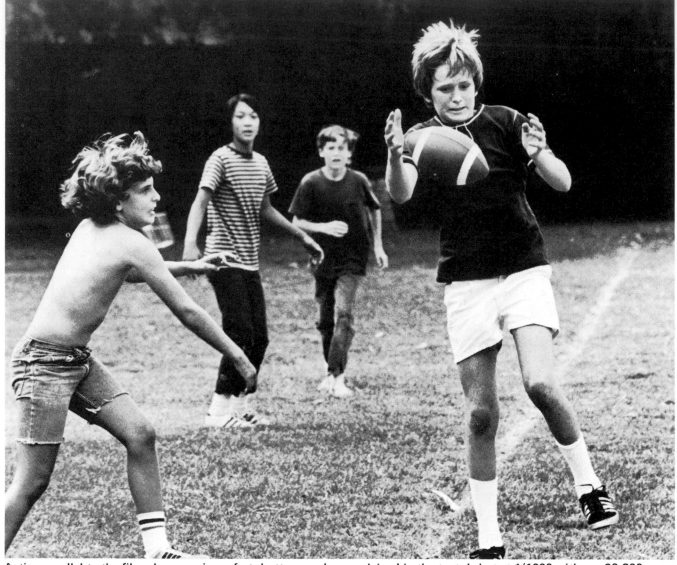

Action parallel to the film plane requires a fast shutter speed, as explained in the text. I shot at 1/1000 with my 80-200mm zoom, and luckily caught the football in midair. The boy at left was running to intercept.

to get as large an image an possible and shooting when the action peaks. He uses one of my Konica Autoreflex SLR's which is automatic, so exposure is no hangup.

Barry likes car and motocross races, favors a 135mm lens or the 65-135mm zoom, and shoots both Tri-X and Ektachrome-X at different times. He has learned from his mistakes, and I mention him here because he is not a seasoned professional. Barry's photos demonstrate that anyone who absorbs some basic theory, concentrates on camera handling and acceptable composition and keeps trying, can begin to really make his/her SLR an instrument of pleasure.

Panning the Camera—Barry's shot of the rider on a motorcycle with streaks in the background was shot by panning, or swinging, the camera. If action is close, fast, and across the film plane, you may never get it sharp with a stationary camera, even at 1/1000. One solution is to pan the camera with a steady sweep in the direction of the action, and expose when the object of interest is just about perpendicular to the lens. Panning is effective because the SLR is moved to keep pace with the subject—which comes out sharp while the background is blurred. You must focus at the distance where you plan to fire the shutter. Start your panning movement a few seconds before the sub-

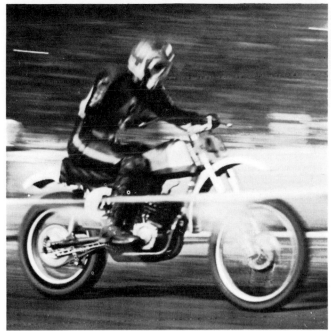

Panning with a moving subject tends to stop motion of the subject but blur the background. It's a good way to imply speed or motion but retain some detail of the moving subject. Two white streaks in the background are lights and the length of the streaks indicates how much the camera was moved while the shutter was open.

A different effect results from holding the camera steady, shooting while the subject crosses the field of view. The difficult part of shooting this way is releasing the shutter at the right instant so you don't get the vehicle hanging off one side of the frame.

Even at speed these race cars were frozen because they are coming toward the camera and shot at 1/500. Picture detail is fine but the viewer has to *believe* the cars are moving.

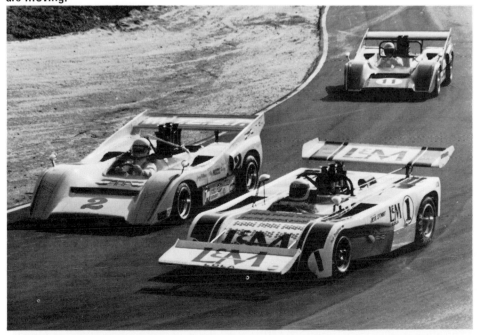

ject reaches the target point and *follow through* after you depress the shutter release, for a smooth operation. If you play golf or tennis you know the value of following through on a drive or serve. The same principle applies to panning your SLR.

Barry's panning picture was shot at 1/60. The motorcyclist would have been sharper at a higher shutter speed, but at 1/1000 it might not have been the best technique. The reason? Well, as you pan, the camera is synchronized with the target which appears sharp, but the background becomes a series of horizontal blurred streaks. If the shutter is open for 1/250 for instance, those streaks will be longer and more pronounced than if you shoot at 1/500 or 1/1000. The background-streak effect is enhanced by a medium-fast speed, and the pan action assures a sharp dominant subject. Panning turns background junk into a decorative pattern—often helping set off the foreground target.

Another of Barry's pictures illustrates how his *stationary* camera caught a motorcyclist rushing by, also snapped at 1/60. The rider's a blur while the background—and a pesky beer banner—are fairly sharp. There are times when this approach is very appropriate. Barry's blurred cyclist is ghostly in areas, and that adds to the illusion of speed.

Two more of Barry's shots contrast with each other. The three Can-Am cars rounding a curve at an angle towards the camera were easy to freeze at 1/500 despite their speed. No panning was required, and 1/250 might have done the trick if the cars had approached the lens a little more straight-on. As you can see 1/60 was insufficient to capture the motocross cyclist in mid-air even at the angle he's riding, because camera shake interfered. Barry, like a lot of eager photographers, was full of nervous energy at this big race and failed to hold the Konica steadily enough. The whole image is slightly soft, but the leaping bike *could have* been much sharper at 1/60 in steadier hands. He's still learning to grasp and shoot an SLR properly, even in adverse conditions; holding his breath, bracing his elbows and squeezing the shutter-release button. He benefits from the memory of pictures such as this one each time he goes out to shoot.

If you are also new to snapping action, experiment with shutter speeds. Make a series of exposures of the same subject at different speeds with

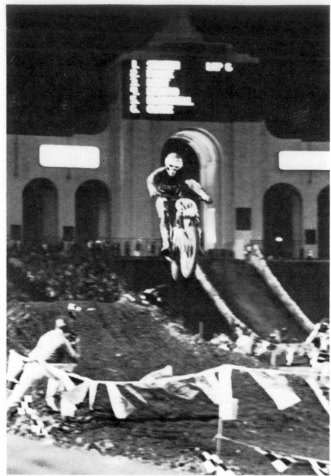

Everything is blurred a little bit here because camera and subject were both moving. As a memento, it rekindles the excitement of the moment in the mind of the young cameraman who took the picture but it really isn't very good. With better technique the background would be sharp. With luck the rider would be framed in the archway behind him. That would be a picture!

panning and stationary camera, and keep track of your exposure times. When you see the slides or prints you'll connect how you did them with both sharp and blurred images. Later your mind will refer back to those tests and you'll feel a lot more confidence as you fit technique to action subject matter.

Using Slow Shutter Speeds—I touched on this subject in Chapter 5 in relation to holding the camera steady. Here I want to point out the pleasure of *planned* blurred images. They usually give the feeling of motion—if not speed—even when the subject is only partly recognizable.

In the first place, though you can hand-hold an SLR for exposures up to ½ second, a combination of camera shake and subject motion is often

Water and slow shutter speeds create illusions of spun glass or plastic flutes because light collects instead of being frozen by a faster exposure. I used an 85mm lens with camera on tripod, exposed for 1 second at *f*-16 on slow Panatomic-X film.

too much to manage with clarity. Therefore, successful blur is achieved by bracing the camera—preferably from a tripod.

Moving water and traffic at night—illustrated in Chapter 11—are prime targets for planned blur. Notice how the stream in the accompanying picture becomes a pattern of soft-focus grays, contrasted with the hard rocks standing against the rush. The picture was made with an 85mm lens, camera on tripod, and exposed at 1 second and *f*-16 on slow Panatomic-X film. In bright daylight, blurred action and *slow* ASA speeds make a great team. Fast emulsions require impossible lens openings, such as *f*-64 or *f*-128, to allow slow shutter speeds. You can use neutral-density filters, but an ASA 400 film with a 4X ND filter is still ASA

100—often too fast in direct sunlight. If you start with a ASA 32 film and use a 2X ND filter, you have lots of latitude to play around with long exposures and create wild blur effects.

Ronald Davis went all out in the intriguing blurred shot of the horse and sulky. The day was cloudy, he used Plus-X film rated at ASA 125 with a 105mm lens set at *f*-16 to allow a shutter speed of ½ second. Not only did the horse move, but the camera moved also, creating tiny streaks in the background for a decorative "texture." Not very often does a hand-held with slow-shutter-speed experiment result in a photo like this which won a prize in the 1973 Kodak/Scholastic High School competition.

Sometimes blur that is not intentional appears

Ronald Davis shot at ½ second with a hand-held SLR to combine subject and camera movement in for very unusual and graphic effect.

An exposure at 1/60 allowed the bus and the passing figure at left to blur in a rainy London street.

With my SLR on a tripod, I zoomed the 80-200mm lens at 1 second while someone walked through the scene—an otherwise ordinary night situation. Zoom patterns are tricky and you must do a lot of them to assure one or two exciting ones.

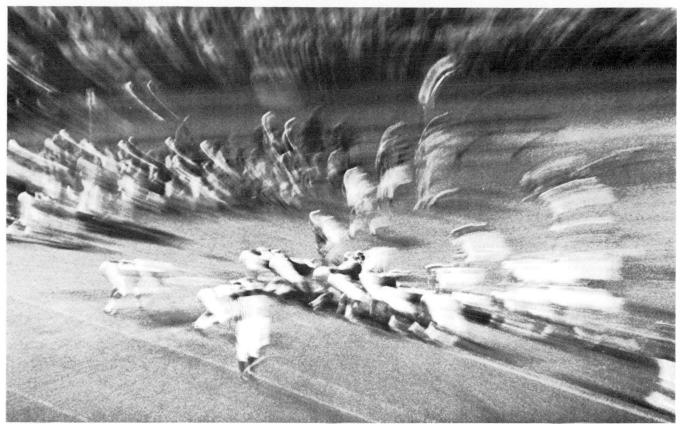

Barry Jacobs hand-held an SLR while zooming with an 80-200mm lens for this football picture exposed at ½ second. Changing focal length during exposure elongates lines and forms.

in a picture and adds to the overall impression. While crossing a street in London on a drizzly day with my Konica Autoreflex T set at 1/60 and *f*-8, I attempted to photograph a passing bus behind two girls under an umbrella. Later I found the blurred image of another pedestrian on the negative, but it is so out of focus I feel it becomes an apt foreground shape, lending a spatial sense to the scene. Accidental intruders usually foul up otherwise good pictures, but if indistinct, weak images can be made into a useful asset.

ZOOM-LENS PATTERNS

Another type of happy blurring results from combining slow shutter speeds with action while you shift the focal length of a zoom lens during exposure. Light levels must be minimal, or film speed very slow—Kodachrome 25 is well-geared to daylight shooting—to make exposures of ½ and 1 second feasible. At night with not-too-bright artificial lighting, a fast film such as Tri-X or High Speed Ektachrome is adaptable with apertures such as *f*-11 and *f*-16.

Your SLR should be tripod-mounted so the zoom pattern is not obliterated by strange wiggles caused by camera movement. Focus on a mid-point of the scene, and zoom the lens from wide to telephoto or vice versa to create strange streaks or blurs of light from moving or stationary subjects and shaded areas. They sometimes defy explanation. Sections of the image may retain a semblance of sharpness, an effective illusion contrasted with blurs caused by the shifting focal length. The longer your exposure, the less recognizeable the target, but variations are infinite according to how fast you zoom and the subject's speed and angle of motion. Sporting events indoors or outside at night are excellent situations for this technique because each play in football or basketball, for instance, creates a different design or composition. Exposure should be normal for the scene as if you were not zooming the lens. Color streaks often overlap and blend for very decorative unpredictable effects.

Zoom-lens patterns call for plenty of experi-

mental shots. Don't try to save film, because the pictures you fail to shoot could have been better than the ones you chance. Use of colored filters with color film is an additional variation some photographers use to increase imaginative impact.

PETS AND ANIMALS IN ACTION

You may have been waiting for this if you have a favorite dog or cat. Photographing pets is very rewarding. I considered including them in Chapter 7; because the same suggestions for successful portraits of people apply to dogs and cats. Simple background, enough light without confusing shadows and medium-telephoto lenses are all appropriate for animals. However, instead of trying to get the subject to think about something other than you and your camera, you aim to get its attention with sounds or words, so the face and expression come through in the picture.

Pets in action can be followed and photographed in the same way you would stalk a child. In this way you get natural poses and situations including humor and peak activity. An animal couldn't care less that you're trying to snap its picture, but when you know its habits and what it is likely to do under certain circumstances, you can be prepared to shoot accordingly. Choose as fast a shutter speed as film and light allow, giving yourself enough depth of field through aperture selection to avoid constant focusing when the subject moves forward or backwards.

Close-ups of pets might also have been covered in Chapter 12. Everything about careful focus and d.o.f. said there should be remembered when you are only a foot or so from your pet.

In other words, animals require the patience it takes to photograph people, with special attention to manipulating the subjects or following them, and going click when you see what you like. At the same time you must try to be close enough, perhaps with a longer-than-normal lens, and avoid distracting backgrounds. Dogs and cats are sometimes more agreeable to photograph then recalcitrant children!

HOW TO ZONE-FOCUS FOR ACTION

Depth of field is related to many facets of good photography. One aspect applied to capturing action is called *zone focusing*. I remember when I first discovered if I focused my 50mm lens at about 24 feet, and set the aperture to *f*-11, every-

A pet familiar with you may not be spooked by a camera; it may stare at the lens as one of our cats did while playing with a slipper. An overcast day provided soft light for an exposure of 1/250 at *f*-8 on Tri-X.

thing from about 12 feet to infinity would be in focus. With focus set at 18 feet, and lens stopped down to *f*-16, everything from 9 feet to infinity is sharp. Amazing! I thought I had *discovered* a new technique to shoot from the hip without bothering to focus in outdoor light when I wanted to catch a subject quickly.

I had merely stumbled on to zone focusing. You can set it with the depth-of-field scale on your lens. If you remember the footage marks for several zones of focus, you can make fast decisions and shoot immediately without checking focus. Simply study the d.o.f. scale of any lens you use often.

MAXIMUM DEPTH OF FIELD

To get the most depth of field, set the center of the infinity mark opposite the far-focus mark for the stop you're using. Opposite the identical near-focus *f*-stop mark will appear the measurement for closest sharp focus. When you set up as just described you are focused at the legendary hyperfocal distance and you will have the greatest depth of field possible for that lens.

Because these numbers and marks are usually jammed together, *exact* depth of field dimensions

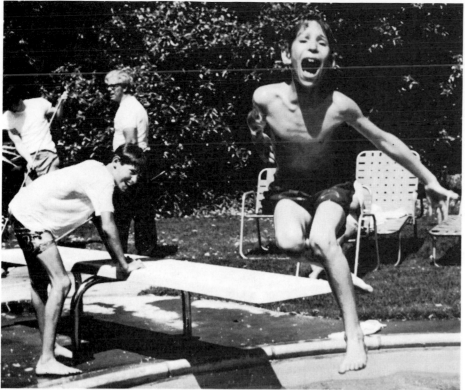

Amateur photographer Barry caught in mid-air, showing off, after I had zone-focused my SLR and 35mm lens for good focus anywhere between 5 and 25 feet. Exposure was 1/500 at f-11 on Plus X.

are only available by referring to d.o.f. tables available in data books or from the camera manufacturer. But they are *not* needed to enjoy the convenience of zone focusing.

Let's take another lens, the 35mm, as a further example. I was standing at the edge of a circular swimming pool and son Barry—a few years younger than today—was doing show-off leaps from the diving board. In mid-air he was about nine feet away from me, so I set this distance opposite the index marker of my 35mm lens. I knew by a fast glance and from memory that at f-11 everything from about 5 feet to 25 feet would be in sharp focus. At f-16 the zone increased from 4½ feet to infinity. With this assurance, Barry did his histrionic "dives" and I shot a series of frames without having to focus again. He was well within the zone of sharpness at f-11 and would have been even at f-8 with this wide-angle lens.

You can see how useful it is to know the sharp-focus zones of your lenses when you're shooting action. This knowledge is also helpful when you are merely walking along the street, and want to capture a face or figure passing—immediately or even sooner. There's no time to check focus, and no requirement either, if you pre-focus and concentrate on picture material.

SHOOTING ACTION IN SEQUENCE

Some people can shoot, advance the film and shoot again faster than others. Manual dexterity, mental agility and sometimes camera design are all involved with the speed and facility it takes to fire off a sequence of pictures. Try it, you'll like it, and you'll get better at it with practice.

Not long ago I was asked to talk about photography at a high school where a day had been set aside to hear professionals from various fields. During a break, when the teens were listening to a rock group, I roamed the edges of the crowd with a 135mm lens on my SLR. Among the opportunities I had, a three-picture sequence developed covering only a few seconds of time. A charming teen couple were kissing when I caught them first in the finder. As they parted, she threw him an amused smile, after which he must have made a wisecrack, because she reached over and covered his mouth. I was able to get two frames of them kissing and one each of the reactions that followed—enough for a good story-telling sequence.

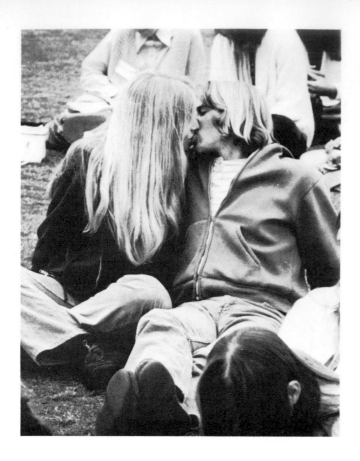

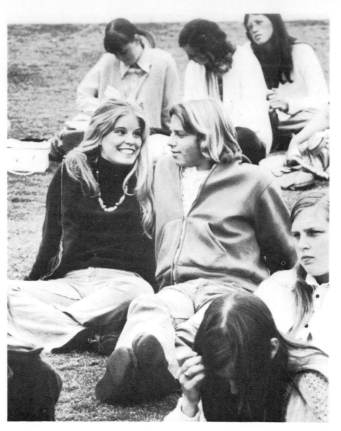

A lucky sequence developed while photographing a high school audience. Both camera and photographer have to be ready when shooting situations suddenly appear. Lens was 135mm; exposure 1/250 at ƒ-11.

Focus didn't have to change and exposure was also uniform. Sometimes when you set out to get one interesting exposure, you come up with more than one if you stay with the action.

MOTORIZED CAMERAS

Camera motors and auto-winders were discussed in Chapter 2, but the subject naturally comes up again relative to action photography. Among the brands for which motor-drives or auto-winders are available are Canon, Contax RTS, Minolta, Nikon, Nikkormat, Olympus, Pentax and Yashika. In addition, there's the Topcon Super DM which includes a spring-operated auto-winder that is user-detachable.

Most professional photographers for newspapers and magazines shoot with motor-drives or auto-winders because they can't afford to miss a piece of the action or a fleeting facial expression. Some years ago, when I was skeptical about motorized photography, I asked a friend and old pro, Gene Daniels, why he *always* shot with a motor on his Nikon. He assured me that even for editorial portraits, it is good insurance. In 2 or 3 seconds, several bursts on the shutter button give him 6 or 8 sequential frames. He said the sound of the motor didn't intimidate people who on the contrary seem impressed with his specialized equipment. "They are likely to think I'm more professional, because they may not own a motorized camera themselves," Gene told me.

Thus a motor-drive or auto-winder is not a gadget, but may be a necessary tool, as illustrated by the pictures on the next two pages taken by Mike Tatum. With his Pentax on a tripod and a 135mm lens trained on the building, he caught the implosion which demolished the structure in about 5 seconds. Mike was able to shoot 21 frames of b&w film at a shutter speed of 1/500 second and capture each essential stage of the demolition. The dozen most dramatic frames were selected here to demonstrate the efficiency of a motorized SLR.

Yashica FR with auto-winder attached.

Action is where it's at as today's youth are apt to say, for better-than-average photographic potential. With your eye and brain prepared, focus set, your trigger finger and winding thumb active and the right combination of light, film and subject, you'll get good pictures with your SLR. But one last plea: Please move in close enough to where it's happening. Don't get run over by a fast car or trampled at a track meet, but crop out all the unnecessary stuff around the dominant elements of your image. Being right in there counts, too.

In just a few seconds while a building was demolished, Mike Tatem shot 21 frames with his motorized Pentax of which 12 are shown here. At 1/500 and three frames per second, all the drama was included.

What makes a good picture? REALISM

Photography has long been used effectively to show how people live. Try to find a thick, wonderful book called *An American Album* in which are collected fascinating photos from the 1800's and early 1900's, or look for *This Proud Land* by Roy Stryker. The latter is the best of documentary photography from the 30's and 40's by the Farm Security Administration which Stryker headed.

Realism tempered with empathy is a mark of documentary photography; your feeling for the medium will be enriched when you are familiar with this approach. Realism is also in news pictures and a lot of ugly or startling pictures we have all seen.

In your own work with the SLR it is satisfying to take realistic pictures, such as this flutist I heard at a recital. The room was daylit and I could shoot from the audience with my trusty 65-135mm zoom lens using 1/125 at *f*-5.6.

What makes a good picture? LIGHT & SHADOW

There's light and shadow in almost every photograph, but some are more successful because these basic elements are dominant. Dunes at Death Valley can be flat and almost formless at noon, but early morning or late afternoon light brings out the drama which is emphasized by the two tiny figures.

One important way to avoid postcard cliches is by rising early and staying until dark to take advantage of the low-angled sunlight that professional travel photographers use. Along with light and shadow are contrasts of size and lovely form in this example. Color goes golden warm in early morning and at dusk, adding a pastel feeling you cannot achieve any other way except by using a colored filter—which is also a good experiment.

Anaconda's copper smelter in Montana, photographed with a 35mm lens in natural light for 1/60 second at ƒ-8. It would have been silly to add flash here and spoil the mood while washing out the people in the foreground. Available light gives people the *feel* of a place.

Available light may have become a nice old-fashioned term like box camera and Brownie, except—in my opinion—it's as good as new. Box Brownie has yielded to Instamatic and maybe available light has also been relegated to the past by some modern gadgeteers. It depends on your natural inclinations, and how dedicated you are to reality in photography. By that I mean, how fast do you reach for a flashcube or electronic-flash unit when the light level, especially indoors, becomes dim.

In the days of the 35mm pioneers, the 1940's and 1950's, shooting in low light levels was a glorious challenge. Photojournalists boasted about shooting "wide-open" at 1/5 or 1/10 second. They experimented with crazy developer additives and

oddball formulas to raise the emulsion speed of old Super-XX film. Prominent grain patterns were a hallmark of the available-light enthusiasts— I almost said freaks—and sometimes grain size was a prideful indication of how difficult everything had been for the photographer. There were some situations where straining the film and camera was necessary, such as a memorable magazine photo essay on the street people of Hamburg, shot completely with hidden cameras.

I'm not sure who applied *available darkness* to symbolize the conditions a lot of photojournalists prided themselves in being able to cope with. Their extremes were ridiculous at times, but they all had the same general goal: *an honest, realistic rendition of people and places without the con-*

trived application of artificial light. They had to squeeze their equipment and films because neither were as fast or efficient as they are now.

Today it's duck soup to shoot Tri-X or HP5 at ASA 1,200 or Ektachrome 200 at ASA 400, and *f*-1.4 lenses are available to anyone. Once a fetish, available-light photography has become a standard procedure. It's no longer very difficult, but the benefits of immediacy and realism are still there. I encourage you to enjoy shooting in natural light when the occasion is appropriate.

PUSH-PROCESSING FILMS

In Chapter 4 I mentioned that black-and-white and color films could be "pushed" in development so their ASA speeds can be boosted while exposing the film. Kodak provides special processing for Ektachrome to shoot daylight type at ASA 400 and Ektachrome 160 at ASA 320. Results are pleasant and predictable, grainier than usual, but you get images instead of the blur or murky darkness you may have had at normal film speeds. In many cities, custom color processors also push Ektachrome 200—some more vigorously than Kodak. Look in the yellow pages because a local outfit can save you time if Kodak is some distance away.

My special joy has been shooting b&w pictures in available light for many magazines over the years. I went through the developer-additive stage, suffered strange contrast quirks and big annoying grain, but bigosh, Super-XX had been boosted from 100 to 400, and that was an achievement. Then along came developers such as UFG and Acufine, and films such as Tri-X and HP5, today's favorite of many professionals because they do the boosting job without excessively amplifying grain or contrast.

My long experience has been with Acufine. It is lovely stuff, very consistent, showing no grain in an average 8x10 blowup of a 35mm Tri-X negative, and offering very manageable contrast. Directions suggest boosting Tri-X to ASA 1,200, but I prefer using it at ASA 1,000 for slightly more negative density to give me crisper prints.

Perhaps all this talk about b&w film development is leaving you cold because you've never tried it, don't process your own film, rarely use black-and-white, and wouldn't know where to take your film if you did shoot it at ASA 1,200.

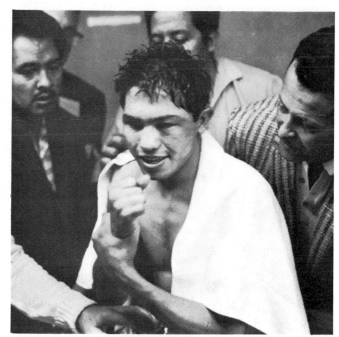

How often do you photograph a victorious lightweight in his dressing room? Seldom? Never? But opportunities to shoot in similar lighting conditions are often yours in room lighting from overhead or lamps, maybe something like this. With a film rated at ASA 400 or faster, you can usually shoot at 1/60 between *f*-3.5 and *f*-8 and get your subject without flash.

OK, boost color film speed if you wish and carry on. Or you might just investigate the custom labs in or near your town, or by mail to a neighboring metropolis, where b&w service is available. If you do use a lab, be particular about quality. Some are more careful with film and processing than others.

And, finally, you might think seriously about becoming a complete photographer and processing your own film. Tom Burk's book *Do It in the Dark* shows you how. If you shoot Tri-X at boosted speed very often, it will save you $$ to develop your own, even if you then turn it over to a lab for proof prints and enlargements. Once you get the feel of handling your film, knowing the pleasure of precise timing and manipulation of the tank, you'll realize that the small investment in materials and time was worthwhile.

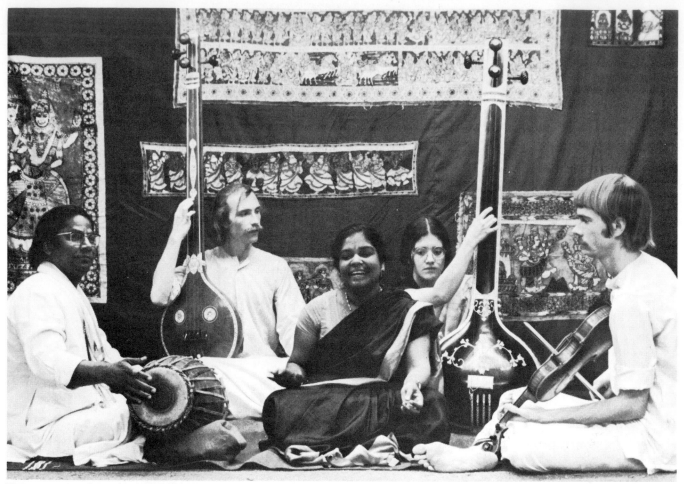

This example of Acufine with Tri-X rated at ASA 1,000 shows no perceptible grain in an 8x10 print, and a good scale of tone values from white to black. Taken with a 100mm lens, 1/125, ƒ-6.3, in available light.

WHEN IS "AVAILABLE" ENOUGH LIGHT?

Two conditions have to be examined to answer that question. 1/According to your camera's exposure meter, there should be sufficient light for an exposure allowing you to hold the camera steadily to stop the action without excessive blur and have enough depth of field in the bargain. 2/Light should not be so contrasty or one-sided to leave out shadow detail unless you overexpose the highlights beyond the limits of film and printing paper.

We've talked at some length about minimum exposure times and camera shake where the subject is moving. The same principles apply if light levels are minimum and there's *no* action or motion. You still have to hold that lovely SLR steady enough to get a sharp image. That's why the tripod was invented. However, according to "Jacobs'

Clean tones and minimum grain show in this natural-light portrait on Ilford HP5 taken with a 50mm lens at ƒ-2.8 and 1/60.

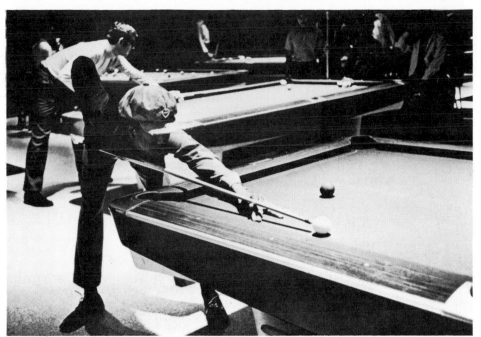

Shadow detail is often lost in contrasty lighting, but Warren Chang of Houston, TX caught the mood of this pool parlor in his Kodak/Scholastic Award winner.

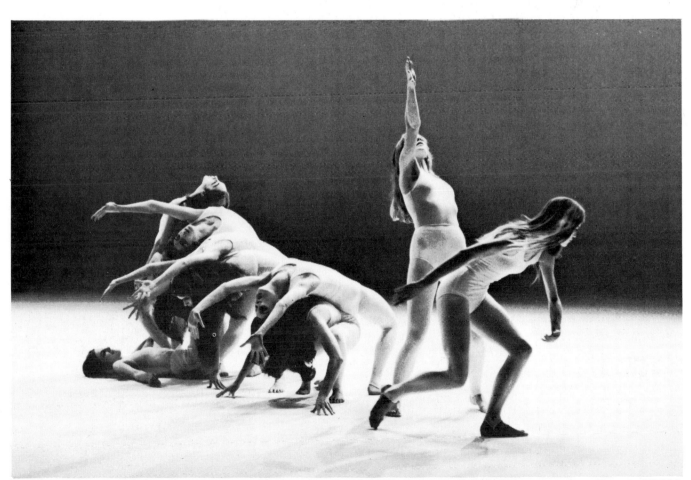

Both contrast and subject movement were problems to Lyn Smith while shooting a ballet company on stage. She rated Tri-X at ASA 400, exposed with a Topcon and 35mm lens at 1/125 as the action slowed momentarily. Stage lighting is not always as evenly distributed as this.

Law," when you *really* need a tripod, you don't have one with you. You have to brace the camera or take a chance on your nerves being nice and steady.

As I have mentioned, I can hold my SLR filmly without shaking at speeds slower than 1/30 but I'd rather not. Occasionally, I can't avoid the risk. When flash or floodlights are not handy or not permitted, my best available-light techniques are called upon.

An example is the shot of Manet's famous painting *Olympia* in the Louvre. It was taken on RGB color film rated at ASA 100, and the b&w print was made from a color negative. The meter indicated 1/15 at *f*-4 and I was using my 52mm normal lens. I needed *f*-4 to carry depth of field from the foreground figures to the painting, having checked using the camera's d.o.f. preview lever. So I fixed my elbows to my sides, held my breath, and made three or four exposures.

The only movement in my shot of *Olympia* shows up in the group of three girls at the right. They shifted position slightly, but it would not have mattered even at 1/8 or slower. I'm not describing how this picture was made to brag about it. I merely want to point out that there are dozens of opportunities to shoot with available light that you may not be enjoying. Instead of attaching flash to the camera and ending up with the flat front lighting it usually offers, consider your ability to follow the pioneers of photojournalism. You may be amazed, not only at how well you can hold your SLR, but also at the lovely natural form and color in your pictures.

To illustrate the second answer to "how much light is enough?" I've chosen a portrait by Mark Packo, winner in the 1971 Kodak/Scholastic competition. Contrast between highlights and shadows is strong but manageable. In the original print you see detail in the dark side of the face—enough to

Mark Packo approached the edge of workable contrast in his moody portrait by window light, but there's shadow detail and the effect is different than lighting by flash or floods. It won a Kodak/Scholastic award.

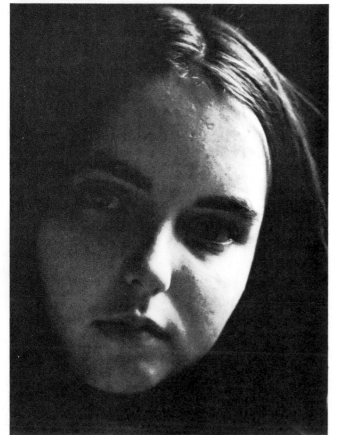

At a museum in Paris I hand-held my SLR steady for a 1/15 second exposure on color negative film rated at ASA 100. The painting is Manet's *Olympia*.

144

be satisfying. Reproduction loses some of that detail, but the portrait doesn't suffer. Strong contrast with some subjects adds to the drama.

When you shoot people or a scene when faces or important details are in shadow, and there are strong highlights elsewhere with few middle-gray tones, *then* you can be in trouble. By overexposing to capture some of the shadow detail, highlights are washed out in color and difficult or impossible to print in black-and-white. A good printer can "burn in" some highlight detail, meaning to give it additional exposure to darken it, but it is tricky to do well—especially with small white areas.

In high-contrast available-light situations, you must be resigned to too-dark shadows or too-bright highlights. As an antidote, you can add diffused or reflected light. In Mark Packo's portrait, this was not necessary, because the natural light implies a mood a more balanced light would not. Besides, there are often times when you miss a spontaneous moment of beauty if you dash off to get flash or flood. By the time you return the situation may have changed, so use natural lighting and catch the mood of the moment.

Use It More Often—Here's the message of this chapter: *When the meter in your camera says you have enough light to shoot at a manageable shutter speed at an aperture giving sufficient depth of field, do it!* If you are accustomed to shooting with flash under such circumstances, make some available-light exposures first and then shoot the same situation with flash or flood—if there's time. Only if you are certain that subject movement and camera shake will definitely give you blurred pictures should you immediately turn to flash or flood, skipping the natural-light possibilities. There are a number of times when I shoot with flash, as you'll see in Chapter 14, but I always prefer the more realistic feeling of daylight or artificial light which is part of a setting—unless it's gloomy or dull or insufficient.

To underline this thesis, I'll talk about one more photo made in a high-school classroom. There was an overhead fluorescent fixture lighting the students and instructor discussing a science project. This type of light usually produces dark eye-sockets and should be avoided at times. I often bounce a small electronic flash to brighten the shadows, as I'll explain further in Chapter 13. However, the walls of the classroom and the table-

Classroom scene shot with 28mm lens and available light.

top reflected enough light into the faces, and allowed me to shoot with a 28mm lens at *f*-5.6 and 1/15. I needed *f*-5.6 for good focus from foreground to background, so I took a chance on the slow shutter speed and made about 10 frames from the same position, knowing subject movement would be arrested in one or two. The natural feeling of this situation was retained as you can see in the accompanying photo. Flash at the camera would have been a visual disaster, and setting up multiple flash—one at the camera and another off to the side—would have disrupted the classroom activity.

I'm a natural or available-light missionary. You may also hear it called ambient or existing light. It won't save your soul, but it can gratify you esthetically without being illegal, immoral or fattening. It saves the cost of flash and gives you a professional feeling when people say, "You can't get anything in *this* light, can you?"

Yes you can!

What makes a good picture? CREATIVITY

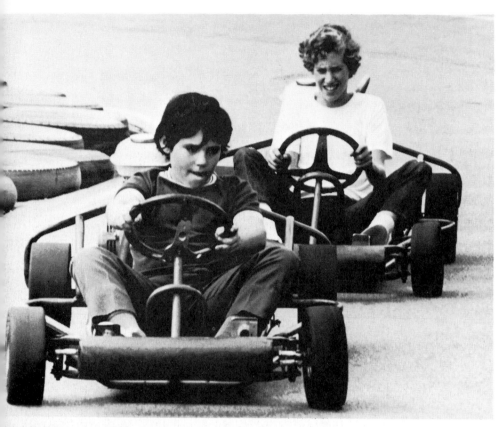

Start a discussion with any group of photographers about "what is creativity?" and you'll get a terrific tangle of definitions. They will say it's offbeat and mysterious, multiple exposures, darkroom trickery, sandwiching slides and negatives, or shooting in impossible lighting conditions.

Creative is a great catch-all word that has been kicked around often by photographers and other artists. The dictionary equates creative with being original in thought or expressions.

Apply this idea specifically to photographing your friends, family, environs, or places you visit with your own personal and original style. All around you are accessible subjects for good pictures in everyday life, and when you travel you can rise above ordinary slides or prints using individual vision.

Here are a few examples:

Go-carting takes on an uncommon look when you use a telephoto lens.

Patterns, such as the one I photographed in a violin repair shop, are always fascinating.

I'm sure the street scene in Venice appealed to me because it has a Cartier-Bresson touch to it, and I welcome that creative influence.

Though everyone shoots pets, you can show an individual point of view by getting up close.

Zooming a lens during exposure creates effects you can't anticipate, but taking chances is a path to creativity.

Set yourself a long-term project to "report" everyday life for the family album, and if you are creative I guarantee you will come up with images good enough for hanging on the wall or submitting to contests. Don't let creativity escape you—we all have it.

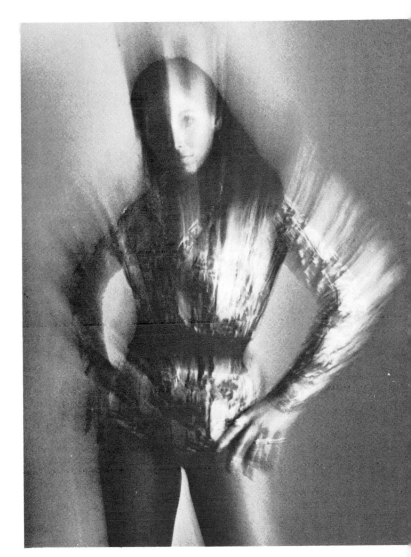

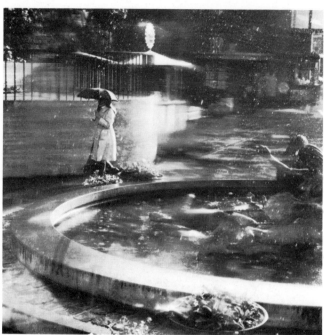

No trick photography or darkroom manipulation was involved in making this San Francisco scene through a restaurant window in the rain—when the sun was shining! A handy camera with 52mm lens, a watchful eye for people to enliven the scene, an exposure of 1/125 at ƒ-11 on Tri-X and I had an unusual travel picture.

My gadget bag holds two SLR's, six lenses, filters and accessories. Similar bags with compartmented top are available at many camera shops.

This is a chapter about traveling with your SLR. Everything you know about lenses, films, light, action and composition obviously comes in very handy when you're on the road—but there are also special considerations. If you're already a world traveler with membership in an air line Million-Mile Club this is old stuff. Otherwise, I hope someday you'll need a lot of what follows, because getting away from the familiar at-home scene is a photographic turn-on.

WHAT TO TAKE AND HOW TO PACK IT

If you haven't already stored the never-ready case that comes with an SLR, do it now. It is excess weight and bulk. You can protect your valuable camera several ways without that floppy contraption.

Definitely take a gadget bag for traveling. Use it to carry your camera, lenses, film, filters, closeup lenses, soft brush and stuff. Choose the size bag that fits your equipment or slightly larger in case you buy more lenses or another camera body in the future. The type I use has a compartmented top with thin foam padding for extra lenses, pockets inside for lens shades and a stack of filters, and a pouch in front for film. Camera shops offer a variety of gadget bags, so enjoy the search.

Lenses—If you have an SLR with only its normal lens, think seriously about including one or two more lenses in your budget. You will arrive at some places behind schedule and want to get some shots in a hurry. A 135mm or 105mm, or better yet a short-range zoom lens including those focal lengths will increase your limited opportunities. If you're on a bus or train, reaching out with a medium-telephoto or longer lens is also a great convenience. If your budget is tight, investigate extenders as mentioned in Chapter 3.

A wide-angle lens is as handy as a telephoto when you're on the go looking for unusual images. I used a 21mm lens on a sightseeing boat in Paris, though a 35mm, 28mm or 24mm would also have been useful. Depth of field capability of the wide-angle was handy here.

The other focal length to take along is a wide-angle, as you have probably guessed. A 35mm lens is the best in-between choice if you are starting a wide-angle collection, but a 28mm has specific values, too. Look through both before you decide.

You will undoubtedly be in places, or even outdoors, where you can't move back but want to include more than the 50mm lens allows. You also know depth of field for a wide-angle lens at a given aperture is greater than with a normal lens. That's a nice feeling, especially if you can move close enough to a subject to fill the frame.

Any other lenses you wish to carry are a matter of personal choice rather than necessity. A 200mm or 300mm telephoto, a macro, a long-focal-length zoom or even a fisheye lens are all useful in certain places. Decisions about them depend on how much you want to carry. I vote for less rather than more, for comfort and agility.

A set of closeup lenses may also do something for you if details of flowers, rocks, and small objects will add to your picture-taking pleasure. Or, if you really enjoy closeup photography, chances are you'll wind up using a macro lens as your "normal" lens.

Tripod and Accessories—A light-weight tripod, no more than three or four pounds, is lovely to have at night and in low-light levels. Beware of teeny little tripods, they fold up compactly, but may also collapse easily in use.

Take lens cleaning tissue and fluid, a small brush to wipe lenses, a larger brush to dust the insides and outsides of your camera, and a cable release to make exposures without shaking the camera when on a tripod or other steady base.

Carry only the filters you will really need, such as a skylight, neutral-density, a polarizer and conversion filters for color films you plan to use.

Either b&w or color film would have been appropriate for a view of fogged mountains northeast of Los Angeles. Taken from a light plane, it might have been shot from any aircraft with large enough windows. The focal length you use from the air depends on your altitude. Some jets fly so high you see nothing but clouds or general earth patterns.

Film—Traveling in the US, you can expect to buy film in most cities and towns. If you get a quantity discount at home, it may pay to take it along. If you're in hot country, color-slide film should be kept cool or the color could be degraded. Pack it in a watertight bag and keep it in a cooler with food. If you send it to the lab for processing as you go along, it will be ready for you at home after the trip, and you need not continue to protect the exposed film from heat and moisture. Black and white and color negative films are less subject to the effects of heat than color slide films but store them in as cool a place as possible—not in the glove compartment of your car, and not under the seat above the car's exhaust system.

If you are going abroad, film is available in many countries, but the brands may not be familiar. Kodak covers the world and European Kodachrome can be processed in the US with comparable results. I suggest you take as much film along as you can conveniently carry when traveling in foreign countries. Keep exposed film with you rather than mail it home for processing, because it can be lost. If you are going to be away more than a month and your exposed film is piled high and deteriorating, check with American embassies in several cities, about the reliability of mail services to see if you can risk mailing your film to a lab in the USA. European countries vary. Italian mail at this writing is slow and strange. I am not familiar with postal conditions in Latin America or Africa, but various sources can keep you posted. H.P. Books' Publisher Bill Fisher reports good results using Kodak and Agfa processing labs in England, both with film purchased there and in the US. He had the finished slides sent home to the US and experienced no problems with over a dozen rolls. You may want to check

into the idea of mailing the exposed films to film manufacturers' designated processing labs, with your home address as the return. This should work fine in England and Europe. For other countries, check as I suggested to find out about the reliability of the mail service.

Estimate how much film you may shoot, and remove the outside boxes to save weight. Label canisters with cloth tape if they all look alike, taping the top so it won't unscrew or flip off. Also mark the exposed film plainly. You can tuck film into your luggage as well as your gadget bag. Exchange fresh for exposed as you progress so you have only new film in your shoulder bag. Customs people will rarely give you trouble about film, because if it is not in cartons they don't think you're planning to sell it in their country. That's their hangup—the possibility of your selling film without paying import duty.

On any trip, take along familiar film. You may add an offbeat brand or type for experiment, but it's better to carry old favorites and not be distracted wondering what the untried stuff may do. One b&w film, slow and fast color film, or a slide film and a print film are all you need. You can also get by on one negative-color film, planning to have slides and prints made from it as the spirit moves you.

THE X-RAY PROBLEM

Airports all over the world are installing X-ray equipment to inspect hand luggage and in some cases bags you check through the counter. It's getting harder and harder to persuade them not to X-ray your hand luggage and you have no choice at all when you check your bags.

Equipment manufacturers and airport personnel all say the X-ray dosage is so small it cannot possibly affect your film, exposed or unexposed. Photographers who have observed strange degradation of color after air travel think it is the X-ray inspection. One magazine recently put film through a series of X-ray inspections and decided there is some effect, *particularly from more than one inspection.*

The safest thing to do is carry your undeveloped film in one of the special lead-lined pouches being built into some gadget bags. There are also protective containers like paper sacks with a special lining to reduce X-ray penetration. When film has

Be sure to take enough film on any trip because you may not be back soon, and film is cheap compared to time. This sunset along California's Big Sur coast was also photographed in color by my wife Barbara. We feel free to experiment with b&w and color but still try to shoot with discrimination.

been developed, X-ray shouldn't affect it.

The shielded container will probably trip the alarm and the inspectors will then look to see what you are carrying, or ask you to identify it, or both. If you are asked, don't joke around and say it's a bomb. They will detain and search you for saying that. Everybody, including other travelers, will think you made a very bad joke. The fine you may have to pay will be totally unfunny.

CUSTOMS AND CAMERA REGISTRY

In most European countries where I have traveled going through customs is a breeze. They are simply concerned about your selling equipment and materials, but unless you have a bunch of cameras and lenses, they will not bother you. While driving in Europe in 1973, we were waved across every border without inspections. I have a feeling customs are also lenient in the Far East

Bruce Rapoport avoided a cliche by including the gulls in his seascape which won a Kodak/Scholastic award. He followed the birds with a 135mm lens, and shot at 1/500 and ƒ-6.3 on Ektachrome-X.

Customs Form 4457 when properly used gets your camera gear back into the U.S.A without duty or *hassles*.

THE DEPARTMENT OF THE TREASURY **CERTIFICATE OF REGISTRATION** BUREAU OF CUSTOMS		Form Approved O.M.B. 48–R0394
		Number
Name of Owner	Address of Owner	
Description of Articles		
I certify that the information shown hereon is true and correct to the best of my knowledge and belief.	Signature of Owner	
Port	Date	Signature of Customs Official
Customs Form 4457 (3/71)		

Few photographers would pass by this pastoral scene photographed by Barbara Mills Jacobs, but not everyone would try it as a vertical format which is less a cliche than horizontal.

Carl Wysocki of Arlington Heights, IL, walked through the snow to improve the composition of his shot with backlighted mounds and darkened farm buildings. He won a Kodak/Scholastic award for his efforts.

and at most Mexican border points. For South America and Africa, you had better do some research. Doug Richmond's book *Central America* explicitly covers customs and border ceremonials as he found them in those countries. As for Canada, you should have your equipment listed in triplicate, and have the list stamped at US Customs before crossing the border. Form 4457 mentioned below would be okay if you have three copies. Canadian Customs can get very sticky I'm told, and if they discover you are a professional, they hit you for a deposit that's like a bond to assure your not selling cameras and gear in Canada.

Before going abroad, take all your foreign-made equipment to the nearest US Customs Office and list it on a form 4457; include the brand names and serial numbers. They'll stamp this form which you take with you. On returning to the US, you merely show it to Customs officials who will not be tempted to charge you duty because they know you didn't buy those cameras and lenses on your trip.

Insurance—By all means buy a camera floater policy on your equipment. It's good anywhere, and is highly advisable even if you vacation 50 miles from home. Check with the people who have your home-owners policy, because they are most likely to cover you. Cameras are so expensive, vulnerable and easy to steal, that insurance companies are sometimes reluctant to sell floater policies. The cost and effort involved are well worth it in peace of mind, and for replacement if you turn out to be unlucky. I can't remember how many people without insurance have told me of camera losses over the years. Their combined regrets would fill several black-edged pages. With

This is one of the pictures I didn't see until it was developed a month later. It's the changing of the guard at Buckingham Palace shot by holding my SLR over the heads of people who had a better view than I did. Focus was pre-set, exposure was 1/500 at ƒ-11. If your SLR has a look-down-into finder, you can look up and see what you're getting from an elevated camera.

inflation rampant, get the cameras, lenses and other equipment insured for actual cash value or full replacement value. Otherwise, the insurance company will make your life miserable by paying a depreciated price for what's lost—and they'll take the depreciation on the price you originally paid, regardless of what the stuff sells for today. This is important! Don't just buy a floater without getting this written onto the policy or endorsement.

CLICHES AWAY

You're packed and on the way. New visual wonders fill your eyes and boggle your mind. Mountains, museums, coastal cliffs, canyons and cathedrals, pageantry, castles, long river vistas, clogged city traffic—an endless list of photographic targets come into view. You're shooting more in one day than in a month at home, hoping to capture the beauty or uniqueness you keep seeing in the finder. Is there any way you can be sure to avoid disappointment when those slides and prints are finally spread over the dining room table for selection?

Not for every single exposure. But there is plenty to keep in mind that will influence the percentage of good pictures in your favor.

The Postcard Cliche—You have sent and received enough scenic postcards to know that they are often bland and unexciting. Composition is conventional, and the different or novel approach is almost nonexistent. Only when postcard photographers shoot at night do they come up with the unusual. They use a tripod and time exposures and search diligently for pictorial angles.

The same evaluation can be made about those sets of ready-made slides on sale by street

Susan Hirsch of Tucson shot a vertical frame into the sun and gave the negative minimum exposure for this unusual interpretation of a subject that seems to invite cliches. Tidepools on a wide beach are made to look even larger by a 35mm lens. A Kodak/Scholastic winner.

vendors and in shops all over the world. In Rome, Paris, London or Tokyo you can buy enough slides of the sights to preclude taking a camera along. Or so it may seem to the duffer for whom photography is a chore.

However, we SLR owners who are challenged by the unusual and try hard to give our pictures a *personal* touch or viewpoint—we can easily surpass the factory-produced postcards and slide sets. Here's how:

As much as possible, shoot in early morning or late afternoon when the sun is at a low angle, giving a golden glow to everything, and accenting form dramatically. My shot of tall house fronts in Venice on the front cover of this book is a sample of what I mean. Professional travel photographers often take a siesta from late morning until mid-afternoon when the sun is high because the light is so conventional.

Look for foreground elements to frame your pictures and give depth to a scene.

Choose camera angles that have to be searched for by walking and waiting. Don't snap your first glimpse of the Eiffel Tower. A little exploration will give pictures with more impact plus the personal approach a postcard-oriented photographer may not risk. Try several different lenses and distances from a familiar landmark or typical scene. A wide-angle view of the Thames River with a boat in the foreground and the Houses of Parliament small in the background may be unlike any you could buy ready-made.

Be selective in crowds. Give yourself time for people to move into patterns you like, or away from a place that you don't want crowded. Find a higher spot to shoot from when you can, and get over the heads of everyone. I held my SLR above the masses at Buckingham Palace and shot into the courtyard while the guard was changing, even though I never saw what I had taken until the film was developed back home. The pictures were not sensational, but I had used a technique the postcard photographer never does.

Back up against walls inside museums, cathedrals or chateaus, to steady yourself for exposures longer than 1/30. Most people with cameras shoot with flash in such places when allowed and they rarely get the real feeling or atmosphere because everything beyond 10 feet goes black. Your slow exposure may include moving figures, but the sense

Oded Burger said he snapped this youngster in Rome without ever being noticed, "Because the kid was so preoccupied reading the phone book!" Patterns of chairs, dark contrast and the small figure add up to a different feeling than any postcard. Burger won a Kodak/Scholastic award for his perceptive photography.

of the place is real.

In some places photography may be specifically prohibited, especially inside English cathedrals. The one at Windsor Castle, for instance, has warders who really get uptight if you so much as point your camera toward the inside from one of the outer passageways. If you want pictures of the insides of places where such a ban exists, chances are slides—often good ones—will be displayed and sold there at the souvenir stand.

Shoot vertical-format pictures for your individual interpretation of places seen on postcards.

Don't be satisfied with the usual static, perfectly balanced composition. Make a few such exposures, then move one way or another to show the same subject with a different twist.

Wait for clouds to move into your scene, or for clouds to pass if they shade the sun you want. If it's overcast, use a skylight filter. If it's raining, protect your camera and go on shooting when you can't wait or come back. Carcassonne in a light rain is even more charming than in overhead sunlight, and lots of other places will be equally attractive in "bad light." The only miserable light obscures the form of mountains or buildings, making them look flat or uninteresting. If you have time, wait for the sun and avoid blah lighting.

People are usually important to scenic views. Put them there or wait for people to move where you want them in the composition. Figures give scale and human interest to pictures that may otherwise seem a bit empty.

If you must shoot from moving trains, buses or cars, do it. Try to avoid reflections on windows, use a shutter speed such as 1/250 or faster when you can, and use an extender or switch to a medium-telephoto lens. A sharp eye helps make instant decisions as you pass rather swiftly by a subject worth shooting.

If you have time, take tours to see where the spots are you want to photograph. Then rent a car, take a taxi or whatever to get back to the place of interest when the light will give you the effects you are trying to achieve.

Take plenty of chances. If you are not sure of an angle or exposure, click off two or three shots. Film is cheap and tickets to faraway places are not. Don't "wish you had" shot something that you might well have waited for or walked to, then and there.

Travel and photography are inseparable to many SLR users. The impressions you see through the finder you'll enjoy again projected on a screen or hung as prints on the wall. You may have pictures worthy of contests or for submission to the pictures-from-readers pages in magazines. If you make a scrapbook of your trip or a slide showing for friends, you can be reasonably certain it won't have the cliche look some of us find to be too conformist.

Small figure gives scale and human interest to this Yosemite waterfall shot at 1/250 to freeze the water partially. Almost any scenic picture is better with someone in it. Cover the top of this picture and notice the loss of dimension and scale.

Though color photography is discussed thoughout the book, in this chapter I want to pinpoint some specific situations people often face.

Color photography used to be a lot more difficult, but today's SLR exposure systems, plus improvements in color materials and processes, make it easier than black-and-white. Here's why:

You don't have to process or print your own pictures to get professional results; good color labs are located all over the U.S.A.—and some bad ones, too.

If you want to make color prints at home, available kits are easy to use once you get the hang of it.

Tone values, the light and dark scale in b&w photographs, are often separated by hue in color pictures. Two gray tones very close together in a black-and-white print may separate handsomely in a color shot because they are two different colors. In other words, you have the element of color to produce visual contrast that might require darkroom manipulation to attain in b&w.

Color films have enough *latitude,* the ability to tolerate at least one stop of over- or underexposure, to provide sparkling color in many cases when the *f*-stop and shutter speed combination do not match light intensity precisely.

Color films are all convertible: You can have slides made from negatives as well as prints, or prints made from slides, and black-and-white prints from color negatives are not bad at all.

Color films from slow Kodachrome 25 to fast Kodacolor 400 are adaptable to all sorts of light and picture situations. I still prefer to shoot slides, but using the RGB Eastman 5247 color negative mentioned in Chapter 4, I have the best of both worlds.

The two main problems in shooting color are enough light of the right type, and making the color count. I have emphasized the strengths, nuances and delights of color photography but you can't always use color as effectively as you may wish. If the subject you shoot is drab, but you know that skin tones will be warm or cool and shadows will be light or dark, you plan and interpret ahead of time. Mentioned before, the skylight filter and the polarizing filter are the two most useful to outdoor color pictures. However, the daring photographer uses the "wrong" filter or the "wrong" film to get startling effects sometimes when a "no-no" becomes the basis for real color impact.

1

1/The lovely pastoral scene in Italy was taken by my wife Barbara Mills Jacobs after a rain. She has a strong affection for backlighted greenery and signaled me to stop the car quickly so she could make this elegant composition. The film was RGB, one firm's name for Eastman 5254.

All color films do not render greens the same. Some are more yellowish or bluish. If you have shot similar outdoor subjects on two types of film, compare them. Whether one is better than the other is subjective. If you have a favorite slide film with hues that please you, stick with it and enjoy.

In analyzing a variety of color situations shown in this section I've chosen different technical problems—mixed with some esthetic ones.
2/The five-second time exposure of Sacre Coeur in Paris taken with a 21mm lens on RGB film. The church is white, but the warm artificial lighting registers in this way on daylight-type film without a correction filter. I knew the very-wide-angle lens would give me some perspective distortion which I wanted for its distinction.

3/The model was photographed on Ektachrome-X in open shade with a skylight filter that prevented cold skin tones. I took advantage of natural reflection from a sunny concrete deck behind me and shot at 1/125 and f-8.

4/My goal was to freeze the whale's jump at the peak of action which I did at 1/500 and f-8 on RGB color at ASA 100. Lens was a zoom set at about 180mm.

5/Blue sky tinted the water and shadow areas are cool-looking on Kodachrome II in this photograph at Yosemite National Park. People in scenic pictures give them scale and human interest, even if the figures are tiny. The new Kodachrome 25 is supposed to have brighter greens which this shot could have used. Lens was a 35mm.

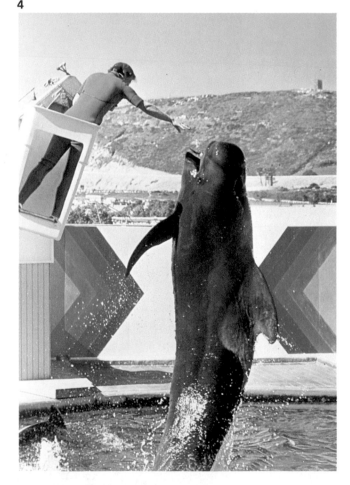

6

6/A different approach was taken from a London sightseeing bus when I knew I couldn't hold the camera steady enough for proper sharpness. At ƒ-4 and with the shutter open on B, I jiggled the camera for a 3 or 4-second exposure. During the ride I tried this half a dozen times and here is the pattern of lights I like best. The film was daylight RGB. Night pictures seem to have better color and warmth with daylight films, even though you are shooting artificial light.

Earlier I mentioned the variability of color print processing which is subject to human error and uncertain laboratory standards more frequently than color slides. Color negatives are usually processed OK, but inexpensive prints are mass produced by machines. Unless someone adjusts these color-printers sensitively, all sorts of color shifts are possible—and probable. Skin tones in a print made by one lab may be agreeably warm but too blue from the same negative handled by another lab. You have to expect and accept slightly-off-color prints at times, but when the color shift is more than usual, even grotesque, ask for reprints

which are due you without charge. If your processing lab is consistently careless, switch to another one. Until you pay more for hand-made color prints—which is only worthwhile in enlargements of 8x10 or more—you can't be too fussy about results but you should expect and demand reasonable quality.

7/An example of bounced electronic flash on High Speed Ektachrome. The light is pleasant and even without harsh shadows. I used a 28mm lens at ƒ-4 and 1/60, focused carefully for sharpness from front to back.

8/The unposed double-portrait was made beside a large window on RGB film. Light reflected from within the room helped illuminate the shadow areas, and a white wall served well as the background. My 100mm lens was set at ƒ-5.6, shutter speed 1/60.

9/A brilliant poinsetta plant became an exciting picture because I had a macro lens with me when visiting friends. Amazingly, I also had a tripod so I could make a careful composition on Kodachrome II. In sunlight, ƒ-16 and 1/15 second. Red

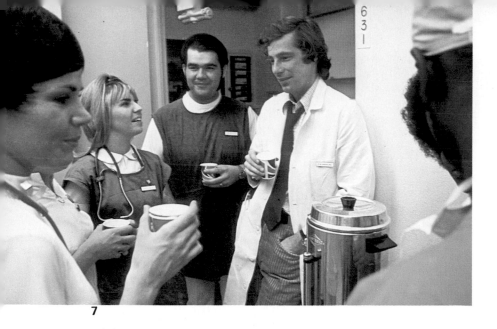

7

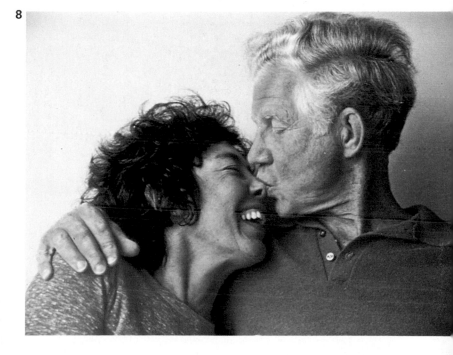

8

9

is another color not reproduced in the same way by different color films; this is accurate, but some are slightly blue or orange.

10/The classroom shot of a child coloring is included to show how an FLD filter corrects the greenish color of fluorescent lighting with a daylight film such as High Speed Ektachrome. There was also a little daylight coming in the windows which is an advantage.

11/On a magazine assignment I photographed singer Carol Lawrence with one of her children at home, informally, the same way you can approach your own family. Near a window in her living room I shot High Speed Ektachrome at 1/125 and *f*-6.3

165

10

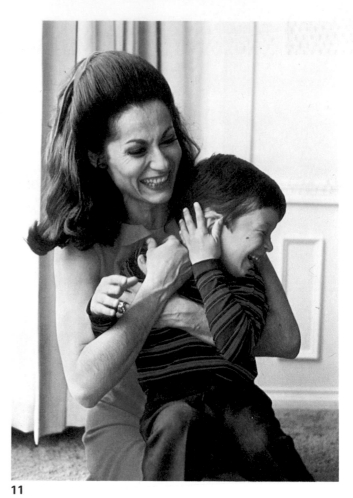

11

12

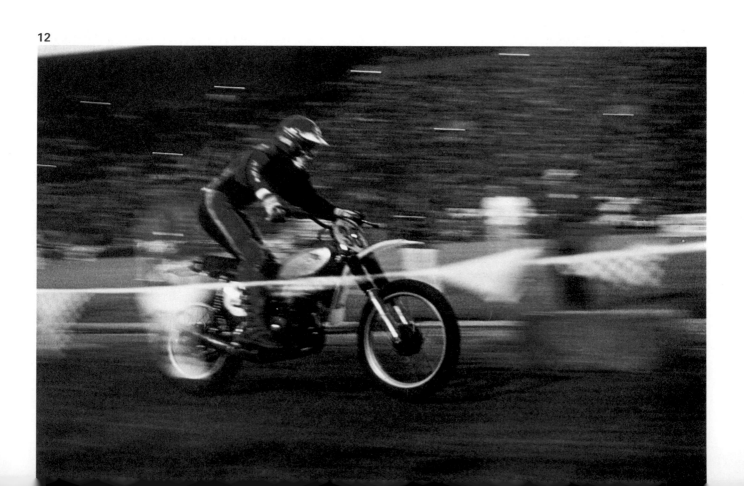

13

14

15

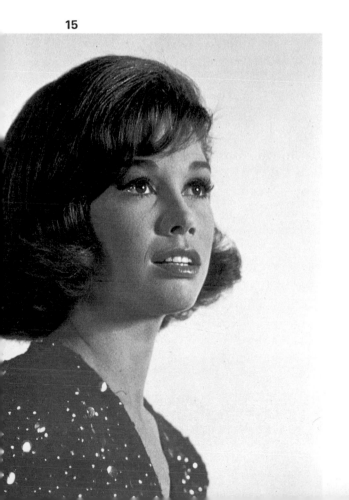

16

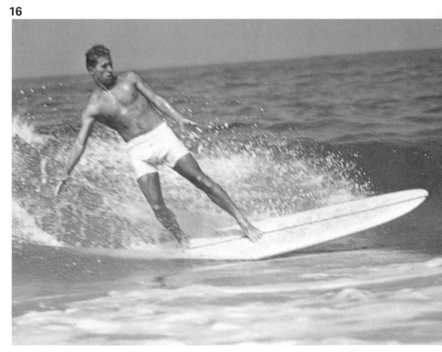

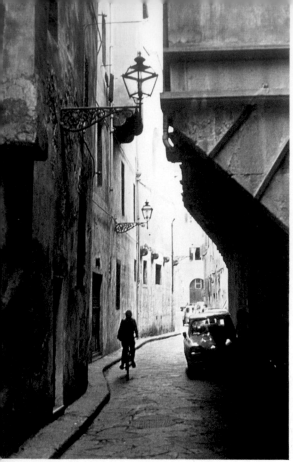

17

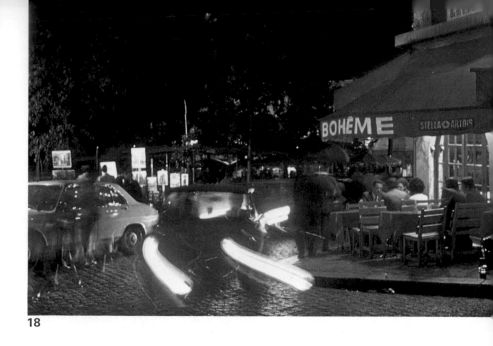

18

with a 35mm lens on my SLR. If contrast had been difficult, I would have clamped a small EF unit on a stand and bounced it from a white wall or ceiling to help fill shadows.

12/In Chapter 7 I described the conditions in which my son Barry Jacobs shot a motocross race using my SLR with a 65-135mm zoom lens. Before darkness fell he shot some color slides on RGB film that was push-processed and rated at ASA 400 —the same speed Kodak and private labs offer for High Speed Ektachrome and special processing. The color balance looks good. He panned the camera at 1/125 and f-4.5 to almost stop the cyclist's action while nicely blurring the background. Panning often creates an agreeable pattern from an otherwise distracting background.

13/Backlighting dominates this scene at Manzanita Lake in Lassen National Park photographed on Ektachrome-X with an 80-200mm zoom at 1/500 and f-6.3.

14/An intentional double exposure put a flower afloat in the sky, taken by Barbara Mills Jacobs who loves to "mess around" with double exposure effects. Camera was a Pentax, 105mm lens, Ektachrome-X.

15/Studio floodlights, the main one at right, another on the background and a diffused one on the left were used for this portrait of Mary Tyler Moore. Again a Pentax with 105mm lens on High Speed Ektachrome Type B.

16/Surfing, like many subjects, requires practice to photograph effectively. If you don't have the right equipment—long lenses or motor drives, for instance—and know what to expect from man and nature, you miss out frequently. I used a 300mm lens on a Pentax, Kodachrome-X film, 1/500 second. Of a series of surfing pictures only a few were OK. Experience helps; it's nice to get lucky once in a while; but if you are using good technique you will always get quality through quantity.

17/I snapped a narrow Barcelona street using a 52mm lens on my SLR. Contrasts of size and tonality help make the picture appealing.

18/I've included another Paris night shot because I like the atmosphere created by the blurred figures, the streaked lights and the overly-warm color. Photographers in recent years have gained such technical mastery of light, action, depth of field and sharpness that many have turned to the influence of painting. I don't mean this in a critical way—but analytical. If you are able to use technique and create images that are soft-focus, blurred, pastel or otherwise reminiscent of the painter's art, why not? There should be no limits about style, subject or approach with your SLR. Good taste and pictorial impact are the only universal criteria.

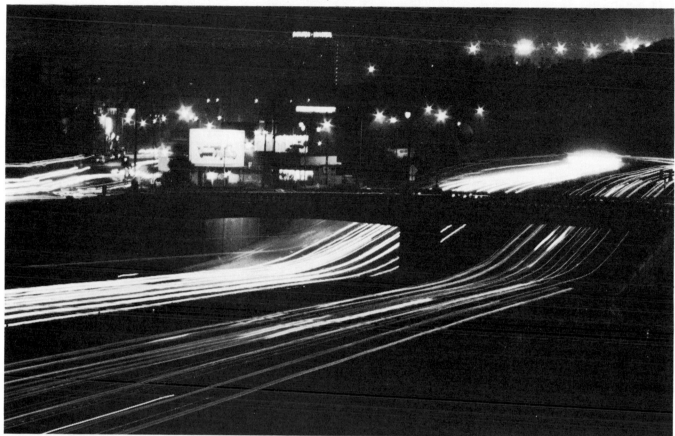

Film collects light—in this case from passing cars. Heavier white lines show where there were more of them. A few bright specks is all you would see without a time exposure at a scene such as this. I set the 35mm lens at *f*-4.5, and locked the shutter open on B. When traffic was light, I held my hand in front of the lens so background subjects wouldn't be over-exposed. Total exposure was probably about 5 seconds on Tri-X rated at ASA 400. Sometimes pinpoints of light turn into stars due to atmospheric effects but you can always get them with a star filter.

Maybe you remember the first night pictures you ever shot. Mine were made of a snowy street-lighted scene in Pittsburgh, with my camera on a borrowed tripod, and a couple of people freezing as they stood under the light, casting angled shadows in the snow. I suppose I bracketed the exposures—meaning to shoot a short series to include exposure times on both sides of the interval that is supposed to be correct. Anyway, I shot at 1 sec., 2 sec. and up to 5 sec. because I was unsure of myself. Later when I saw the proofs, I was amazed. Detail appeared on the film that was invisible to my naked eye. Finally I figured out

why: Film *collects* light, depending on exposure, while the sensitivity of our eyes has a limit. By adding seconds, I increased shadow detail and picked up even dim highlights in the darkness, none of which I could perceive in the finder.

Time exposures after dark or in deep twilight can produce photographic effects to give your pix a new pictorial reality. This is especially true when lights or figures are moving. I'm sure you have seen photos of strange streaks of light from automobile headlights in a street, or perhaps the famous photo of Picasso "painting" in the air with a wand that had a small light at the end. I think it was David

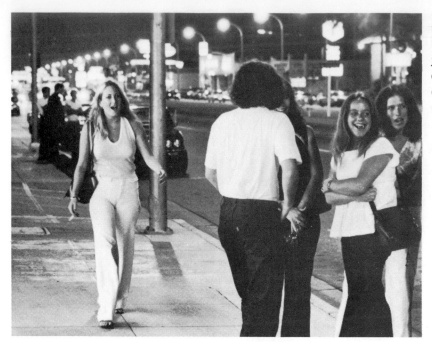

A fast film such as Tri-X was indicated for this shot of teens meeting on a busy street at night. I shot at 1/60 and ƒ-5.6 by rating film at ASA 1,000 and developing in Acufine. My built-in camera meter was quite adequate to measure exposure in this illumination.

Douglas Duncan's picture, shot in total darkness, after which he flashed a strobe to show the artist behind his painted-light pattern. In the color section of this book is an impression of London traffic and lights made by purposely jiggling my camera with shutter open. I was on a tour bus stopped for a traffic light, and knew I couldn't hold the camera steadily for about 3 seconds, so I moved it to attempt a decorative pattern.

CHOICE OF FILMS

For time exposures, fast, medium and slow black-and-white films are all adaptable . If a situation calls for 2 seconds at ƒ-3.5 with Tri-X, it would be about 6 seconds with Plus-X and 25 seconds for Panatomic-X. The image will be the same on all these films for a scene in which nothing is moving, but streaks of light or blurred figures will be more extended or pronounced with slow films than with fast ones because the shutter is open longer. My preference for Tri-X is an advantage for time exposures when I choose to expose only a few seconds, or want to use smaller ƒ-stops for longer intervals. In other words, you will have a broader range of exposure times and apertures with a fast film, particularly useful when lights or people are in motion.

Though a color film balanced for artificial light may seem more appropriate outdoors at night, I use daylight-type films because of my personal preference for their warmer hues. Also, a lot of artificial lighting today is the colder fluorescent and mercury-vapor type, or colored neon, all of which benefit from the warm rendition of daylight-type films. Even the house lights seen from outdoors look better as yellowish areas with daylight film, than they appear in the colder hues of Type A or Type B films.

Whether you shoot Kodachrome 25, Agfachrome 64, one of the Ektachromes, or a color negative film, is up to you. Experiment first with one that is familiar and if you want to have experience with a different one try it next. In case of slightly inaccurate exposure, especially overexposure, a negative can be corrected somewhat in printing by a custom lab but the results of a slide are fixed. Slides can be copied to correct them somewhat—but it takes some experience to do it yourself.

ESTIMATING EXPOSURE

Sensitive built-in SLR light meters will register some night scenes, but keep in mind that mostly the bright subject matter is being measured. If you want better shadow detail, and don't mind some highlight areas being overexposed slightly, increase exposure by about 50% over that indicated by the camera meter. As an example, if the meter reads 1 second at ƒ-2.8, opening the aperture halfway between ƒ-2 and ƒ-2.8 is 50%.

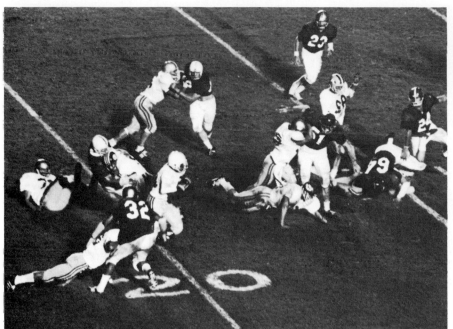

With a fast enough film you won't have to guess at exposure for sports events at night, especially if you measure the light through a telephoto lens. This scrimmage was shot with my 80-200mm zoom at 1/125 and *f*-4.5. Because the action was many yards away, I focused at infinity and didn't worry about depth of field. Choose Kodacolor 400 or Fujicolor 400 or get special push-processing for High Speed Ektachrome at ASA 400 if black-and-white is not your favorite.

As an approximate guide to exposure which varies according to the brightness of lights and how evenly distributed they are, here's a table of estimates:

Subject	Exposure at ASA 25	Exposure at ASA 400
Brightly lighted streets	1/2 second, *f*-4.5	1/60 second, *f*-3.5
Lighted fountains and monuments; if colored lights, open lens at least one stop more	1 second, *f*-4	1/30 second, *f*-2.8
Interiors, medium-bright	1/2 or 1 second, *f*-2.8	1/15 or 1/8 second, *f*-2.8
Dimly lighted street scenes	3 to 15 seconds, *f*-2.8	1/4 second, *f*-3.5

When shooting in dim light, it is sometimes very handy to use an automatic camera and let it control exposure. This usually requires shutter speeds longer than 1 second—a point you may wish to consider if you are shopping for a camera. Depending on brand and model, some cameras have slow shutter speeds ranging from 8 to 30 seconds or longer.

When making exposures longer than 1 second, you are likely to need more exposure than an exposure meter or automatic camera will suggest, because of a film characteristic known as *reciprocity failure*. Check the film data sheet. One way to give more exposure with an automatic camera is to set the film speed dial to a lower number. Dividing film speed by 2 gives one stop more exposure. Some automatic cameras have a special control to give an extra stop or two of exposure.

SPECIAL EFFECTS AFTER DARK

Time exposures after dark are a combination of happy chance, careful planning and good technique to achieve drama, impact, mood and atmosphere. You may also discover exposures where you can't figure out exactly what happened. Expect the unexpected as the film collects an image or series of images your imagination can visualize, though your eyes cannot.

Shooting at night is a great time for experimentation. I've found offbeat techniques often accomplish artistic effects I would not enjoy unless I took some chances. Here are ways to use your SLR for special effects:

Multiple Images—Making a double or multiple exposure with your SLR might be tricky, if the mechanism to do it is not incorporated into the camera body. As mentioned before, with a lever that allows you to cock the shutter *without* advancing the film, placing one exposure on top of another is easy. You must remember this: *For*

A different kind of street scene taken by Terry Healy of Bethlehem, PA, won a Kodak/Scholastic award. Flared lights were caused by thin fog which gave Terry's picture the atmosphere of a painting. His hand-held SLR moved slightly during the 1/30 exposure, but the fog made everything soft-edged anyhow.

Panning my camera on a tripod with a 2 second exposure produces an impressionistic image of a jet landing.

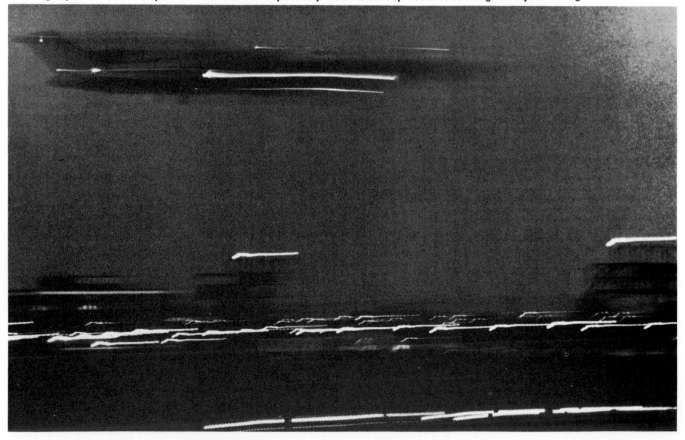

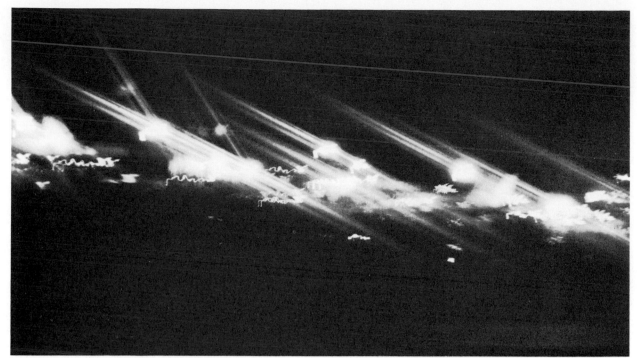

Blurred, jiggled and light-streaked by oily haze on a jet window, San Francisco's airport becomes a decorative pattern from a moving plane. The shutter was open about 3 seconds at ƒ-4 with a 50mm lens.

a double exposure, the exposure time for each image must be cut in half. If correct exposure for a scene is 1 second at ƒ-4 and you plan a double image each of which requires about the same time, cut each in half by shooting either at 1/2 second or ƒ-5.6. Cut shutter speed or ƒ-stop, but not both. In this way the film receives the correct total exposure, half of it for each image. This rule is *not* so important for time exposures of a few seconds or more, as it is for fractional exposures such as 1/125. There's more leeway for error when exposure time is lengthy than when it's short. You'll find more about making multiple exposures in Chapter 15 with some examples.

Blurred Images—In many time exposures after dark, even at 1 or 1/2 second, moving subjects appear as short blurs on the film. Try to anticipate where and how these blurs will fit the composition and visual impact you're aiming for. Sometimes you just can't tell in advance what will happen, or you don't care. This is what I call the *serendipity factor*. Serendipity is a lovely word describing the faculty of making happy or desirable discoveries by accident. You compose as accurately as possible and make a series of time exposures, knowing or hoping that one or more will be a fortunate accident, the conditions for which you set into

play. You'll enjoy the serendipity factor when shooting with care, but you'll probably not get it if you expect random photography to offer the same rewards.

A blurred time exposure I enjoy is reproduced here. It was made from a tripod at Los Angeles International Airport after I finished shooting some other more conventional pictures for a book about air-traffic control. The sun was setting. Planes were landing a hundred yards in front of me. It was too dark for anything but a time exposure, and I accentuated the blur and light streaks by panning the camera a short distance while the shutter was open for about 2 seconds and the aperture set at ƒ-3.5. The film was Tri-X rated at its normal ASA 400, developed in my old favorite, Microdol-X. Against a gray sky the darker plane and buildings form a rather spooky decorative pattern that immediately said "Flight" to me. At the same time I shot four other negatives—none had images as well composed as this one.

Another impression of lights, forced into long streaks by the thin layer of smog on the window of an airliner, was taken as the plane taxied for take-off at San Francisco International Airport. You see the jiggled lines of other lights on the ground, but the strongest ones were affected by the resi-

173

Moon at dawn through branches of a tree is part of an undistinguished composition—considerably altered by a zoom effect seen in the adjoining picture.

Serendipity and a 1 second exposure while zooming converted an ordinary view into a mysterious and exciting image. Photography with your SLR is full of surprises such as this if you search for them.

due on the glass. The shutter was open about 3 seconds.

A more predictable variation of this effect is possible by using a "star" filter over your SLR lens. Star filters are disks of clear optical glass into which extremely fine straight lines have been etched in a cross-hatch pattern with many lines per inch. More widely spaced lines produce larger star effects, while more closely spaced hatching makes smaller stars. Such a filter influences small circles of light most strongly, and can be used best for daylight scenes when shooting into a light source. Some pinpoints of light will flare into star shapes all by themselves on film without a filter, but if you want unusual images you can predict, a star filter can be pleasing. You can see the effect in the first photo of this chapter.

Changing focal length of a zoom lens during exposure for action subjects was described in Chapter 8. After dark the same technique is often fun, using a few seconds exposure, whether there's movement in the scene or not. You have to experiment with moving-zoom pictures, and serendipity plays a large role. To show you how unpredictable the results can be look at the two shots of the moon through tree branches. I set my SLR on a tripod at dawn one morning when a full moon

was shining in a dark gray sky. From the straight shot of the moon you might never anticipate that moving the lens from long to short focal length would produce the delightful blurred image. A really "nothing" composition was converted by zoom magic into a mysterious and artistic photograph.

The possibilities of zooming during exposure are limitless. I don't suggest that it will turn the commonplace into the extraordinary all the time, but if you've used other techniques at night, and have a zoom to play with, by all means use it to stretch your photographic potential.

There's a blend of conditions after dark and in available light, especially indoors, when long exposures provide slides and prints impossible any other way. Shooting by candle light, with just the glow of city lights in the distance, or by moonlight along a country road—all can be photographic adventures. During or after a rain, city streets pick up fantastic reflections and highlights—especially in color. Fog and darkness often make a strange mixture to fascinate, and the world after a snowfall has a storybook look at night. Pack your tripod, a watch you can see in the dark, some film and your SLR. Take off into the night, and become Prince of Serendip.

The Greeks had a word for it . . . *macro,* meaning large or great. Adapted to photography, macro signifies an enlarged image shot closer-than-normally to a subject using close-up lenses, rings or a bellows attachment.

With a single-lens reflex, moving within inches of a human eye or a postage stamp is really a cinch. You often get slides or prints with larger-than-life details which are sometimes not readily recognizeable. Years ago *Ford Times* ran monthly "mystery" photos of tree bark, tire tread, sea shells, watchworks and hundreds of other items for readers to identify. Small details, blown up, appear with a sometimes offbeat new reality because of unfamiliar scale.

Before reviewing equipment for close-up photography with the SLR, let's discuss a few special approaches necessary to enter the macro world.

CLOSE-UP PRINCIPLES

Sharpness is even more important to close-up work than to average photography, because fine details are being enlarged and anything less than precise definition is immediately noticeable. This means two essential prerequisites: A firm, steady camera and as much depth of field *as possible.* The former stipulation is best satisfied by a good tripod. Buy the sturdiest model you can afford—not too heavy for comfortable carrying—with as many tilts and adjustments as you'll need. There are lots of brands at many prices. I have a four-pound tripod with an elevator I bought for traveling—about $15—and a $55 nine-pounder that opens to a seven-foot height. When I'm shooting at home or can haul the latter in my car, I feel more secure with the larger one, though my camera only weighs about two pounds.

It's also feasible to shoot close-ups with a hand-held SLR in bright light, using a fast shutter speed to compensate for not having a tripod. Excellent sharpness is possible this way, though depth of field suffers if you cannot use small *f-*stops. A number of the pictures in this chapter were taken with my Konica Autoreflex T hand-held. These include the blow-up of the tape-recorder circuit and the bee on page 207.

Close and closer—that's the macro world open to the SLR photographer with minimum investment. With a macro lens, close-up lenses or rings or with bellows, the close-up world is easy and fun. Both shots were made at 1/500 and *f*-16 on Tri-X. My camera was on a tripod, though at that shutter speed I could have hand-held it.

This close up of a tape recorder circuit was shot with a hand-held SLR about five inches from the surface in bright sunlight at 1/500. If you plan to make big enlargements or will project your slides, the improvement in sharpness will usually be noticeable when you shoot from a tripod.

Both were shot on Tri-X with a macro lens set at f-16 and 1/500. This is a normal outdoor exposure for fast film, and allowed me to follow the bee with far more mobility than a tripod permits.

You remember that the closer you are to a subject, the less depth of field you have at any given aperture. Depth of field is often measured in fractions of an inch when you are very close to something. Stop down your lens to the smallest opening possible to assure sharpness from the closest to the farthest point or plane of the subject. Critical focusing is also very important. The depth-of-field scale on your normal lens barrel is not marked for macro photography, so you often must rely on the depth of field preview which is practical most of the time.

As you'll see, there are several ways of making close-ups. If you do it with a special lens designed for macro photography, the lens will usually have scales to indicate depth of field at all settings but

the lens-barrel scales may be hard to read. The instruction booklet that comes with such lenses probably has detailed tables including depth of field.

If you get higher than normal image magnification—another way of saying close-ups—by some other technique it is difficult to find depth of field tables applying exactly to what you are doing. Use the preview button on your camera and after you have some experience depend on the know how you have gained. Carl Shipman's book *Understanding Photography* has close-up photos he took of a yardstick to show depth of field under different magnifications. Calibrate your own equipment that way and then you will know.

Light may be the problem. If you can't get enough light to shoot at the smallest aperture or nearly so then close-ups will suffer from limited depth of field. Make a compromise focus to get the nearest items or details sharp and let the rest

Lighting for this close-up of orange slices is discussed in the text. Two inexpensive close-up lenses were attached to a normal SLR lens about five inches from the subject.

of it soften as it recedes into the background. This is how the human eye sees normally, though you are not very aware of it, because eye-focus shifts instantly as you look deeper into a scene.

If you have vision problems, an accessory magnifier or diopter lenses to correct the finder image in place of your glasses is valuable in macro and most other photography. You'll see detail and sharpness more clearly. In addition, it is advisable to use a cable release to operate the shutter. This helps avoid camera vibration. Remember—even the slightest jiggle will be magnified many times in an enlarged print or projected slide.

LIGHTING FOR CLOSE-UPS

Proper lighting depends on the size, shape and texture of your subject. If what you're shooting is fairly flat and finely textured, you will probably want a main light—assuming you're using floodlights manageable for macro photography—at a low angle to accentuate whatever texture there is. When I shot the slices of orange I used one reflector-flood bulb low at the right and illuminated the shadows with another reflector flood pointed into an umbrella for a soft, shadowless light. Highlights and shadows are tiny in fine-surface texture; hence the low-angle light to amplify them. Had I shot the same or a similar subject outdoors, I would have waited for the sun in late afternoon, and used the umbrella again to fill the shadows.

Quartz lights, regular photoflood bulbs in reflectors and electronic flash can be positioned in the same way for fine texture, or any close-up work.

General Electric makes a neat 150W reflector-*spot* bulb that throws a beam of light just right for small objects. It doesn't cover a large area, but you are usually focused on an expanse of only a few

Yashica *f*-2.8 60mm macro lens was only two inches from this fingerprint on a pistol showing the detail possible in the close-up world.

inches, so the spot bulb is excellent. Its *beam* picks up texture better than the more diffused spread of a flood bulb.

 Two lights are usually sufficient for close-ups. The main light is usually closer to accentuate surface form or texture, while the other is farther away, or aimed at a reflecting surface to lighten shadows, but not eliminate them. In some cases, particularly when a subject is light-colored, one light is enough because it bounces around and shadows are not very dark.

 Flat lighting is called for when you photograph a flat subject. This category of the macro world is called copy photography. The enlarged picture of postage stamps is an example. Two lights, one from each side at equal distances, are preferable and the goal is even illumination without shadows. Camera and accessory manufacturers offer copy stands to mount an SLR to move up and down on a center post like an enlarger. Movable arms for two reflector flood bulbs are usually included with a copy stand, which you only need if you are really going to copy a lot of material. I once made 500 slides of magazine and book pages for a photo-journalism class I teach, and without a stand I would have been lost. You may also make a copy arrangement with a tripod, by pinning something

Another kind of close-up with a macro lens caught a small bird landing on a piece of driftwood in a studio setup, using electronic flash. The picture won an award in the Kodak/Scholastic competition, but unfortunately had no credit line. Camera was about 14 inches from the subject.

to a wall and setting the camera opposite it or arranging the tripod so the camera overhangs a table.

Of course, outdoor sunlight is excellent and sometimes the only close-up lighting. It is directional and available for birds and bees and flowers that are such popular macro subjects.

CLOSE-UP LENSES AND EQUIPMENT

In the first place, the average normal SLR lens will focus to about 18-inches from a subject, which gives you a lot of flexibility unknown to owners of most cameras without through-the-lens viewing. In days of yore photographers were worried about something called parallax because the window finder next to the lens of a range-finder 35mm camera, for instance, didn't give the same view as the film actually got through the lens. This is the reason some photographers with non-SLR equipment continue to "cut heads off" when they get close to a subject.

You have no worries about parallax, because what you see through the lens goes on film an instant later as an image. There is one small exception to that statement which you may have wondered about before now. The average SLR camera finder gives you a view a couple of millimeters smaller than the image size which appears on the film. However, the tiny extra margin of picture on the film compensates for the miniscule borders cropped off by a slide mount or enlarger negative carrier. Even if you frame tightly while making a composition in the viewfinder, you'll have a small margin for error, but it's hard to get at and use, so don't count on it except in emergencies.

Macro Lenses—There's a brief introduction to these special close-up lenses at the end of Chapter 3. They are designed primarily for photographing from an inch to a few feet from the subject, and are commonly f-3.5 because a larger aperture is usually unnecessary and it is easier to manufacture fine small-diameter optics than larger ones. Who needs lens speed shooting from a tripod at f-16 and 1/8 second? Thus a macro lens gives you excellent sharpness combined with an ability to focus extremely close to your target. If your budget can stand the cost, a macro lens is the most direct and labor-saving device for a wide spectrum of close-up work. Most are offered by camera manu-

A "mystery" picture if you don't recognize close detail of a shag rug taken with one floodlight and a #2 close-up lens over the normal lens of an SLR. Camera was hand-held, and the f-8 aperture was not small enough for good depth of field because I shot at 1/125 to avoid camera shake.

A thick extension ring between the SLR and its normal lens was used to photograph the outside of a pineapple. Normal-sized textures and shapes assume strange proportions when a small section is enlarged. Weak sunlight gave the pineapple even illumination for an exposure of 1/250 at f-11 hand-held.

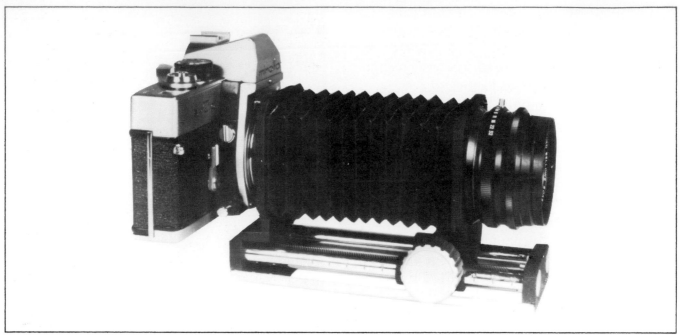

A typical bellows setup on a single track with one focusing knob. Notice how far the lens projects from the camera. This accounts for the extreme close-up capability of bellows with the SLR. Reversing a normal lens adds sharpness if you don't use a macro.

facturers, which is unusual in the photo equipment business. Independent suppliers market all sorts of wide-angles, telephotos, fisheyes and zooms in competition with brand-name lenses, but very few macros come from outside the camera-makers' factories.

Anyway, ask to see a macro lens for your SLR and "try it for size." Experiment with it in the photo camera store at least. It's good for portraits and small segments of faces, for copy work and to explore the details of nature with the convenience of hand-holding your camera, or working from a tripod.

Close-up Lenses—Much less expensive, lighter in weight, not quite as versatile and with somewhat less optical quality than a macro lens, close-up attachment lenses are a great substitute for many purposes. They are usually sold in sets of three, and you screw one into the front of your camera lens, and another one or two into that for greater magnification. Used with a normal 50mm lens, here are the focusing ranges:

	Minimum Subject Distance	Maximum Subject Distance
No. 1 Lens	12–18 inches	40 inches
No. 2 Lens	8–11 inches	20 inches
No. 3 Lens	5–8 inches	13 inches

If you use more than one close-up lens, put the one with the highest identification number closest to the camera lens.

In combination, 3+1, 3+2 or 3+2+1 will allow even smaller subject distances. Check the data sheets that come with close-up lens sets for precise measurements, but don't get all involved with tables of magnification numbers signified with an "X" or charts showing the area each lens or combination covers. Both questions are answered visually as you move your SLR back and forth to compose to include as much of the subject as you wish—to the feasible limits. You and your viewfinder decide on appropriate close-up images.

Though my macro lens makes exceptionally crisp negatives and slides, I usually carry a set of three close-up lenses in my gadget bag to be ready when I don't also have the macro along. My set in its own little case cost only about $15, and takes up very little space in the top compartment. Definition with the attachment lenses is not as good as with the macro, but quite acceptable.

Extension Rings—Called *close-up rings* or *tubes*, these also come in sets of three. One or more rings can be screwed or bayoneted into the body of your SLR, after which you mount a camera lens into the front ring. Minimum focusing ranges are

approximately the same as those listed for attachment lenses. Rings cost more than a lens set, but they are less subject to damage, and offer the advantage of a little more working space between the end of the lens and the subject being photographed. Sometimes this can help you get light in there and onto the subject.

There is a more or less continuing debate about whether close-up lenses are better than extension rings—or vice-versa. Some say the supplementary lenses *have* to degrade the image because they put another piece of glass in the optical path—which is true. What they overlook is the fact that the pure and sanitary extension ring with no glass whatsoever puts the lens farther away from the film than the lens designer intended—which *also* reduces image quality.

The Kodak technical publication N12A *Close-up Photography* says there's not enough difference between the two methods to worry about, and shows pictures to prove it!

Be sure you get a set of rings with the necessary mechanical linkages to preserve the automatic features of your camera. Otherwise close-up work *is* work! Non-automatic ring sets are made for many brands of camera, but they are inconvenient and are being supplanted by those with automatic capability. Often the automatic kind may only be available from an accessory maker.

Bellows for Close-ups—If you have a lot of very precise close-up photography to do, a bellows attachment offers the advantages of shooting extremely close to a subject, plus very fine focusing. Less-expensive types operate on a single rail on which you adjust image size and focus by moving the bellows back and forth. Your SLR is mounted at one end of the bellows, and a lens at the other. Sturdier bellows, usually with greater extension, include a double rail. With a bellows attachment your camera has the configuration of an enlarger, offering an infinite number of lens-to-subject distances and greater magnification than you get with other types of close-up equipment.

Some bellows for specific brands of SLR cameras include a special cable release accessory for semi-automatic diaphragm operation. Without this cable, because the lens is detached from the body, the auto-diaphragm is inoperative, and you must adjust *f*-stops by hand. Thus a special cable release is a real convenience; you usually open the

Stamps copied with Pentax bellows equipment on a copy stand and lighted evenly from each side.

Afternoon sunlight was perfect to bring out texture and detail of this movie camera. Taken with a macro lens on hand-held SLR, *f*-16 at 1/500 on Tri-X rated at ASA 400. Out-of-focus background was expected and appropriate.

lens manually to focus, and the mechanism automatically stops it down to the aperture you've chosen when you make the exposure.

Most bellows can be used to copy slides by attaching a slide holder at one end. More about slide duplication and copying appears later in the chapter.

CAMERA LENS CONSIDERATIONS

Here are some facts and pointers to round off this review of macro equipment: If you use a normal SLR lens in a *reversed* position on the camera or at the end of a bellows, you can get closer to a subject and improved sharpness at the same time. You can buy reverse-lens adaptors to attach the lens to the camera body or to bellows units. You have to open and close the aperture manually, but you're usually not in a hurry when you are doing close-ups.

A few manufacturers offer non-focusing-mount macro lenses in 80mm, 100mm and 105mm especially designed to be used with bellows apparatus. Only if you are going heavily into macro work should you bother to find out if such a lens is available for your camera. Investigate its extra usefulness to determine whether you really need it.

Though close-up attachment lenses and extension ring sets are usually used with a normal SLR lens, they will also fit other focal length lenses with the same thread diameter.

A few macro lenses come with special ring-extenders to provide very close focusing, usually 1:1. That ratio means life-sized images on the film. Some postage stamps are so large today that you can only get a portion of them at life-size on the 24x36mm format of 35mm film.

CLOSE-UP EXPOSURE

If you read the general literature on photography instead of a book dedicated to the SLR like this one, you will encounter advice about exposure correction for close-up photography. If you watch the normal lens on your camera while focusing, you will notice the lens moves away from the camera when focusing on near objects.

To focus on still nearer objects, you have to get the lens still farther from the camera which is what extension rings and bellows arrangements do. Because it changes the geometry of the light path, anytime you move a lens farther from the

film it takes more light to get correct exposure.

When exposure is calculated by light measured *outside* of the camera a correction is necessary when the camera is not set up normally. In the old days, the subject would be metered with a hand-held meter and the resulting exposure setting increased to allow for the additional lens extension for close-up work. The formulas are tedious and troublesome.

Today all that is done by the camera metering system because it measures the actual light intensity that will reach the film. In other words, don't worry about exposure with your meter-equipped SLR when shooting close-ups. Except for long exposures which I'll get to in the next section, there are no problems.

Aside from that, all you need to be concerned about in terms of macro exposure are the usual problems of lighting and subject contrast occurring in many other types of photography. If in doubt, bracket the indicated exposure, over and under a stop or half a stop. Once you know how your camera and meter perform, this probably will not be necessary unless contrast is very tricky.

Incidentally, some macro lenses include a scale on the extended lens barrel with numbers representing lens-stop conversion for extreme close-ups. I suggest you read the literature with your macro lens to discover if all exposures indicated by the camera meter will be normal, or must be adjusted in special cases.

RECIPROCITY EFFECT

Film emulsions are designed to respond best to a range of light values considered normal for a particular type of film. If you expose that film using excessively bright or dim light compared to the normal range, the light is not as effective in creating an image. This is called *Reciprocity Failure.*

High and low light values are naturally accompanied by unusually short or long exposure times. Because we don't know the amount of light absolutely, it is simpler to use exposure time as the clue to reciprocity effects.

Look at the data sheets packaged with film and there will usually be instructions to compensate for reciprocity failure. For unusually long or short exposure times the instructions will tell you how much extra exposure the film needs.

A typical SLR with extension tubes makes many kinds of macro photography easy, including slide copying. Put your camera on a tripod—the slide against opal glass illuminated from behind—and that's all the setup you need.

Yashica TL Electro-X on a copy stand provides great versatility for shooting small objects, flat copy or slide duplication with an illuminated box such as the Maxwell described in the text. Copy stands are also available without lighting equipment for less money.

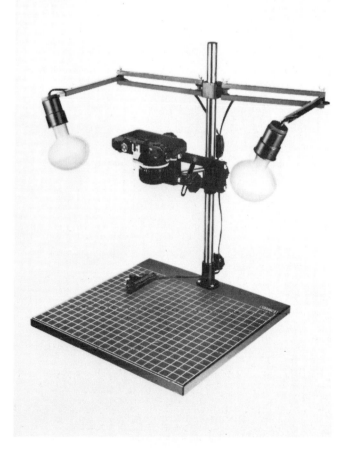

This problem and handy solution apply to any kind of photography including night-time but is particularly likely in close-up photography on account of the lens extension business discussed above. You should always know when you are courting reciprocity failure because your exposure times tell you. Just follow the data-sheet info or get Kodak's Darkroom Data Guide.

SLIDE COPYING

If you have a bellows, you can add a copy attachment to duplicate slides in color, or make black and white negatives from them. There are also several varieties of slide copiers on the market. One type attaches to your camera body and has a simple built-in lens. Another type accepts your normal lens, which seems a better system, because it is likely to give sharper images. Camera shops sell slide copiers or duplicators for about $20. At the same price there's also a new and clever model sold by Maxwell Photo-Mural Tanks, 999 E. Valley Blvd. No. 6, Alhambra, Calif. 91801. It's a plastic box with three translucent plastic sides through which light is directed and diffused. You use a macro lens with it and position slides over a hole in the box at any angle. Write to Maxwell for literature on his unique copy device.

You can also make your own setup to copy slides by positioning a sheet of opal glass or plastic in front of a light source, and laying a slide on the glass. A similar scheme can be built to stand the slide in a slot; the camera is set in a jig-like arrangement that requires minimum focusing. Take a look at some commercial copiers and you'll see what I mean.

Two things happen when you copy a slide onto similar slide film. Contrast increases and the colors change a little bit. You can cause other bad things by not focusing carefully or using the wrong light to illuminate the slide you are copying. Anybody who says his slide copies are identical to the originals probably is not looking at them critically.

Kodak makes Ektachrome Slide Duplicating Film No. 5038 with reduced contrast which you should consider if you plan to make copies in quantity. Otherwise, I'd suggest films such as Ektachrome 64 or 5247 color negative which have less inherent contrast than good old Kodachrome. In the process of copying, some subleties are lost, even though they may not be noticeable unless

original and copy are side-by-side. Therefore, you have to think about accurate color rendition, sharpness, exposure and contrast for successful slide copy work. I hope it doesn't sound too easy, because it isn't.

You must use photofloods balanced to the type of tungsten color film in the camera, or electronic flash if you load daylight-type film. You may also rig up a mirror to reflect sunlight at your color slide, if you want to work with nature's illumination. To make b&w negatives from color slides, any of the above will do, but one flood is easiest to manage, and color temperature of the light doesn't matter.

What *does* matter in slide copying is: Cleanliness. Even the tiniest speck of dust or a scratch on the original will be faithfully duplicated in copies. Fingerprints or smudges have to be carefully cleaned from the slide, too.

Correct exposure is also important. Shoot several frames of each slide you copy and keep a record for later reference. You may then be able to set up a standard arrangement of light, copier and camera with the same film, and know precisely what exposure to use. Even this proven setup is subject to variation when slide colors are subtle, contrasty or too dark in the original. However, with experience, you'll come up with a technique that is dependable. I say that glibly perhaps, because it takes a lot of patience and skill to make consistantly good slide dupes or negatives. If you have only a few copies to make once in a while, send them to a lab and relax.

If you want the creative pleasure of copying two or more slides together—called sandwiching—to form a multiple image; or to enjoy the special effects of using colored filters or copying only a portion of a slide or slides together, then a dependable copy arrangement can be worthwhile. There is special equipment for this purpose, such as a lightbox on which you lay slides, or an expensive machine called a Repronar in case you really get involved in slide duplication and color manipulation. If you have seen the beautiful work of Pete Turner, many of his pictures are slide combinations made with a Repronar.

When I shoot b&w negatives of slides from which I occasionally wish to make enlarged prints, I use Tri-X film—not for its speed—but because its inherent contrast is lower than slower films. I

Some photographers use a macro lens on an SLR instead of the normal lens, making it easy to focus close for a subject such as sunspotted leaves.

make such copy negatives rather seldom and I shoot at least three exposures of each slide to assure one that will print well.

SPECIAL STUFF

There is other equipment for your SLR if you want to shoot through a microscope, using its lens in place of the camera lens. Check with the manufacturer of your camera or a well-supplied photo shop.

Special circular ring-light electronic flash units are available to fit around a macro lens, or normal lens with attachment lenses or extension rings. These units provide a soft, almost shadowless illumination for close subjects. Dentists often use a ring-light for macro shots of teeth and mouth details.

The close-up world is waiting to be explored. It is wide open to you and your SLR, and for a few dollars investment, you can be shooting flowers, insects, coins, stamps, models—and a whole gamut of subjects with comparative ease.

What makes a good picture? **SPONTANEITY**

Spontaneity is tied to human interest, emotional impact, drama and peak action. That's because so many qualities of a good picture are interlocked. As you shoot with an SLR, there should be an image or a concept in your mind of the pictures you hope to get.

In this case twin boys were being readied for a bath, and their mother stood behind me to talk and distract their attention. My electronic flash was pointed at the ceiling, and the white bathroom was a natural bounced-light location because every wall served as a reflector. In fact, I overexposed the negative slightly because the setting was so bright. Notice there are soft shadows only, a lot more pleasant than flash on camera ever produces.

Look for spontaneity in people indoors or out; by ingratiating yourself, being alert for exciting moments and taking plenty of pictures, and you'll never shoot another ordinary snapshot.

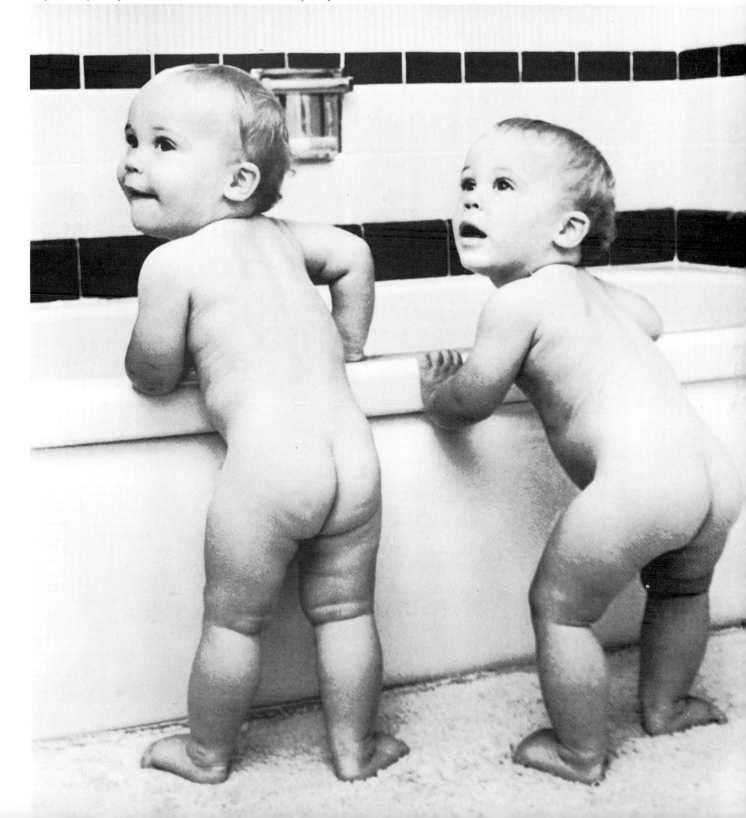

What makes a good picture? LUMINOSITY

Sunset. I yielded to perhaps the photographer's oldest cliche here and used a shot symbolizing, "As the sun slowly sinks into the horizon," which any travelogue viewer has seen a thousand times. Some things are basic: A pretty girl, a gurgling baby, awe of the highest mountains, and the majesty of a sunset in symphony with clouds and sky.

For a shot like this to work and bring on the elemental sadness that comes with the end of a day, or separation of friends or lovers, it must achieve the fundamental quality of sunsets—luminosity. The sky is ablaze with assertive colors adorning magnificent cloud forms—punctuated by laser-rays of sunlight reaching out to what we don't know. It glows everywhere near the sun, and every being takes meaning from it.

Shot by Bill Josh Young with his Nikon, while doing his usual fine job as Art Director for this book.

What makes a good picture? LUMINOSITY

Electronic flash is fast, light-weight, economical and adaptible to color or b&w. Every SLR owner should consider buying an EF unit if enough flash pictures per month make it worthwhile. Kids were lighted with two EF's one at the left and one by the camera.

Flash, called "the lively light" by another writer years ago, is really a convenience most of the time, and a necessity when other lighting is too weak, too contrasty or absent. I appreciate flash, especially electronic flash—referred to here as EF. But as you will discover, I believe in keeping it in its place.

The newcomer to SLR photography may have graduated from a simpler camera with few controls and a relatively small-aperture lens. Such

a camera *requires* flash a lot of the time indoors to assure an image.

The average single-lens reflex is far more adaptable to lower light levels in which you may use a large ƒ-stop, fast film, or both. It's my feeling that too many photographers with versatile SLR's shoot with flash when they might get more natural pictures in available light. They are hypnotized by the "glamour" of flash photography that seems to affect so many people. Flash *is* expedient and valuable, but it is not a status symbol to own and operate a fine EF unit which provides flat, monotonous illumination that takes no imagination, and only wins prizes when the subject is of exciting news value or when action is frozen to fascinate the viewer.

I think you should own a small EF unit and understand flash technique. At the same time, you should develop a feeling about the value of flash—when it's appropriate—how to exploit its versatility and when to leave it in your gadget bag. Otherwise, you will end up with a collection of uninspiring flash-on-camera snapshots that may look no different than you could get with a $50-camera, except they may be a little sharper.

FLASHBULBS & CUBES

Let's assume that you have recently bought an SLR with a few rolls of film and have been enjoying a new depth of photography. Pretty soon you have an urge to take pictures indoors or after dark where flash is fast and handy. It's too early in your photographic experience to think about floodlights but it's perfectly normal to turn to flashcubes, especially if you have used them in the past with another less-sophisticated camera.

Flash bulbs—They cost more than cubes, and you need a separate reflector, but some sizes offer a lot more light than cubes or small EF units. If you are shooting slow color film in large rooms where you have to stand 15 or 20 feet from a group, for instance, you *may* need flashbulbs. I doubt it, so let's dispense with them for average use.

Flashcubes—An adaptor that fits into the accessory shoe of your SLR is inexpensive, either the hot-shoe or synch cord type. It has a small battery case which is unnecessary if you use Magicubes. An adaptor for Magicubes is smaller and may be more efficient, if you choose this variety of flash.

If you find you are shooting one or two rolls of film a month with flash bulbs or cubes, figure out how much you've spent on light. At this point, a small EF unit often becomes economically advisable. Even before this point, however, remember cubes and bulbs have to be stored, carried and disposed of, that shutter speed is limited, and that you keep buying and buying forever. To avoid these disadvantages, think first of electronic flash for your SLR, and you may be glad you never bought a cube or bulb.

FLASH THEORY

Before delving into equipment and techniques, there are a few important slices of photo theory which influence the kind of flash you choose and use. You may have noticed that the farther something or somebody is from a light source the darker that subject appears in a slide or print. Someone very close to your camera and its flash may be overexposed, but the same burst of light somehow dissipates before it gets to the background.

This problem is caused by what's called the *inverse square law.* There's a mathematical formula to explain it, but this isn't a math book. Think of it this way: *Light falls off. The intensity of light diminishes rapidly as its distance from a subject increases.* It's another of those laws of physics that some understand better than I, but my experience is practical. I know that if I am six feet from somebody, I use a smaller ƒ-stop with flash than if I am 10 feet away in the same kind of setting.

When you use floodlights and the amount of illumination diminishes on a subject more distant from the light source, your SLR meter measures it accordingly, and you expose properly. No problem.

But flash is the instant light, and it looks very bright. When you know it falls off or loses intensity as it gets farther away, you'll understand flash exposure. Just keep in mind that the greater the distance you want your flash to carry, the larger the ƒ-stop you will set. There is an exception to this rule when you use an *automatic-exposure* EF unit, and you'll hear more about it shortly.

SPEED: FLASH DURATION

I have mentioned before that electronic flash "freezes" a subject in action. This happens because the duration of the light averages 1/1000 second—and ranges up to 1/70,000 for some automatic EF units. The average small electronic unit consists of

This and the next picture demonstrate two things: Light falls off, and flash is sometimes better than natural light. Floodlights from the right side of the picture left strong shadows on this dinner crowd, and the light level was so low an exposure of 1/15 at ƒ-4.5 on Tri-X rated at ASA 1,000 was indicated. The hand-held camera was not perfectly steady, and d.o.f. carried only about half way back.

From the same spot a few moments later I shot with one small EF unit at ƒ-8 and 1/60. Bright foreground and dark background illustrate how light falls off or diminishes in intensity as it travels farther from the source. Image is sharp and depth of field is greater. My client—a large industrial magazine—was happier with this lighting than the natural room lighting, because the image is sharper and more people are recognizeable. Film was also Tri-X at ASA 1,000.

Flash freezes action—especially electronic flash—and is ideal for sports events indoors when you can get close enough to the subjects. A high school student shot this Kodak/Scholastic award winner.

a case with a plastic lens covering a reflector fitted around a gas-filled tube. When you depress the shutter release of your SLR, a circuit within the camera fires the flash at the precise moment when the shutter is open all the way. The flash is *synchronized* with the shutter. An electrical charge ignites the gas-filled tube which glows brightly for a tiny fraction of a second. Electricity from batteries or household current replenishes the EF components and in a matter of seconds, the unit is ready to fire again. This is called the *recycling time* which ranges from one to nine seconds depending on the unit and battery condition.

A flash bulb or Flashcube is also ignited by an electrical charge except for Magicubes which don't need batteries because they are fired mechanically. The duration of a bulb or cube is much longer than electronic flash, averaging about 1/50 second. This is fine when people are not moving very fast, but 1/50 is not adequate for many action subjects, so you get a certain amount of blur unless you use

a fast shutter speed with bulbs or cubes. This is not possible with most SLR cameras, unless you use FP bulbs made especially for focal plane shutters. More on this soon.

EXPOSURE: *f*-STOP VERSUS SHUTTER SPEED

Knowing the duration of flashbulbs, cubes and EF, it has probably occured to you that because bulbs and cubes are relatively slow at 1/50 second the *shutter speed* you choose determines whether you stop motion. With electronic flash, the reverse is true because it flashes in thousandths of a second, it freezes action even if the shutter speed is only 1/60 or 1/125 and exposure is therefore determined by the *f-stop* you choose. In a darkened room, even if you set your SLR at 1/8 second or slower, it's the EF duration and intensity that must be matched with proper *f*-stop for correct exposure.

Exposure for a cube or bulb is also set by adjusting the *f*-stop, but people dancing wildly will be blurred at 1/8.

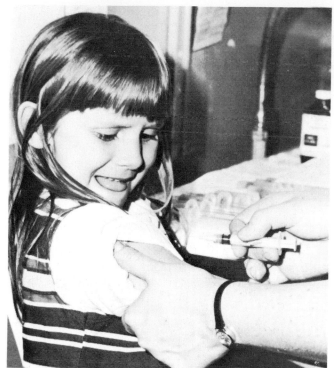

A flashcube on the camera was convenient when John A. Webb caught a moment of grim anticipation for this youngster and won a Kodak award. At distances from very close to 10 feet flashcubes offer plenty of light for fast color or b&w.

FLASH OUTPUT

Each size of flashbulb and EF unit offers a specific amount, or output, of light. Large flash-bulbs put out a large amount of illumination, but you will have little use for them. They are expensive, require special reflectors, are bulky to carry, are relics of the past now used only by professional photographers who shoot large areas with slow films and want a lot of instant light. Small bulbs and cubes are adequate for almost all average picture situations.

Electronic-flash units are manufactured to look almost alike in size, but inside their electronic parts differ. More expensive and powerful units put out a stronger light per flash than smaller, more economical models. EF units are rated in *beam-candlepower-seconds* (BCPS). The higher the BCPS output of a unit, the more light it offers, and the smaller the f-stop you need for a given flash-to-subject distance. EF units are also rated by guide number for one or more film speeds such as ASA 25.

GUIDE NUMBERS

A guide number—GN—relates the ASA speed of a film to the light output of the flash. Guide-number tables are printed on bulb and cube cartons, and sometimes on small charts on electronic flash units. You simply divide the number of feet from flash-to-subject by the flash guide number for the particular film speed you are using and you come up with the proper f-stop.

For instance, if the guide number for your EF unit with K25 is 40, and you are 10 feet from a group of people, the proper f-stop is $40/10=f$-4. If the distance is 6 feet, 40 divided by 6 is roughly 7, so set your f-stop between f-5.6 and f-8.

Most EF's have an exposure calculator dial built-in. It's faster to use than dividing distance into guide numbers.

As a comparison of guide numbers in relation to BCPS output of various EF units, refer to the chart on page 193. Literature with your flash unit should state its BCPS rating or guide number.

Neither guide numbers nor the exposure guidance from a built-in calculator dial can be taken as total gospel. Instruction booklets should point out the conditions used to rate the unit. Assuming that ratings are made in a neutral gray room of "average" subject matter, neither all white nor all black, you must keep in mind that you

The instruction book with your electronic flash should tell how to use the flash with backlight subjects so the face is well illuminated, rather than in shadow.

At weddings, dinner parties, receptions and other crowded and poorly lighted events, one flash on the camera is a practical way to shoot with an SLR. It's not artistic light, but images are sharp and expressions can be captured without subject blurring. For this group I used a guide number of 110 with my small EF unit. At 10 feet with a 35mm lens, the guide number indicated f-11 as the aperture for Tri-X. Lighting is even because all were about the same distance away.

An automatic EF sensed the brightness or reflectivity of these teens having fun, and set the flash to match an f-4 opening. A large number of new and automatic electronic flash units make this kind of photography more accurate and expedient—but the effect of any type of flash on camera is often monotonous.

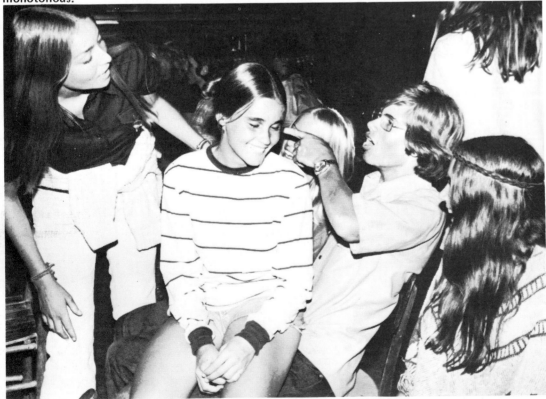

don't always shoot in the similar circumstances. Indoor settings may be all white or off-white, walls may be brightly colored or wallpapered, ceilings may be high or low, carpeting and furniture can be any brightness and reflectivity, and people are black and white with all sorts of clothing. Therefore, you should follow these guidelines:

In a very bright room of average height, where light will bounce around, decrease exposure by at least one-half-stop from that indicated by a guide number.

In a very dark setting such as wood-paneled walls and dark ceiling, increase exposure one-half to one full stop above that indicated by guide number.

Outdoors at night when there are no reflecting surfaces around, increase exposure by one stop more than indicated by guide number.

If your EF is automatic, you should also consider the above conditions, because light or dark surroundings, or non-reflective outdoor night locations, can "fool" the sensor. If you photograph a couple in light-colored clothes against a dark wall, the unit over-compensates to average the two extremes of tonality, and you'll probably get overexposure. The reverse may be true with a dark subject and a bright background. What happens is similar to the reaction of a camera's exposure meter under similar circumstances. Again, you have to apply eye and brain power to adjust your clever—but non-thinking—equipment.

FIND YOUR OWN GN

Over the past couple of decades I've heard it said many times that camera shutters vary, and we know very well that individual standards of taste about "good" negatives and "good" slides are not decreed by a government agency. Therefore if you have an ordinary non-automatic electronic flash unit or an automatic unit with a manual setting, you should make a simple test of its guide number. Besides, if you are not familiar with an EF unit, this is a fine way to break it in and get the feel of its light. Here are the instructions, and you can have some fun at the same time:

1. Find a setting and a model: An average room that's not too light or too dark, and an attractive model dressed in medium-tone clothes.

2. Load your SLR with Kodachrome 25, set the camera with EF on a tripod or firm base exactly 10 feet from the *face* of your seated model. Measure the distance with ruler, tape or anything reliable but don't guess and don't depend on the camera's focus scale.

3. Make a series of f-stop signs. Ordinary typewriter paper will do. With a felt-tip pen write in large letters the f-stops you will need. If the

If you know the BCPS rating of your EF unit you can find the GN for common film speeds listed on this chart. BCPS ratings are across the top, film speeds down the side, guide numbers in the body of the chart. For example, a BCPS rating of 1,000 has a GN of 55 when used with ASA 64 film.

GUIDE NUMBER CHART

ASA Film Speed	BCPS Rating									
	350	500	700	1000	1400	2000	2800	4000	5600	8000
25	20	24	30	35	40	50	60	70	85	100
32	24	28	32	40	50	55	65	80	95	110
64	32	40	45	55	65	80	95	110	130	160
80	35	45	55	65	75	90	110	130	150	180
125	45	55	65	80	95	110	130	160	190	220
160	55	65	76	90	110	130	150	180	210	150
400	85	100	120	140	170	200	240	280	340	400

recommended guide number for your unit is 40 for K25, at 10 feet f-4 would be on the nose for exposure if all conditions are right. That's what you're testing to find out.

So you need an f-4 sign and others to bracket exposures two stops over and under.

4. Starting at any f-stop you like, make a series of two shots at each lens opening while your model holds the identifying sign for that aperture and makes faces at you. The camera stays at 10 feet distance. Monitor the time it takes the EF ready-light to come on and wait that much longer before you trigger the next flash—this assures uniform light.

5. When you get the slides back, look at them and pick the one you like best. If modern technology is dependable and the manufacturer of your unit is not overoptimistic about guide numbers, the most acceptable slide should be the one shot at the recommended f-stop—the one you got by dividing guide number by distance.

6. If you like another shot better there can be two possible reasons. The room you used for testing may not be average in the mind of the EF manufacturer. There's not much you can do about that. If the room is average in your view and you plan to shoot in such rooms, then you need a guide number you can use in those surroundings.

The other reason is that the manufacturer got it wrong. Your attitude is the same. You still need a good guide number for the places you like to shoot.

Whatever the possible reason, the practical answer is to use a different guide number for that EF unit. You can find it through simple arithmetic. Multiply the f-number of the frame you prefer by the distance of ten feet and the result is your own guide-number rating. If you liked the exposure at f-5.6 best, then your guide number will be 56 no matter what anybody else says.

Now That You Found It—You have to remember that the guide number is only for that film speed and that kind of a room. The suggestions I made earlier about shooting in non-average surroundings still apply. If you want a guide number for another film speed, the surest way to get it is make a similar test with the different film.

If you're sold on science you can save a roll of film. Figure the new guide number for a new film speed as follows: Divide the new film speed

Bounced flash by itself offers a softer light than flash on camera, and is also useful to augment existing light. This technician was testing a lens arrangement and bounced EF illuminated his face while reducing contrast from overhead fluorescents. Exposure was 1/60 at f-9 with Tri-X rated ASA 1,000.

Even with a known guide number for my EF unit, it was necessary to experiment to photograph fish in a tank with a macro lens, because water absorbs a certain amount of light. The flash was located above the water and light bounced upwards from bright gravel to fill shadows.

If you set a shutter speed faster than the maximum allowed for electronic flash with your SLR, this is what can happen. The shutter is only half open as the EF fires. Be sure to stay with the recommended shutter speed or a slower one to assure synchronization.

by the old speed. Take the square root of the result. Multiply that square root number by the old guide number. Result is the new guide number. Example: Old guide number is 33 feet for ASA 25. What will it be for ASA 64? $64/25 = 2.56$. $\sqrt{2.56} = 1.6$. New guide number = 1.6 x 33 = 53.

USING AUTOMATIC FLASH

Automatic-exposure EF's include a sensor to measure light reflected back from something you're photographing. The sensor measures and computes, and the unit puts out just the right amount of light for the film speed and an *f*-stop stipulated for that ASA rating—according to the brightness of the subject.

Inside a circuit responds to the sensor, to *quench* or shut off the light at the precise instant dictated by *f*-stop, film speed, subject distance and subject reflectivity. Instead of 1/1000, the light for a close-up subject might be quenched so quickly the flash duration is only 1/10,000. In this way speeds attained with EF units can even freeze a bullet in flight.

Most auto-flash units can be switched to a non-automatic mode and used with a guide number, the same as the simpler variety of EF.

Automatic doesn't mean you should assume one of these units will give you *exact* exposure under all conditions. Automatic flashes are subject to all of the things non-automatic flashes must be compensated for—but you don't have to change the *f*-stop for distance—within the range of the automatic's light capabilities. You do have to compensate for non-reflecting rooms, high ceiling or outdoors.

The best automatic EF units have tilting heads but sensors that point at the subject no matter which way the light is aimed. You can also remove the sensor on some units and mount it on the camera shoe to shoot with the light off-camera.

While automation isn't perfect, you can give it a boost toward consistent reliability by reading instruction booklets and following directions. For instance, an auto-flash unit may allow you to shoot at two to five different *f*-stops so you have some control of depth of field.

Some units have a sufficient-light indicator you can watch as you make a test flash before shooting. If the light glows, the flash is producing enough light and you can make the shot.

There's no need to worry about guide numbers or a calculator dial—unlike non-auto flash. With some units, you can switch to manual mode and adjust a dial to get half, a quarter, an eighth, or even smaller fractions of the total light output. In the manual mode, therefore, you should know the guide number or numbers if there is more than one power setting. If your instruction booklet doesn't give them, find out what they are by testing as described earlier.

These guide numbers will come in most handy when you want to shoot at distances closer or farther than the automatic range provides, or if you work with multiple flash.

Other Ways—A big advantage of automatic electronic-flash units that measure reflected light from the scene and then turn themselves off is that you don't have to fool around with guide numbers and distances to the subject. Within limits you can just walk around and shoot letting the automatic flash unit worry about exposure.

There are a couple of other clever approaches to free you from guide-number cares. Nikon offers a GN—for Guide Number—lens. It is mechanically smart inside . . . already knows f-stop equals guide number divided by focused distance. To use the lens, you set in the guide number for the film and flash you are using. When you focus, it automatically adjusts aperture to the right size for distance and that guide number.

Canon's CAT system—Canon Auto-Tune—consists of a camera-mounted flash unit and an adaptor ring to fit over the front of the lens. When you focus, the adaptor ring sends a signal back through a cord connector to the flash unit and camera. The signal tells how far away the subject is, and is used to affect the match-needle display in the viewfinder. The result is, you shoot the same way with flash on the camera as you do without. Just match up the needles and fire. You do have to wait while the unit recycles, as with any other EF.

When you have used any system that allows you to forget guide number and distance calculations, you won't go back to doing it the old way.

FLASH TO MATCH COLOR FILMS

Electronic flash should be balanced for daylight-type color films. Occasionally, its light is too cold or blue and a correction filter is necessary. If yours is off-balance and you don't want to worry about filters, take it back and replace it.

Blue flashbulbs or cubes are also balanced for daylight films, and clear bulbs are available for tungsten-type films. Chances are you will rarely use the latter, but you'll find the clear ones slightly less expensive than the blue kind so buy those for use with black-and-white films.

SYNCHRONIZATION WITH YOUR SLR

If your camera has a hot shoe to mate with a flash or EF unit without a connecting cord, use it when you prefer flash-on-camera results. If your unit will tilt to face the ceiling for bounce flash, a hot-shoe connection is even more valuable.

Otherwise you connect your flash or EF equipment to your SLR by a sync cord from unit to camera. Plug it into the X outlet for electronic flash and the M or FP outlet for most bulbs and cubes. Special FP bulbs for use with SLR focal plane shutters allow you to shoot at all shutter speeds. Check the instruction booklet for your camera to determine which sync outlet is used with specific types of flash equipment and bulbs.

On the shutter speed dial of your SLR opposite 1/60 or 1/125 second there is probably a small red X or some other special marking. This is the recommended speed for electronic flash. A chart in your instruction book probably indicates synchronization for EF will be okay at all slower speeds but *don't use EF at faster speeds than the one marked.* The reason? Well the shutter will only open part way before the flash goes off, and you get half an exposure as seen in the example by an anonymous person who accidently set the shutter speed dial at 1/250.

The average single-lens reflex camera synchronizes at 1/60, for EF, but some sync at 1/125. The latter is an advantage in two situations. First, outdoors when you use electronic flash to fill shadows cast by sunlight, you can shoot at a faster speed and avoid overexposure. It is impossible to shoot Tri-X for instance, at 1/125 and f-16 in bright sun, unless you use a neutral-density filter. However, a slow film will allow that exposure though a 1/60 limit might still require a neutral-density filter. The other occasion is when there is a lot of daylight and you're shooting EF. The faster 1/125 speed helps to prevent what are called *ghost images.*

Remember that electronic flash lasts only 1/1,000 or sometimes less. The focal-plane-shutter mechanism in your SLR requires selecting a shutter speed of 1/60 or 1/125 only to be sure the shutter is fully open during that brief 1/1,000 second when the EF is popping. For the rest of the exposure interval, the EF is turned off but the film is still being exposed by the surrounding light. The surrounding light—even though less bright—gets on

With an electronic flash that recycled in a few seconds, Owen De Vere Rogers of Phoenix, AZ could snap half a dozen shots of his brothers posing in front of a flag before they lost patience. Check recycling time of any EF unit, because it is important when you're in a hurry. Owen's shot won first prize in the Scout Photo Scholarship Awards sponsored by Eastman Kodak. His dad held the EF unit high and to the left.

the film longer so it can make an image also. It doesn't matter much if the second image overlays the first one but if something moves or you move the camera the second image won't overlap exactly and will appear as a ghostly copy of the main image.

Obviously ghost images can only happen when the surrounding light is fairly bright such as outdoors or in strong room illumination. When that is the case, the sooner you can get the shutter closed the better, so 1/125 is a better shutter speed with EF than 1/60.

BOUNCE FLASH

Flash-on-camera gives interesting photographic effects like those you see on the public enemy posters down at the post office, or on your driver's license. If someone photographs you that way, try to look mean and maybe there'll be a reward posted.

When a flash unit is connected to the camera by a cord, many photographers use a long cord so they can hold the unit off to the side and not illuminate the subject prison style. From there it's a natural step to aim the flash at a wall or ceiling so it bounces before it falls on the subject. This gives a very nice effect.

If your flash is connected by a cord, just point it where you want the light to go. If it mounts on a hot shoe on top of the camera, check your camera shop for an adaptor swivel to allow pointing it in different directions. The swiveling head on some EF units will point up while installed in a hot shoe.

With flash bulbs or a non-automatic EF, you calculate exposure using the flash unit's guide number. But you can't use the distance to the subject because the light doesn't travel that direct path anymore. It's bouncing off the ceiling or a wall. Here's a rule of thumb that fits average surroundings: Figure exposure for the direct distance to the subject and then open up the lens another two stops.

Then use your own judgment as described earlier. If the room is dark open up some more. In addition, you have to allow for quite a bit of light being absorbed by the wall or ceiling which will probably require opening up another stop or two. The difference in aperture between a direct-flash exposure and bounce flash under the same circumstances can be three f-stops more for bounce.

Make some tests similar to the guide number tests described earlier. You'll get familiar with the technique and the results that way.

If you have an automatic EF, bounce may be very easy. It depends on where the sensor of the auto flash is looking. In some units the sensor always looks where the flash goes, which means it is looking at the ceiling when you bounce the flash. If you have that kind, you can't easily use it on auto while bouncing. Switch it to non-auto, or manual operation and work with the guide number as described above.

Other EF units provide for bounce flash. With the kind that mount on the camera but swivel the flash head upwards, the EF sensor continues to look in the same direction as the camera. Thus it always sees the same light the camera lens does and shuts off the flash when enough is enough.

A more sophisticated type of auto EF uses a light sensor attached to the camera with the EF on a long cord so you can point it anywhere while the sensor continues to look where the camera does. With these types of auto EF, just let it go until it turns itself off.

THE CASE FOR ELECTRONIC FLASH

If you can afford a single-lens reflex, you can afford a small electronic flash unit, because they are sold for as little as $15-20. More power and more adjustments come for more money, but a unit for around $40 to $60 should be more than adequate. The lower figure pays for an excellent non-automatic model, and the higher one is close to where automatics begin . . . at least in 1974 when this book was first printed.

For the investment you get convenience, freedom from further expense except for occasional batteries and high-speed light that stops action. Why carry flashcubes and be restricted, when you can tuck a small EF unit into your gadget bag, and pay for it once?

Many EF units can be powered by household current as well as batteries—at no cost per flash. Many times I attach the 10-foot cord to my small unit and plug it into a wall socket when I am shooting from a fairly stationary spot. I also plug the AC cord into an extension and range 25 feet from the wall socket when the cord will not be in anyone's way. My unit recycles in 2 seconds on AC, and the light is ready almost as fast as I can advance and shoot, with no battery drain.

RECYCLING TIME

The time it takes for an EF unit to replenish its power between flashes is called *recycling time.* Super-fast thyristor units recycle in ½ to 1 second, and models using high-energy batteries recycle in 2 seconds. The average unit with alkaline or nicad batteries takes 4 to 10 seconds, depending on brand and battery condition.

When the ready-light indicator comes on, your unit is probably not completely charged. Wait another few seconds to be certain you have a full charge, because in some brands the ready-light is set to come on at 75% of charge, on the basis that you're going to take a few more seconds before shooting anyway. Check with the manufacturer of your own unit for specific data.

BATTERY POWER

Choosing the type of battery power best suited to your personal photography habits is a serious consideration when you buy an electronic flash unit. Here's a run-down on the options:

Alkaline batteries are first choice for anyone who takes flash pictures just occasionally. They

Vivitar Model 202 electronic flash is one of the least expensive automatic units. It weighs about 7 oz. and has a guide number of 30 with K25 film.

are relatively inexpensive and long-lasting. They give more flashes than ordinary carbon-zinc batteries and are usually the better buy.

Nicad batteries are rechargeable, cost a lot more than disposable cells, and are advisable only if you shoot 3 or 4 rolls a month with flash. Being able to recharge a set of nicads in 15 to 30 minutes is very convenient, and frequent use amortizes their cost in short order. But—unless you use the nicad-equipped unit regularly, nicad life expectacy dwindles. In other words, every 2 or 3 weeks you should use the flash unit to shoot, or just fire it without exposing film, to exhaust the power in the nicad set. In this type of service nicads retain their full capacity for up to 1000 recharges. If you don't use the battery, it deteriorates in storage. Unfortunately, electronic flash manufacturers don't

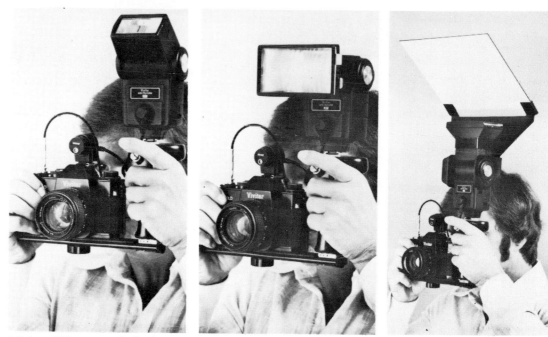

Vivitar 283 automatic flash can be used several ways. At left, flash head is swiveled upward to bounce light off the ceiling. This gives more diffused natural-looking illumination of the subject. Center photo shows flash head pointed directly at subject, but an accessory lens or filter is clipped over the front of the flash tube. These accessories are available to widen the light beam for use with wide-angle lens, or to change the color of the light, or to diffuse and soften the flash. Without any accessory clipped over the flash head, the resulting photo would show effects of direct flash. At right, flash head is pointed straight up so light is bounced off card held in holder—also for diffusion. In all examples, flash sensor is detached from flash unit and mounted on camera hot shoe, so it always "looks" directly at subject.

often tell us how to keep nicad batteries in good condition. Discharge nicads regularly and then recharge them to retain their distinct advantages. I have two nicad packs for my EF unit, and can replace an exhausted sets in moments if necessary.

High-energy dry-cell packs are available for some EF brands, and they are great if you shoot a lot in locations where AC power is not accessible. However, high-energy batteries made in 240V, 267V, and 510V, are fairly heavy, costly, and bulky. In other words, I'd recommend them to a professional, but the average serious amateur would be better off with nicad power.

Finally, there's AC power, the practically-free electricity you plug into. With a long extension cord, you can roam around most rooms firing an EF unit without worrying about battery depletion.

In quick review, most portable EF units use penlight cells, and the alkaline type is most practical for the average user. If you shoot frequently enough, or drain-and-charge nicad batteries regularly, they're great. And there's always plain elec-

tricity, good old AC, when you want to save your batteries and there's a place to plug in.

THE CASE FOR AUTOMATION

Shortly after you buy a single-lens reflex, you'll feel the urge to shoot with flash at night, or during the day in dimly-lit places. Some people start with a flashcube adapter, because they don't want to rush into buying electronic flash. That may be a good idea, if you use a couple of cubes a month. But if you'd rather not be limited, consider a simple, manual, compact electronic flash. These retail for around $10 to $15.

However, for twice that amount, you can buy an automatic unit—which I advise unless you are operating on a very tight budget. It is so convenient, it saves film by assuring good exposures, and it may encourage you to take pictures with flash more often because it's so easy.

As you pay more for electronic flash, you get more versatility in terms of adjusting the direction of the light and varying flash output, and you get

Compact Canon AB-56 has tilting head for bounce flash and guide number of 56 for K25 film. When mounted on some Canon models, this flash automatically sets the camera to the correct shutter speed for electronic flash.

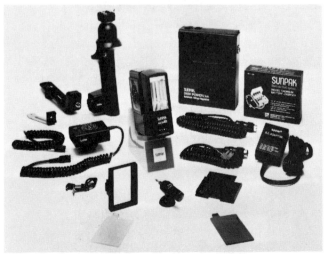

One of 15 Sunpak electronic flash units, the automatic 411 is medium-priced, with a guide number of 50 for K25 film. Accessories for the 411 include bracket and pistol grip at top left, remote sensor at mid-left, filter holder, slave-eye at bottom center, accessory connecting cords, case for high-voltage batteries top right, nicad recharger and AC adapter at right.

more light and greater choice of battery operation. More expensive units offer nicad, or high-energy batteries, along with AC, while cheaper units may operate only on throw-away batteries.

The use of thyristor energy-saving circuits is spreading widely, and that's good for us all.

All automatic EF units shut off the light to provide only the amount of illumination needed for a given film, distance, and f-stop. In a non-energy-saving unit, the unused energy is dumped or wasted. In a thyristor energy-saving unit, unused energy is saved for the next flash. Battery life is extended and recycling time is decreased. The closer you are to the subject, the less light is needed, and the faster an automatic unit recycles.

As for battery life, if a manufacturer says a unit gets 150 or 200 flashes or more on a set of batteries or a nicad charge, that's under ideal conditions, but it's a good guide. Carry fresh batteries or a nicad charger if you need insurance.

As for the size and shape of the EF unit you choose, price, power, individual needs, and what's available should all be considered. A one-piece rectangular shape is most common. A rectangle with a tilting flash head is a good choice. A two-piece unit with separate battery pack is very specialized, a lot more expensive and usually much more powerful. A detachable sensor that you can attach to the camera is useful—particularly with flash units that you can hand-hold away from the camera.

SHOOTING TECHNIQUES WITH ELECTRONIC FLASH

Look back in Chapter 6 at the illustration for direct front lighting. That is usually the effect you will get with a flash unit mounted atop your SLR. It's expedient, and millions of pictures are taken every year with this variety of light. I use it myself when I'm covering a wedding or a news event or something mobile that will quickly be over. There's no time for more artistic lighting—except for bounce flash.

Bounce Flash—I explained previously to aim your unit at a white or light-colored ceiling which acts like a big reflector and spreads the light while softening shadows. You can bounce a flash to cover six people or one without the pasted-on black shadow behind them that appears when you shoot with flash-on-camera. Bounce is pleasant for portraits, and I use it often to fill or strengthen

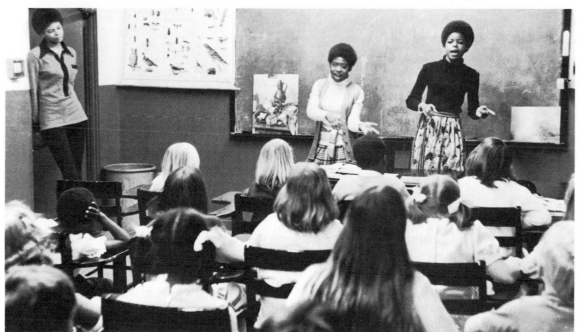

Classroom lighting was not bright or even enough, but the addition of one bounced EF unit allowed an exposure of 1/60 at *f*-6.3. White ceiling was high requiring ½-stop more than usual diaphragm opening. The girls were part of a singing group called Sunday's Child performing for youngsters in school.

existing light in offices where I photograph people for business publications. Overhead fluorescent lighting may be a bit too weak, and a bounced EF unit gives my pictures more brilliance. At the same time, light bounces from desks or tabletops into eyes and under chins to lighten them. By all means experiment with bounce flash to be familiar with its effects and advantages.

You can also bounce an EF unit against a light-colored wall to get a side-lighting effect. If the room is average size, and the opposite wall is also light-colored, illumination will bounce back to fill the shadow side of a face or figure. In offices where I can work in an 8x10 foot room, for instance, I sometimes switch from ceiling to wall for my bounced EF for an interesting variation.

You can use an umbrella as a bounce reflector, and place it over or beside someone. It will give you approximately the kind of light seen in the floodlight example in Chapter 6.

Flash Off the Camera—Somewhere you may have seen a professional photographer shooting with an SLR in his right hand and an electronic flash unit held high in his outstretched left hand. Or the EF might be positioned above a group of people on a light stand. As you know, the high angle adds form to faces, avoiding the flat look, and moves background shadows down to a point where they

An extender between camera and EF unit gives the light a few inches elevation for better modeling. U-joint extender is made by Rowi. Extenders also prevent "red eye" which sometimes results from flash on camera reflecting directly back from interior of subject's eyes.

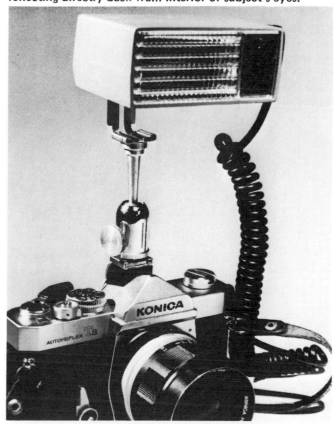

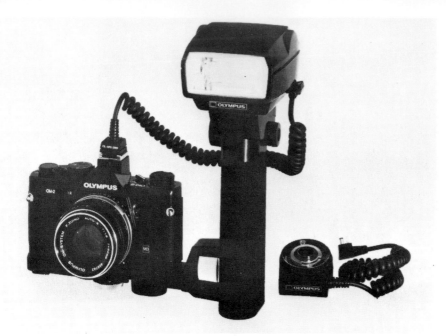

Olympus OM-2 camera provides automatic control for Olympus Quick Auto 310 electronic flash unit, using camera's internal light sensors. At right is remote sensor for use with other 35mm cameras.

may be out of the picture. A pro may take time to improve the lighting even if he can only use one flash source. A direct flash held high and to one side of a subject is stronger than if it were bounced, allowing you to use a smaller ƒ-stop, important for slow color film. Remember, if a bounced exposure requires a large aperture with which you get almost no depth of field, you can hold the flash off the camera for better modeling of the light.

Multiple Flash—It should be obvious each lighting example shown in Chapter 6 can be duplicated using electronic flash. Floodlights are much less expensive, and you can see the effect of the light before you shoot. This is only possible with flash if you also place a flood bulb next to EF unit. Professionals do this in a studio. Their large electronic flash reflectors also have a small tungsten modeling light inside them next to the EF tube. Studio EF produces 10 times as much light as an average portable unit we may use, but it costs 10 times as much, and the power pack is operated on AC and rolls around on wheels!

The point is: Fundamental placement of light applies to EF just like floods. If you get the itch to use two EF units at the same time, it's not difficult. You experiment placing them as you would with floods; one in front, one to the side for fill,

or one into an umbrella to illuminate shadows. You may attach the second unit to a light stand, clamp it to something in a room, or ask someone to hold it for you outside of the picture area.

And how do you get both EF units to fire in unison? It's easy with a *photo-eye,* a small electronic gadget that plugs into the off-camera EF unit. When the flash at the camera fires, light from it triggers the $15 photo-eye or *slave* unit to fire the second EF unit instantaneously. No wires, no fuss, no batteries. There are also photo-eye units that operate from small batteries, but I'd look for the non-battery type because it's worry-free. The one I have is called a Green Dome. In your local camera shop ask to see flash slave units.

If you use two automatic EF units at the same time what they do will depend on where the sensors are looking. You'll have to do some thinking and testing. If your units are not automatic, use the guide number for the closer one to determine exposure; the more distant one, acting as a fill, will be slightly weaker and provide the effect you want. If both are equally distant from a subject, the light is apt to be flat. These directions, by the way, are based on using units of equal power. If one has a higher BCPS rating than the other, you might use it as the main light and the

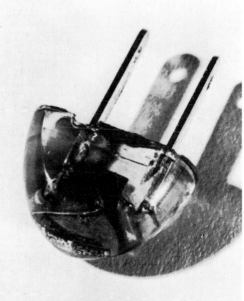

Versatile clamps can be used to hold EF unit or a floodlight reflector, and will hold an SLR clamped to a support. Rowi unit at right has camera or light mounting rod which extends.

Green Dome plugs into an EF unit to fire it simultaneously with one at camera. Light-sensing circuit makes multiple-flash photography easy without extra wires.

other at an equal distance from the subject will be appropriately weaker so as to fill shadows without removing them completely.

Flash-Fill Outdoors—Most of the time we shoot b&w or color in bright sunlight, and are grateful to have it. As we become more sophisticated about using an SLR, we look forward to slightly overcast days to shoot portraits, for instance. Strong sunlight makes people squint, and creates harsh dark shadows. There's a way to fill or illuminate those shadows with flash, but it can only be done under certain conditions.

The problem comes from using two light sources of about equal brightness to expose the film, complicated by the fact that normally you can only set the shutter of an SLR at a speed such as 1/60 or 1/125 when you use EF.

Within those limits you have to figure out some way to shoot so one of the two light sources is less effective than the other or the result will be flat lighting rather than just some fill light cast into the shadows.

The general procedure is to calculate exposure settings to give full normal exposure by each light source alone. If you actually exposed that way, not only would the light be flat but also there would be twice as much light as necessary for proper exposure on those areas of the scene or subject receiving illumination from both sources.

When the fill light is at an angle from the main light not much surface is illuminated by both sources. When the fill light is also significantly less bright than the main light the addition of the two illuminations where they overlap is usually ignored.

When you consider the sun as the main light and an electronic flash as fill, you will attempt to control the amount of flash illumination because you can't do much about the sun. It depends on the angle of the flash but in general you will want about two stops less light from the flash than what would by itself give full normal exposure. You do it differently with an automatic electronic flash than with a non-automatic unit.

Assuming the non-auto case, suppose you have K25 in the camera and the sunlight exposure is 1/125 at f-8. You figured it at 1/125 because that's the sync speed for the flash unit you are also going to use. Then you figure exposure for the EF unit at the distance you are shooting, assuming the EF is at or near the camera. If the EF guide number is 40 and you are 6 feet from the subject, the full-exposure f-stop for flash would be about f-7, which is 40 divided by 6 approximately.

Outdoors the required f-stop would be closer

To demonstrate flash on camera and multiple flash, the same group of singers were photographed both ways. One flash is OK but the lighting is flat as you can see. A second light held off-camera to the left and fired by a small photo-eye gives modeling and form to the faces and figures. Two compact EF units used in this way can give your flash photography distinction, because so few people bother with multiple lights.

Strong overhead sun created shadows which were filled by EF unit on camera. Slow Panatomic-X rated at ASA 32 allowed an exposure of 1/125 at ƒ-11 to achieve good balance between flash-fill and daylight. To shoot closer, I would have put a layer of tissue or handkerchief over the electronic flash and cut its output in half.

to ƒ-5.6 because the light is dissipated rather than reflected onto the subject from interior walls and ceilings. If you were shooting with flash alone, ƒ-5.6 would be your choice.

If you make the exposure at 1/125 and ƒ-8 you will get normal exposure from the sunlight but one stop less exposure from flash because it would need ƒ-5.6 to fully expose the film. Thus the fill flash illumination is one stop less than normal and this might be OK in some cases. If you want two stops less, you can put one thickness of handkerchief, or a facial tissue, over the flash unit.

Much of the literature about photography reminds you that you can also reduce flash illumi-nation by moving the flash farther from the sub-ject. If you double the distance, that's equivalent to reducing the light by two ƒ-stops. That may be practical in the studio but it is usually not for an amateur with ordinary equipment. In this exam-ple you could detach the flash from the camera and move it back another six feet but you will need a six-foot-long flash cord. You could move both camera and flash back if your composition will allow that.

Fast films aggravate the problem. Without fill flash you can set shutter speed anywhere you choose—even 1/1,000 if you are out in the bright sun with Tri-X. But when you are planning to use

flash you have to set at the flash speed for your camera. Even with a medium-speed film a shutter speed of 1/60 or 1/125 may require you to close down the aperture completely and wish you could close it some more. If you then add some flash illumination you risk overexposing the whole scene rather than just filling the shadows.

The obvious solution is not to use fast film but that's not much help if you have it in the camera and don't have any other film anyway. This is the kind of problem neutral-density filters are intended to solve. You can use one to slow down the film. The final solution is not to use fill flash. Revise your composition, or rig up some kind of reflector to get light into the shadows, or just shoot and hope.

An automatic flash will always make enough light to fully expose the film at whatever f-stop the EF unit *thinks* you have set into the camera. To use an auto unit as fill, set the f-stop selector on the EF at the next lower f-stop than you are actually using on the camera, or set the camera aperture higher than the setting on the EF unit. Again, it's a matter of finding normal sunlight exposure at the EF sync speed of the camera, then finding normal flash exposure, then finding some way to use less light from the flash. The handkerchief trick won't work on an auto-EF because it will just make light longer to compensate.

TROUBLESHOOTING AN EF

If your EF unit seems to be in good working order, but will not fire, one of the following may need attention:
1. Synchronizer cords are often fragile; they break inside where you can't see, and fail to work. Borrow or buy another, or carry a spare, just in case.
2. Batteries fade when you may not expect it. Take fresh batteries on trips, keep a spare set in your refrigerator if you're shooting a lot around the house. Use the longer-lasting alkaline type. They are worth the extra cost.
3. Charge nicad batteries at least once a month. If you forget, one of the components called a capacitor "deforms" if uncharged for a long enough period, and may fail to operate entirely.
4. If cord, batteries and everything are okay, but the unit's ready-light won't come on, there's something wrong inside probably. Try it on household current, and if that works, you still have one way

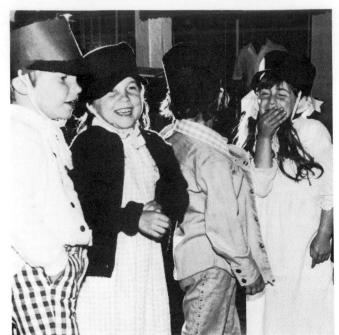

Another example of multiple flash, with the remote unit almost behind the children giving a rim-lighted effect and canceling the usual black shadows from the flash on camera.

to use it. However, it probably needs repair. Don't try to do it yourself, unless you're an electronics expert. It can be dangerous. Find a factory service center or ask your local camera shop for guidance.
5. The internal sync mechanism of your SLR is also subject to malfunction. Tiny wires or parts of circuits fail and must be repaired by a trained expert. Check your camera shop for recommendations, or refer to repair stations operated by the camera's manufacturer.

KEEP FLASH IN ITS PLACE

Remember, I said I was an advocate of keeping flash in its place. This should be evident from what I've written about the pleasures of available light. I expect you to check exposure and depth of field in any situation, and decide if you really *need* flash. If you do, it is there to use with as much artistic skill as you can muster. When you really need flash, there's just no substitute.

What makes a good picture? **EXPERIMENT**

After reading about close-up photography, it probably sounds easy enough, but have you actually tried it? The single-lens reflex adapts naturally to a *variety* of styles and subjects, so if you get into a rut you have only yourself to blame.

Start with close-up experiments and you will soon be motivated toward other new ways to enjoy your SLR. With a macro lens on the camera I followed this bee as it flitted from flower to flower and snapped about 10 frames of which this is best. Shooting at 1/500 and ƒ-16, I knew depth of field would be minimal but the bee would be sharp.

Take some photographic chances and discover the pleasures of experimenting with macro, filters, blurred action, double exposures, night photography or anything else that seems different from the average approach. It's all there, but *you* must open your imagination to the possibilities.

What makes a good picture? IMAGINATION

How would you describe your approach to photography? Is it romantic, functional, interpretive or unlabeled? You have probably given the subject little thought, and it may seem ridiculous to categorize pictures you shoot just for pleasure with an SLR. Isn't it enough to feel satisfaction from good pictures? Yes it is, but when you are more aware of goals, there's more possibility of growth in photography.

Reaching goals takes imagination. It is the shaping force behind every good picture from a baby's smile to a gorgeous sunset. Some situations just happen, and you need little more than competent technique and a sense of composition to get them on film. Other times imagination stimulates you to shoot people, places and things that are easily overlooked.

That's one of the incentives I felt as I walked London's exciting streets at night. I waited for a car to pass in the foreground, held my SLR steadily at 1/60 and f-5.6. Experience told me the 52mm lens was correct, but imagination drew me to visualize the scene in black and white. Imagination leads us to take chances that turn out to be good pictures, night or day, rain or shine, static or active.

1/TEXTURE SCREENS

A lot of things rattle about in your mind while writing a book such as this. One of the most urgent is: "Am I including everything that's important to the average SLR owner?" It's one thing to explain techniques of photography clearly, and it's another to be thorough enough without being boring or redundant. I've written other books about photography, but this one's different. It details more material, it benefits from my experience since the last books, and it concentrates entirely on SLR photography.

At any rate, these case-history pictures were chosen to augment some situations covered previously, and to show a few specialized ways single-lens-reflex pictures can be taken or manipulated through darkroom efforts—yours or those of a lab.

2/AGAINST THE LIGHT

1. TEXTURE SCREENS

Both black-and-white and color prints, plus color transparencies, can be enhanced by the thoughtful use of texture screens. Textures such as canvas, linen, burlap, brush strokes or etching can be printed with your pictures or projected on a screen with slides. I've never been a strong enthusiast about this sort of thing until recently. For one thing, it seemed contrived, and for another, it was too complicated. However, I've discovered that some people love their portraits printed with a screen that is not too rough, and certain scenics have more appeal in conjunction with decorative textures. In addition, I've discovered background texture films—individual frames of 35mm film with minute texture in the emulsion. You place a texture film in the negative carrier of your enlarger with your own negative, and it prints in proportion to the enlargement you make. It looks good and has a subtlety that I like. You can buy texture films and ask a professional lab to use specific ones for you from time to time.

A separate set of texture films is made to sandwich with color slides for projection. This gets a little more expensive, because a piece of film may stay with a specific slide, while texture screens used for projection printing are re-usable. However, if you want to add a new spark to a slide showing—an artistic touch—a texture screen is worth the experiment. They are sold in camera shops or by mail. The set I've found very handy is marketed under the Kalcor trade name, or is available directly from b-g Texture Screens, 2551 Jamestown Court, Oxnard, CA 93030. Write for descriptive brochure and prices.

My sailboat shot was not as visually interesting before I printed it with a canvas-texture screen. It was taken with a 135mm lens on Tri-X from another sailboat.

2. AGAINST THE LIGHT

Now that camera and lens manufacturers are stressing the super-coating of optics in their advertising, it seems likely you will attempt shooting into a light source or against the light. I can't imagine anyone telling you to follow the old nonsense about "having the light come over your shoulder," because it is not necessary. If the sun is behind you, and your subject looks great, that's fine. But when you can shoot into the light and get a picture as striking as Christy Jewell did of the bird in the quiet surf, no one should pass up the opportunity.

Christy, a high-school photography student in Los Angeles, used her SLR with 105mm lens and exposed at 1/1,000 second at ƒ-8 as the sun set. The pattern of water reflections was correctly exposed, and there was little concern for shadow detail. Christy used Plus-X Pan and developed it herself. Before meeting her I had chosen this picture a winner in a contest I judged, and afterwards I asked Christy for a print to show in this book.

3. SEMPER PARATUS

That's the Coast Guard slogan meaning "always ready," but I've always thought it meant "be prepared," which has something to do with Boy Scouts. Carrying a

3/SEMPER PARATUS

camera can become a matter of habit, zone-focused and set for grabbing a fast shot or two at an opportune moment when you're traveling. Ernest Reshovsky was ready for this young Parisian with an armful of bread strolling home from the bakery. He used a 35mm lens and this was enlarged from a portion of that negative. The child was in diffused daylight, and Ernie shot quickly at 1/60 second and ƒ-4.5, so there's a little camera movement. It's not important if you find the face and scene appealing.

4. SILHOUETTE

Maybe it's unnecessary to tell you that silhouettes often present good picture opportunities, but I will. Somehow people overlook the strong interest of a dark recognizeable form against a lighter background. In Jerry McCune's shot of the three youngsters on the fence, the eye goes immediately to the silhouettes, and behind them in the original color slide is a beautiful sunset sky. Exposure is easy because the brightness of the sky background dominates and your SLR meter indicates a small enough

ƒ-stop and fast enough shutter speed. There's so little light from the figures, foreground and overhanging tree that they register as black.

Jerry's photograph was a winner in Kodak's Newspaper Snapshot Contest, and this was made from the Ektachrome-X original via a b&w neg. One of the reasons I chose this picture as a case history was to show you how brilliantly a slide can be translated to b&w negative. From color slides and negatives, you can get just about anything you want.

Keep your eyes alert for dramatic silhouettes that tell a story better than more conventional pictures.

5. ON A RAINY DAY

Here's another black-and-white picture, and another Kodak Newspaper Snapshot winner, made from an Ektachrome-X slide. The original was taken by J.N. Watson, and because he used a skylight filter to warm the natural cool hues of an overcast sky and shadow areas, his color was pastel and lovely.

4/SILHOUETTE

6/THE DESIGN PHOTOGRAPH

One reason pictures in "bad weather" with an SLR can be interesting compared to similar shots taken with less sophisticated cameras, is the superior sharpness of SLR lenses. The SLR photographer also has the awareness to use correction filters when necessary. In other words, this is another suggestion that you take your camera out—protected in a plastic bag or under a jacket—when it's raining. The average photographer stays home and misses the beauty of overcast light. You'll find new opportunities for unusual and personal expression.

6. THE DESIGN PHOTOGRAPH

Many years ago when I was studying photography, I came under the influence of pictures by a master named Edward Weston. Nature and nature's effects on man's works, were Weston's forte as he saw the world through the ground glass of his 8x10 view camera.

I have taken many 4x5 pictures I called studies, in the Weston tradition. These might also be called design photographs, because their impact is dependent on the arrangement of elements, whether a close-up of wood texture, or long shots of landscapes. Each picture was taken slowly and carefully, not only because you load one sheet of film at a time into a view camera, but because I wanted the arrangement of things to be visually impressive, and I took time to make it so.

In recent years I have attempted the same approach to fine design photographs with my SLR. Because films and lenses are much sharper than they were 25 years ago, it is easier to attain crisp images, such as this weathered wood shot by 17-year-old James Visser of Lansdale, PA. He won an award in the Kodak/Scholastic contest because the judges were impressed by the composition and interesting contrasts of his entry. His SLR was mounted on a tripod—advisable for ultimate sharpness in design-oriented pictures—and he used a normal lens stopped down to f-11 with Plus-X Pan film.

In addition to Weston's work, you can also benefit by knowing the photography of Ansel Adams, Walker Evans, Harry Callahan, Wynn Bullock, Steve Crouch, Brett Weston—Edward's oldest son—and Paul Strand. Make some of these names familiar to yourself by finding their photographs in books, exhibits and magazines. Each of these men is outstanding in the way he sees ordinary subjects in an exciting manner. There are other men and women who take pictures in the same vein. Check the art and photography section of libraries and bookstores.

Edward Weston was primarily a black-and-white photographer, but you have the added advantage of viewing the world through your SLR finder in color. Shapes, textures, contrasts of simple subjects such as rocks and water—all of these and much more lend themselves to careful seeing that becomes strong design. Painters extract

7/ARCHITECTURE

from natural subjects all the time; they rearrange and eliminate, distort or revise as they wish, artistically. Photographers have equal chances to compose the plain or fancy portions of the world made by man and nature, from sculptured rocks to fantastic cityscapes. The key to design photography—at least in the tradition I value—is complete sharpness. Use a tripod whenever it's feasible, and be certain of full depth of field from front to back of your composition. In many ways an SLR is "a view camera on a neck strap," because you see exactly what the lens will put on film. And an SLR is a lot easier to carry than a heavy, ponderous view camera—and you get to look at the scene right side up through your viewfinder!

7. & 8. ARCHITECTURE

When you photograph a room interior or the exterior of a building, you can make an effort to line up vertical edges of walls so they are parallel to the edges of the picture, as shown opposite, or you may exploit the drama of converging lines, as shown above. Architecture pictured with slanting corners because perspective was not corrected in shooting, can be embarrassing.

With an SLR you should hold the camera so the film is parallel to the face of a building or wall of a room. This may require moving back with a medium-telephoto lens or finding a higher place to stand so the camera is midway between top and bottom. Indoors, position your camera half-way between the floor and ceiling so corner

lines where walls meet and the sides of windows or pictures are parallel to the sides of the film frame and perspective distortion is avoided.

Professional architectural photographers use a view camera with adjustments not found on your SLR. A counterpart of the view camera for SLR users is the special PC—perspective control—lens which offers correction for architecture. You place the back of the SLR parallel to the subject, and the PC lens can be moved up or down to give a suitable image. The amount of correction with a PC lens is less than you get with a view camera, but it's very helpful if you shoot much architecture.

The skyscrapers above were shot with a 24mm lens, and you see the full negative. The view inside the Pala Mission in California was made with a 35mm lens on a tripod, and a couple of floodlights for good detail.

9. & 10. BIG HEADS AND SIDE LIGHTING

Though I discussed moving close to a subject for intimate portraits in Chapter 7, these two contrasting photographs emphasize the points. Both were shot by teen-age winners in the Kodak/Scholastic contest, and both take advantage of the SLR's ability to focus within a few feet of someone, and crop out extraneous background. Eric Laugen of Seattle used an 85mm lens to capture the bearded man, while Jean Gardner of Fullerton, CA shot a pretty friend with the normal lens of her SLR, and enlarged her head with the doll. Eric was able to crop in the cam-

8/ARCHITECTURE

9&10/BIG HEADS & SIDE LIGHTING

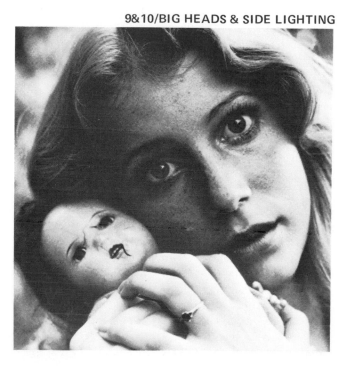

11/GROUP PORTRAIT

13/THE ABSTRACT LOOK

11. GROUP PORTRAIT

It's easier to photograph a group of strangers—who are more inclined to pay attention to you—than your own family who may horse around and refuse to take you seriously. The latter chore takes patience and authority that you try to exert without making everyone up tight. Photographing people with whom you are not emotionally involved is less traumatic because they are usually flattered and cooperative.

That's what Eleanor Bralver discovered when she grouped students at the high school where she teaches to shoot a delightful pattern of faces as an illustration for a book we did together titled *Teenagers Inside Out.* Eleanor used the 52mm normal lens on her Konica Autoreflex T and Plus-X Pan film. Though she cropped very tightly on some of the heads, there's a strong flow in her composition that is dominated by the young man in the white hat. They were enjoying the experience, and the variety of their expressions makes an unusual group portrait.

12. PETS WILL POSE, TOO

This handsome photo of "Tristram" was part of a prize-winning portfolio by 16-year-old Emily Wheeler of Fairfax, VA. She won a $1,000 scholarship in the Kodak-Scholastic Contest. Her direct approach plus the use of backlighting gave a strong simplicity to her entry.

A friend attracted the dog's attention off camera, and Emily shot the alert look from about three feet away at f-16 and 1/500 on Tri-X. The fast shutter speed plus holding her camera steady provided excellent sharpness. The tree trunk in the background is unfortunate, but excusable, because the detail and lighting are flawless.

Many pets are good subjects in moments of repose, or when distracted to ignore you and your camera. Outdoor locations are usually preferable because the light is strong enough and you can shoot at 1/125 second or faster, even with color film.

13. THE ABSTRACT LOOK

In the late 1800's and early 1900's photographers often tried to imitate the soft-focus feeling of a painting. In fact, there has been a more recent resurgence of this "painterly" feeling in color photos accenting blur and movement.

Abstract painting has also influenced camera work, but not as successfully, because a photograph has a hard-to-disguise literal quality. You will occasionally come across a subject seeming to defy reality, as I did with these reflecting pillars at a hotel in downtown Los Angeles.

It was dusk when I came through the hotel lobby after shooting a reception, and I was fascinated by the irregular geometric shapes reflected as lines and tones in the mirrored decorative columns. I walked around slowly, viewing up at this natural abstraction with a 50mm lens on my SLR, and shot about four pictures to finish a roll. Now I wish I had reloaded and explored further, because a really exciting and mysterious abstract picture in black-and-white or color is often worth enlarging to 16x20 and mounting to display. Keep your eyes peeled for the unreal

era more easily with a longer lens, but Jean knew the face with those eyes would grab the viewer, so she cropped accordingly later.

Both pictures were made with daylight coming from the right side. This effect is more pronounced on the man's face, but notice he was turned to provide light in his shadowed eye. In Jean's photo the dark side of the girl's face contrasts very well with the light-colored doll. The foreground hands threaten to pop out excessively, but the model's eyes are so expressive, we see them as dominant without question.

The next time you take portraits, move your model near a window and enjoy the strong light-and-dark effect that has been used so distinctively by photographers such as Irving Penn in studio portraiture. Choose a longer-than-normal lens if you have one or an extender, and get photographically closer to your subject than ever before.

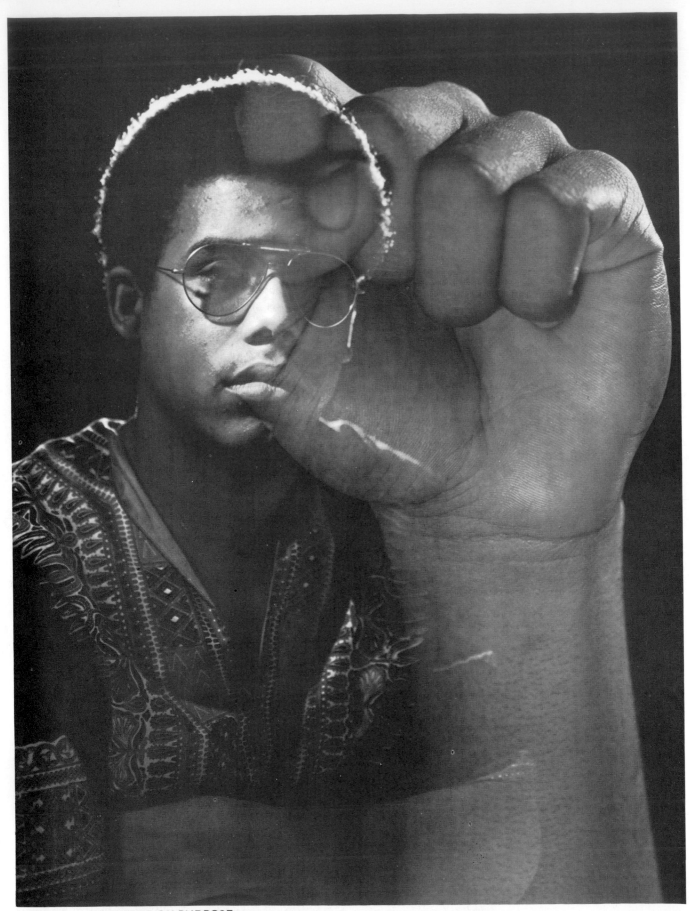

14/DOUBLE EXPOSURE ON PURPOSE

to be captured on film instantly in patterns which may make painters envious.

14. DOUBLE EXPOSURE—ON PURPOSE

Double exposures in the camera are difficult, but often rewarding. Some SLR models include a lever to cock the shutter without advancing the film. If your camera does not have this feature check the instruction book for the recommended method. On most cameras without special provision for double exposures, the following method will work.

1. Double the ASA rating of your film. If it's 64, set the dial to 125, etc. This way only half the total amount of light will strike the film in each of two exposures, adding up to the correct exposure.

2. *Without* depressing the rewind button on the bottom of your SLR, turn the rewind knob to tighten the film. This takes up the slack and holds the film more steadily so that both exposures will register within the same frame lines. If you do a number of double exposures in succession this way, expect the images to be off-register in the later ones. You simply cannot hold the film in a completely stable position, but it will be close enought to make the attempt worthwhile. Be prepared to get your color film back unmounted from the processor; they don't want to risk cutting it when some images overlap the margin between frames. You decide how to cut the film, and mount it yourself in cardboard mounts with heat and pressure, or by sliding a frame of film into a plastic mount. The latter is easy and neat.

3. Now make your first exposure, and remember the composition, especially the light and dark areas. A light area such as a sky will overpower a second image which will be very faint, but within a dark area, a second image will show up very well. Make a few double exposures and you'll see what I mean.

4. Hold the rewind knob, depress the rewind button on the bottom of the camera, and gently cock the shutter. If you're very careful, the film will stay in place, and you're ready to shoot again.

5. Make the second exposure, trying to arrange its composition harmoniously with the first.

6. After the second exposure, advance the film as usual, ready for another try, or a return to single-exposure photography. When you do stop making multiple exposures, remember to return the ASA rating to normal on the proper dial.

Double exposures take practice, but there's a fascinating serendipity about them that makes the time, effort and film well spent. If you put more than two exposures on one frame of film, you must multiply the ASA film rating accordingly by 3, 4, or whatever is indicated.

In the double-exposure shown, Ray Shaw of Lompoc, California placed the clenched fist far enough away from the face so details of the latter remained clear. He purposely used a black background and lighted the fist with subtle contrast so it would stand out without dominating the face. He also backlighted—or rimlighted—the model's hair to separate it from the background. The blend of images in this planned double exposure titled "Inner-Self" which won a Kodak/Scholastic award. How would you have arranged the elements of this picture?

15/DARKROOM MAGIC

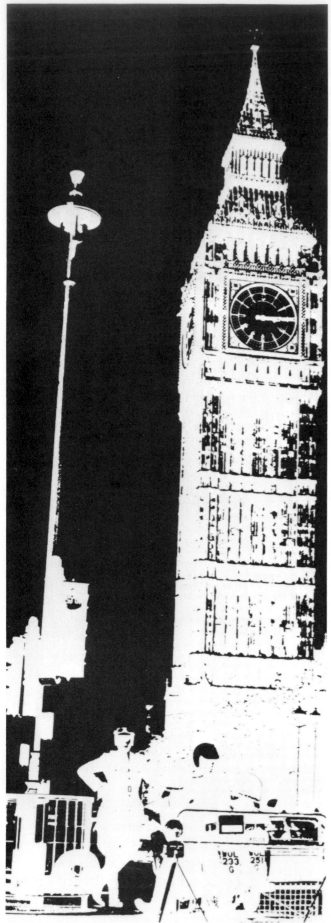

15. DARKROOM MAGIC

While fine pictures are often made completely in your single-lens reflex, they can sometimes be improved in printing by careful cropping. Special effects are possible in the darkroom to create new images the camera didn't see. You don't have to process your own film or make your own prints to benefit by this book, but I do want to point out just a few examples of darkroom magic to increase your awareness of future possibilities. I would like to urge and inspire you to try darkroom work eventually, because the added controls and variations can help lift your spirits as well as offer opportunities to creativity.

The running animal silhouetted against the sky is from two different negatives. When I shot the greyhound running up a sand dune, the sky was a monotonous gray. Soon after the sun appeared behind clouds and I shot a few more pictures—using an 80-200mm zoom lens set at 200mm—but the dog was gone. In the enlarger I first printed the bottom of the picture and held back the sky area by covering it up. It was simple to draw the horizon line and indicate the dog's position on a sheet of paper which I then used to determine placement of the cloud negative. The foreground of the second negative was blacked out by the sand dune except for a slight curve at the bottom left which I thought effective for visual depth. I tested the exposure for each negative, and printed them both into one picture that developed evenly. This process is called *double-printing,* and if you know what to ask for, a custom lab could accomplish similar results for you.

16. POSTERIZATION

A darkroom manipulation—called *posterization*—began with a negative shot by William Heiden of Lompoc, CA, and ended up another Kodak/Scholastic winner. He projected a narrow cropped section of his picture onto a sheet of 4x5 Kodalith high-contrast film and when it was processed and dry, he made this print from it. His negative produced a positive image on Kodalith, which eliminates most of the halftones and registers largely black and white. The positive 4x5 film reversed to become a negative image on paper when printed again. The result is decorative and different. If you want to know more of the possibilities, one of the books you might study is *Creative Darkroom Techniques* published by Eastman Kodak in 1973, or *Do It In The Dark* by Tom Burk.

16/POSTERIZATION

17/A NOSE FOR NEWS

17. A NOSE FOR NEWS

Occasionally, you may happen upon a news event that could be an interesting SLR target. Accidents and fires are most common, and if you stay out of the way of law enforcement officers and firemen, while including some of them in your shots, the chances are good to catch the excitement on film.

Medium-telephoto lenses, such as 100mm and 135mm are useful to help keep your distance, and fast films are needed at dusk or at night. If you really get unusual pictures, and no news photographers appear on the scene, phone the nearest daily newspaper, and ask if they would like to see your pictures. When they are interested, they will usually suggest you bring the film in immediately, and they will develop it for you. Should they use a picture, payment will be $25 to $50, but be sure you get *all* your negatives back. You are under no obligation to hand over the negative of a picture sold and printed in the paper.

Brig Denison of Petaluma, CA happened upon a small house burning, and got this news-worthy photo which won a Kodak/Scholastic prize.

Another practical H. P. Book by Ted Schwarz, *How To Make Money with Your Camera,* explains a series of money-making projects, including news, weddings, theater, children, pets and industrial photos.

MISCELLANY

What else can you do to take better pictures with your SLR? For one thing, shoot plenty of film as often as possible. Plan short trips to photogenic spots, even for half a day, and I don't mean just scenic wonders, but places where people are doing things. Kids at museums, people playing or resting in a park, motorcycle and car races, offbeat roads between large highways, or a neighborhood parade—all of these and more offer picture possibilities. Feel free, experiment, keep looking for new angles, help friends and relatives relax, and enjoy yourself as well. Photography is *your* means of self-expression, and a single-lens reflex is your personal instrument of pleasure.

Read plenty of books and magazines where fine photography is featured. *Time/Life* has dozens of volumes such as the *American Wilderness* series, with outstanding photos. Become familiar with the shelves in your library and a few local bookstores, looking for older books and the

latest publications that use photography excitingly. Start a library of your own, and fill it with the books and magazines you cannot resist. Bulge your budget once in a while. Books become more valuable over the years as they continue to inspire you.

Read contemporary photographic magazines. Many of them are full of advertising that may frustrate you because you can't spend thousands on equipment, but there are also pages of outstanding photographs—along with some contrived, oddball, imitative and silly examples. It won't hurt you to get annoyed at pictures you feel are inferior, because your urge to shoot better things and your conclusions about why something seems terrible will help reinforce your own convictions about composition, color, or whatever. You may not agree with my judgement in selecting pictures for this book and if you don't, I say, "Good for you!"

Talk with friends who are also interested in photography, but try to steer clear of too much gab about equipment. It's easy to discuss lenses and gadgets, but you want to develop your values about *pictures*. If you belong to a camera club, try to elevate the standards by which photographs are judged. How could a picture—yours or anyone's—be improved?

Photography is an art, a science, a skill, a craft and a hobby. It should also be a compulsion. Only then will you enjoy the greatest rewards from your wonderful single-lens reflex.

Frame 37

You can find a recipe in a magazine for a chocolate cake. You can stir one up and serve it to admiring friends. If it's good, some will want the recipe. Thousands of people across the country are baking that same chocolate cake.

Do you ever wonder where that recipe came from? Who gets the most out of it—the person who made the recipe or the people who follow it? I think the originator did.

As you have seen, this is not a recipe book about photography. I never did tell you to stand exactly ten feet from the tree, use a 35mm lens, point the camera upward at 45 degrees, wait until the sun just touches the top, and so forth.

Photography is too variable and too individual to use recipes. I have tried to emphasize that throughout this book by using all kinds and types of pictures. Most have some special quality, which is why I think they are outstanding. None of them was shot by a recipe.

When you know what your camera does with light and photographic emulsion, and when the use of lenses and exposure variables is part of you and your self-expression, then the whole photographic process is an extension of your mind's vision. When you take a picture it is *not* a casual happening in the stream of life. It is your creation and it is a measure of you.

If you have the vision and the will, you can take great pictures. I hope they fill your life with pleasure and accomplishment.

INDEX

A
action, 122-135
 angle of, 125
 peak, 120-121, 123-124
 sequence, 133-137
Adams, Ansel, 70, 213
animals and pets, photography of, 132, 217
architecture, photography of, 214, 215

B
babies, photography of, 109, 111
backgrounds, 94, 115-117
bellows for close-ups, 181

C
camera handling, 79, 80-85
camera systems, SLR, 20
Cartier-Bresson, Henri, 124-125
children, photography of, 109-111
close-up photography, 175-184
 exposure for, 182,-183
 extension rings for, 180-181
 lenses and attachments for, 179-182
 lighting, 177-179
 principles of, 175
 slide copying, 183-184
color, pleasures of, 160-161
composition
 abstract, 217
 content, 90
 elements of, 90-94
 impact, 90
 postcard cliche, 155-158
 pictorial components of, 94-98
 tension points, 93
contrast, characteristics of, 74-75
cropping, 55, 99-101
customs regulations, 151-154

D
darkroom techniques, 220
depth of field, 31-39, 85, 132-133, 176-177

E
electronics of SLR, 4
exposure
 estimating chart, 171
 for close-ups, 182
 for flash-fill, 203-205
 in available light, 145

 meter averaging, 76
 meter characteristics, 80
 metering system, 71
 time, 169-174

F
film-advance lever, SLR, 6
films, characteristics of 55-59, 160
 speeds (ASA), 55-57
 for time exposures, 170
 for traveling, 150-151
films, types of, 54-64
 charts, 58, 59
filters, use of, 63, 65-67, 149, 174
finder display, SLR, 9
flash
 duration of, 188-190
 exposure for 190
 for color films, 196
 guide numbers, 191, 193
 lens guide numbers for, 196
 sync with SLR, 196-197
 theory of, 188
flash, electronic
 automatic, 191-196
 battery power for, 198-199, 206
 bounced, 164-165, 197, 200-201
 multiple units, use of, 202
 off-camera, 201-202
 photo-eye for, 202
 recycling time, 198
 slave, 202
 special types, 184
 tchniques for using, 200-206
flashcubes, 188
flash-fill outdoors, 203
floodlights, 113-115
focal plane shutter, SLR, 5
framing, 95

G
ghost images, 196

H
hot shoe, SLR, 11

I
insurance for equipment, 154

K
Kelvin scale, 113

L

lens characteristics, 25-45
 aberrations, 43
 coating, 44
 depth of field, 31-39, 85, 132-133
 elements of, 25
 focal length, 25-30, 32-33
 f-numbers, 40
 formulas, 42
 sharpness of, 43-44, 45, 85
 speed of, 39-43, 85-86
 zoom patterns, 130-132, 174
lens mounting methods, 12
lenses, types of, 13, 45-51
 close-up attachments, 180
 for travel, 148
 macro, 50, 179-180
 normal, 32
 portrait, 111-112
 special purpose, 51
 telephoto, 32, 46
 variable-focal-length, 49
 wide-angle, 32, 45-46
 zoom, 47-48
light, available, 140-145
light, direction of
 backlighting, 74, 77-78, 118, 210, 211
 front light, 73, 118
 indirect, 74, 119
 reflected, 119
 sidelight, 74, 118, 214-217
 toplight, 74
lighting exercises, 117-119
lighting equipment
 electronic flash, 198
 flashcubes, 188
 floodlights, 113-115
 quartz lights, 114

M

macro photography, 175-184
metering techniques, SLR, 76-80
mirror, SLR, 9
mood, 95
motorized cameras, 135
multiple exposure techniques, 167-168, 171-172, 219

P

panning the camera, 126-128
pets and animals, photography of, 132, 217
portraiture, techniques of, 107-111, 214-217
push-processing of film, 62, 140-141

R

reciprocity failure, 182
reflectors, 115
rewind knob, SLR, 7

S

self-timer, 10, 85
shutter release button, SLR, 6
shutter speeds, characteristics of, 82-86
shutter speed dial, SLR, 6
slide copying, 183-184
sync connectors, SLR, 10

T

take-up spool, SLR, 8
tele-converter, 51
texture screens, 209, 210
time-exposure techniques, 169-174
travel photography, 155-158
tripod, use of, 83-84, 112, 128-129, 131, 149, 175

W

Weston, Edward, 102, 103, 213

X

X-ray problems, 151

Z

zone focusing, 132
zoom lens patterns, 130-132, 174